The Business of Being an Artist

Daniel Grant

ALLWORTH PRESS, NEW YORK

Copublished with the American Council for the Arts

Special thanks to Elliott and Jane Barowitz, Alexandra Chesner, Marjorie Grant, Anne Mochon, Monona Rossol, Larry Smith and Tad Crawford for their assistance and ideas.

© 1991 by Daniel Grant

Published by **Allworth Press,** an imprint of Allworth Communications, Inc. 10 East 23rd Street, New York, NY 10010.

Distributor to the trade in the United States: Consortium Book Sales & Distribution, Inc. 287 East Sixth Street, Suite 365, Saint Paul, MN 55101.

Distributor to the trade in Canada: Raincoast Books Distribution Limited 112 East 3rd Avenue, Vancouver, B.C. V5t 1C8.

Book design by Douglas Design Associates, New York, NY.

Library of Congress Catalog Card Number: 91-71887

ISBN: 0-9607118-5-6

Table of Contents

Foundation Support
Church Support
Who Decides Artistic Merit

Introduction

These are curious days in the art world, when dealers claim that they will speak only of art and not at all about the pricing or market while artists can talk of little else than name-recognition and money. Artists are told that they must think of themselves as businesspeople, sending out letters, resumes, clippings and slides of their work to critics, dealers, curators and other possible exhibitors, following up with telephone calls and visits, arranging for the framing, crating and shipping of their work, negotiating with their dealers and galleries, responding to inquiries and whatever else the advancement of their careers require. Appointments with the Muse are fit in when their schedules permit.

Small wonder, then, that so many artists find themselves needing help. Some pick up information in the few "survival" courses offered at various art schools; others hire publicists and advisers to help promote, or give direction to, their work; most others glean what they can from the growing number of business and legal guides for artists available these days, or just improvise.

A strong case can be made for just improvising as there is little rhyme or reason in the way that certain artists become successful while most others do not. All of the hard work of researching galleries, making telephone calls, sending out slides, developing a portfolio and a long resume of exhibitions may amount to nothing, while someone right out of art school who happens to know the right person or to be at the right place at the right time is lionized. Luck really cannot be talked about, and talent is not a subject for advice.

Still, throwing up one's hands or waiting for lightning to strike is no answer either. The business side of being an artist means knowing what the options are and making informed choices. Too many artists are un-

aware that they have choices, or that there is more than one way for them to achieve success — defined here as the ability to make a living as an artist.

Every known method of attaining career goals has worked for certain artists, failed for others. Therefore, to prescribe a path for success — advising artists to write this sort of letter to a print publisher, sign this type of contract with an art dealer, dress in this manner for a potential corporate buyer — is doomed to fail most artists. It makes the most sense for artists to know what the possibilities are for helping themselves, allowing them to improvise but with informed choices.

Each artist has his or her own measure of achievement. To some, that might mean being written up in a textbook or getting into a major museum collection; perhaps, it is being represented by a prominent art gallery or any gallery, or just having one's works displayed somewhere for the public to see. Artists who are starting out are likely to have career objectives different from those of artists who have been working for a number of years.

Chapter 1.

How to Get an Exhibition and Sell Art

Artists aren't people who simply create art and then drift off into oblivion; they want their work to be seen and to receive some sort of reaction from those who see it. Putting art in front of the public establishes an artist as a professional and, for many, the quest for a show is their primary goal. Fortunately, there are many venues for exhibitions available.

Dealers and Art Galleries

For the past 150 years, art dealers and galleries have been the principal route to success in the art world. Dealers frequently have a select clientele, or one or more principal backers, who do the bulk of the buying, and it is the closeness of the dealer to these important collectors that establishes his or her prestige. Few long-term successful dealers survive without this clientele, and gallery owners who rely on walk-in traffic for their sales tend to go in and out of business in a hurry.

Finding the right dealer who will lead the artist's work to major collections is a challenge, and few generalizations can be made. Dealers become interested in potentially representing artists largely through two means: The first is when dealers personally know the artist (meeting him or her at an art opening or on a studio visit) as well as hear about the artist from people they trust, such as other artists they represent, curators, critics and collectors.

The second way is through the strength of an artist's work and market. Artists usually send dealers slides of their work and some indication that there is a market for it. To that end, artists who are starting out need to build a track record of group and one-person exhibitions and, along

with that, develop a group of consistent buyers. Dealers don't like to try to build a market for an artist but, instead, look for artists who already have a market that can be expanded.

A Variety of Exhibition Spaces

Building that track record involves getting into shows, and there is a wide variety of exhibition spaces available for the starting-out artist. Banks, libraries, offices and restaurants, for example, are frequently willing to allow artists to hang up their works on the walls where the public may see them. The likelihood of sales is low and the possibility of damage to the work (fingerprints, coffee splashes, cigarette smoke) is considerable, but this type of show is a chance for feedback and for the artist to circulate press releases, announcements and exhibition cards and be remembered the next time his or her work is on display.

Many towns and smaller cities have arts centers where exhibits can be seen in an actual gallery setting. A notch above the art show in the bank or library, the arts center is likely to have its own means of promoting its activities, increasing the number of people who may come to view the artwork. Here may be a first opportunity for a write-up in a local newspaper, again increasing the number of people who know about the exhibit and the artist.

Art also becomes visible to the public at juried art competitions. Some clearly have more prestige than others, based on the renown of the juror(s), whether or not prizes are offered (for instance, by paint manufacturers), whether or not any sort of catalogue is published and where the exhibit is held. Shows that take place in more august settings, juried by a person of some importance in the art world and leaving some sort of memento behind after the event is over, such as a catalogue, are most likely to increase the artist's visibility and chances for later success.

Alternative spaces (nonprofit organizations dedicated to arts activities that may be outside the mainstream) and cooperative galleries (in which a group of artists band together to share the work and expenses of running a gallery that features their own artwork) are questionable in terms of leading to actual sales, but they are places where artwork may be seen, written about and discussed.

Arnaldo Roche Rabell, a Puerto Rican-born painter, came to live and study in Chicago and eventually exhibited his work at university galleries and alternative art spaces throughout the city. In time, that paid off.

"There are a lot of alternative spaces in Chicago, which are set up to show new stuff, fresh work that maybe the other galleries haven't caught

on to yet," Roche said. "Over the course of six, seven or eight years, people got to see my work at various places, saw the quality and consistency, and after a while my paintings got mentioned in the newspaper reviews of these shows."

Two of the most important of those exhibitions were one at the School of the Art Institute of Chicago (which Roche entered as an undergraduate and walked away with the top prize of $5,000, enabling him to pay his Masters of Fine Arts tuition at the same school) and another called "Emerging" that took place at the University of Chicago, which brought him telephone calls from art dealers wishing to represent his work.

"A show here, a show there and your name starts to travel around as more people have seen your work," he stated. "I've never knocked on doors, trying to get big galleries to show my work. I've never written letters to big galleries asking them to look at my work. The big galleries called me because I've shown elsewhere."

Shows at university galleries are in a class by themselves, not as potentially lucrative as commercial gallery exhibits but of a higher prestige than the town arts center or cooperative space. University galleries expose work to the public, although it is not often a buying public. However, some of the renown of the college or university itself rubs off on the exhibitor to a degree, because these shows reflect some degree of curatorial selection.

A notch above college or university galleries are exhibitions at local museums. A number of museums in cities around the country have established "emerging artist" or "matrix" series, featuring short-term shows of local, regional and (sometimes) mid-career artists. This has been a burgeoning area of programming for museums as these shows cost far less than major scholarly exhibits (the National Endowment for the Arts has provided much of the financial impetus for "matrix" shows), require months instead of years to plan, spotlight the work of local artists where there is not a significant market for art and enable essentially historical institutions to have a relevance to the art of the present day. Frequently, although not always, museums buy work from these shows as a way to develop or improve their contemporary art collections. The museums' publicity departments are also able to generate considerable community enthusiasm within the community for at least seeing the work.

All of these spaces for exhibits are opportunities for artists and potential collectors to get together. Opening receptions provide a means for people to meet, talk about the work and take down names and addresses of visitors who might be contacted about future shows.

Artists should research the galleries that they hope will represent them

in order to determine, not only whether or not they show work that is similar thematically to their own but, if the galleries will look at new, unsolicited art (that can be discovered through a telephone call). Both national magazines *Art in America* and *Art & Auction* publish summer issues listing art dealers around the country as well as the type of art that the gallery represents. *Art Now* gallery guides (available by subscription from Art Now, Inc., P.O. Box 888, Vineland, NJ 08360, tel. 201-322-8333), which are published regionally around the country — New York greater metropolitan area, Boston and New England, Philadelphia, Southeast, Southwest, California-Pacific Northwest, Chicago-Midwest as well as one for Europe and an international edition — are another source of information. An additional source for artists who have computers is ARTLINK (costing $35 a year, tel. 404-377-2210, or use the modem access number 404-377-2115), which electronically provides information on jobs for artists as well as galleries in search of new artists and museums that show the work of contemporary artists.

Certain cities also have their own separate publications, such as *The Artists' Guide to Philadelphia* (available for $11 through The Artists' Guide, P.O. Box 8755, Philadelphia, PA 19101). One wishes that *The Artists' Guide* existed nationally, since it provides the specific information that artists want to know, such as how and when each gallery in Philadelphia reviews slides or original work, the price range of the art sold at the gallery and certain points concerning how the artist-dealer relationship is structured there.

Personal contact usually makes a substantial difference. Knowing the dealer or knowing (or favorably impressing) someone who has the ear of the dealer is likely to turn the tide for a dealer who is unsure about the saleability of an artist's work. That is why artists need to have their work shown as widely as possible — a critic, collector, curator or dealer may spot it (for instance, as a juror in a competition) and pass the word on about an interesting find — and to make themselves available to potential buyers and gallery owners.

Make Sure You Have Good Slides

There are, unfortunately, only a handful of cities around the country where an artist can make a living selling work. Sooner or later, most serious artists decide to pursue dealers and galleries in those few cities. This pursuit can be conducted through the mail or in person. All of the material that would be brought to a gallery — a telephone call in advance to line up a few minutes with the dealer (or his or her assistants) is advisable —

should be included in any package mailed to the gallery or dealer.

The postal route requires mailing slides of one's work (a sheet of slides holding as many as 20) along with a cover letter, resume and any other biographical or artistic information and published write-ups of one's work along with a self-addressed stamped envelope. Since being in the right place at the right time is important, these packages should be sent out periodically, as it is never clear when a dealer will be looking for new talent. Some dealers handle only 20 artists while others represent as many as 200.

If asked, galleries may return slides to the artist, sometimes months after they were originally sent in and looked over. Slides can be expensive, but they only do the artist some good if they are in the hands of the dealers or gallery owners who may at some point be in the market for new talent. A lot of artists choose not to ask that slides be returned.

Of course, as the slides are to represent one's work and career, they should be made with care. A high quality 35mm camera should be used, set on a tripod (especially when shutter speed is below one-sixtieth of a second) to prevent accidental movement, placed parallel to the work (in order to reduce distortion and blurriness), with the photograph taken indoors in order to control the direction and distance of the light source. The type of film should be matched to the light source. One might also experiment with the light source (diffused or aimed directly on the object, perhaps bounced off a white wall) to determine how the work being photographed looks best. If it all seems overly complicated, hire a professional photographer (particularly one who specializes in this kind of work). That may be expensive, but it's worth it.

Apprenticing and Internships

Catching the eye of a noted critic or meeting people at art openings or other social gatherings are ways to make contact with the larger art world. Another way is by working alongside artists, dealers or museum curators in some professional capacity. Besides meeting important people, this can provide an opportunity to learn how the art market operates, how to set up a studio or prepare a portfolio.

Since the Romantic era, the popular image of the artist has been someone who works alone, going to a studio for conferences with the Muse and reentering the world with something that is Art. There is still much truth to the image, but many other factors exist now that lessen the artist's direct involvement with his or her work. Most artists no longer make their own paints — grinding up pigments and mixing them with oils to form

their own distinctive colors — but rely on a few manufacturers.

Some of today's more renowned artists have groups of people working regularly with them, often acting as personal secretaries (answering the telephone, making appointments, etc.) and occasionally working directly on the work of art itself. One artist's assistant, who worked for Julian Schnabel and previously for Richard Haas, noted that he "schedules appointments, books reservations and, if needed, will strip down and model."

Most of these assistants are artists in their own right whose work with a mentor enables them to meet dealers, collectors, curators and other artists who may provide some career help. For some assistants, that help may mean constructive comments or an invitation to bring one's work around to a dealer or curator; perhaps, a sale may even result. Painters Brice Marden and Dorothea Rockburne, who both worked as assistants for Robert Rauschenberg, are examples of successful artists who began their careers this way.

With other assistants, the benefit may be less tangible although, perhaps, just as real. Jeanne-Claude de Guillebon, the wife of environmental artist Christo, noted that the people working under him — hundreds at times — learn that "art is not easy. Your knees are bruised, hands are bleeding, backs in pain. People also learn to be persistent, generous and not to give up. They learn that by example."

Becoming an artist's assistant is generally not something done by answering an advertisement in the newspaper. Art dealers tend to know which, if any, of their artists may be looking for an assistant, and gallery openings provide opportunities to meet these artists. The pay is not necessarily good and the turnover is sizeable, which indicates both that opportunities are never long in coming and that this is not a career for everyone. However, it can mean a foot-in-the-door entree to the art world.

Besides working directly with an artist, one can also take on an internship with an art dealer or nonprofit art center (running the gamut from alternative spaces to major museums), although this tends to be as much a career path for a future dealer or student of arts management as for an artist. One of the fastest ways to find out which organizations have internship programs is to ask, writing or calling, and then to apply, with a resume and cover letter, following up with a telephone call to arrange an interview. The National Network for Artist Placement (935 West Avenue 37, Los Angeles, CA 90065) also publishes a *National Directory of Arts Internships* ($35) that lists programs of this sort at small and large arts organizations around the country.

An internship is a useful way for artists to learn about the art world

and to support themselves while continuing to do their artwork. Many artists have some museum or art space experience on their resumes, regardless of their later renown. Conceptual artist Sol Lewitt, for instance, worked for a time as a museum guard.

Painter Howardena Pindell lasted a little longer than Lewitt, working in various curatorial capacities in the Department of Prints and Illustrated Books at New York City's Museum of Modern Art for 12 years, before she finally left to devote more time to her own art (she also teaches at the State University of New York at Stony Brook).

Being an employee of the museum had previously tainted relations with the dealers Pindell approached. "A lot of their actions seemed to say, 'I'm only looking at your work because you're with the museum, and I want you to help me out there,'" she said. "There was a sigh of relief by a lot of people when I left that 'she's finally out of there.' People would say to me after I left the museum, 'Gee, your work has gotten better,' when they had actually seen the same painting two or three years earlier."

There are some hazards to working for an arts institution or with a successful artist, as many artists have discovered.

Howardena Pindell found that her life became more coherent after quitting the Museum of Modern Art. She no longer worked days at one full-time job and nights and weekends at her painting, maintaining two separate resumes neither of which refers to the life she led in the other. In addition, Pindell found that artistic expression was not wanted in the curatorial realm.

"The best thing that has happened for me since leaving the museum is that no one says to me now that I must be speaking for the university when I have something to say," Pindell stated. "Back then, it was assumed that I spoke for the museum, which was nonsense. There is academic freedom, and there isn't curatorial freedom. There may be people at the university who despise me, who don't believe in cultural diversity or equality for women, but the stance of the university is diversity of opinion, and what I say is protected. I'm also tenured and my job is protected. At the museum, your job isn't protected, and you have to present a corporate front, which controls the way you speak, the way you look and your politics."

Working for an artist may also stunt one's development. One painter who has worked for Frank Stella ("mostly paperwork") over the period of a few years, complained of feeling "pressure when I do my own artwork. You are so exposed to someone else's sensibility that you can become stymied. Stella's works are so supported by the art business world that my own starts to seem so insignificant."

She added that "people who work with Stella have largely stopped doing their own art. It's hard knowing how to deal with these problems."

The artists' assistants of today are far different from the journeymen apprentices of the Middle Ages or Renaissance. Then, the relationship between master artist and apprentice was that of teacher and pupil, and young hopefuls were contracted out to artists for specified periods of time, doing certain duties in exchange for instruction. Often, these duties included helping the artist complete a piece. One began as an apprentice, became a journeyman and then a master, in turn. The studio of Peter Paul Rubens, for example, had such promising apprentices as Anthony van Dyck and Franz Snyders, who worked directly on the master's paintings.

By the 17th century, the officially recognized art academies in Europe spelled the end of the guild system, although apprentice-type conditions lingered on, if in different form. Academies were the creation of artists who wanted their profession elevated into something higher than artisan; they brought more structured art schools into existence. With the advent of Romanticism, there was a greater emphasis on individual style and on working alone. Being able to do the same kind of art as one of the great masters was no longer highly regarded, as distinctiveness became the predominant artistic virtue.

Still, the master-disciple relationship continued in various forms and exists today. Eugene Delacroix, often considered the father of Romanticism in painting, worked with several apprentices (most of whom are not household names) as did classicist Jacques Louis David, who taught such notable talents as Baron Antoine-Jean Gros, Jean-Auguste-Dominique Ingres and Theodore Gericault. Jackson Pollock, one of the most original artists of the 20th century, worked first with Thomas Hart Benton in something like an apprenticeship, and later with Mexican revolutionary muralist David Alfaro Siqueiros. Pollock learned much about painting from both artists and made contacts that helped him later on.

An artist who has assistants and "fabricators" is more and more the norm. Sculptor Henry Moore made small models and handed them to others to turn into large pieces. Andy Warhol had what he called "the factory" from which works that ultimatedly had his signature on them emerged. Red Grooms' family and friends helped him out. Art is very much the process of doing it and not solely the conception in the artist's own mind, but the complicated processes of creating works and of being a successful artist these days lead many artists to look for assistance from others.

Getting Ready to Exhibit

What art should cost and how it should be presented are matters that only its creator can decide, sometimes in consultation with a dealer, but these decisions affect others as well. Sculptor David Smith defied his dealer by keeping prices out of reach of all but his most ardent and well-heeled admirers — a scornful attitude to a world that he believed had too long ignored and disdained him — and it resulted in very few sales during his lifetime and great misery for his heirs and the executors of his estate immediately after his death. Joseph Cornell bought dime-store frames for some of his works, giving them a sort of mock-elaborate quality, and it turned off some potential buyers.

Artists can clearly be quirky, which may or may not work to their benefit, but most prefer not to do anything that will harm the possibility of sales. There are no hard and fast rules to pricing and framing, but there are ways of playing it safe.

How to Price Artwork: For lesser-known, "emerging" artists — the type of artists for whom establishing prices is the greatest concern (artists who already have a market can simply incrementally raise their prices from time to time) — the best way to establish market value is by going to art fairs, art galleries and other places where artworks of comparable size, imagery and quality are sold. Those prices should offer some guidelines to what an artist may charge for his or her works.

Of course, prices for works will vary greatly from a small town to a major city. An artist whose market is (or is more likely to be) smaller town collectors would want to set prices at the level of those buyers. Similarly, for those artists whose goal is to be represented in the larger urban center, those city prices should determine value. The prices an artist sets should be uniform, however, as dealers in cities won't want to have the same works sold more cheaply somewhere else, known as regional pricing. Artists should feel confident that collectors everywhere will pay what something is worth, if they want it enough.

Raising prices becomes justified as one's market grows, and a heightened demand for a fixed supply itself gives the sought-after works increased value.

Consider the case of Scott Fraser, for example, a painter in Longmont, Colorado. His paintings were first shown in an art gallery in Denver and sold for $300 in the early 1980s. Some sales took place and, the following year, his prices went up to $900. The value of his work continued to rise, to $1,500 and beyond; at present, an average oil painting sells for $7,000, with some works fetching as much as $20,000.

"Each time you make a jump in pricing, you have to get a new set of buyers," he said. "I've lost some of the people who bought my work in the early years, because they can no longer afford me. Every time you break the couple of thousand dollars barriers with your prices, you have to look to get new collectors."

For Fraser, the plan for attracting new buyers involves keeping in touch with current collectors by letter ("I write to them, telling them what I'm working on, when and where I'm having a show") and also writing to potential buyers when "a lead" is mentioned to him, either by a friend, associate or dealer at one of his galleries. That letter usually includes a biography, slides of his paintings and a statement about his artistic purpose as well as some mention of the person known in common (who gave Fraser the "lead" in the first place).

For other artists, raising prices may require finding another gallery or dealer, where opportunities for having works purchased by collectors who will pay more or lend enhanced prestige to the work are greater. Some dealers may only be able to work with emerging artists and not have the contacts to help an artist who is selling work steadily. Changing galleries may be a difficult decision for an artist who got his or her first big break with a particular dealer, and it can be doubly hard in the art world because the relationships between artists and dealers are often on a personal, friendship level.

The issue can be discussed with other artists, some of whom may have experienced the same situation or might facilitate an introduction to their own dealers, or by directly making contact in one form or another with a dealer whose gallery and contacts better reflect the artist's current situation. Networking, passing on information and using the "favor pool" are the most common ways for artists to advance their careers.

"You have to be discreet when you're looking for a new dealer," painter Nancy Hagin said. "Dealers certainly don't like it if you bad mouth them but, of course, why are you shifting and looking around if you aren't unhappy?"

Hagin noted that she "sniffed around...put out the word that I was looking for other representation...talked to people who knew me and knew which dealers were looking for what" and, finally, found the right match. She had been represented since 1973 by New York City art dealer Terry Dintenfass and found, "I got a fair number of sales, but I didn't get a lot of shows and the prices were low."

She began sending out announcements for her shows at Dintenfass to the director of New York City's Fischbach Gallery in the late 1970s, later adding a note "that said, in essence, I was restless and had a body of

work ready to go. Would he be interested in talking?"

The Fischbach Gallery, as it turned out, was happy to represent her work. At the outset, she requested a show every two years, higher prices for her work and faster payment, all of which she obtained.

"Fischbach doubled my prices immediately" — from $2,400 for a 4'x5' picture to $5,000 and up — "and began paying me monthly installments instead of in one lump sum, which is a lot better for me," Hagin stated.

To Frame or Not to Frame: It would be easy to say that most contemporary painting seems to call for relatively simple, unadorned frames — New York City's Museum of Modern Art thinks this way, having reframed a large portion of the works on display in solid metal frames — but many works look even better in a fancier casing, and sometimes the frame becomes an integral part of the artwork. Picasso sometimes placed his own paintings in 17th century Dutch frames, which not only worked aesthetically but also fit his overall concept of viewing each piece as within an artistic tradition.

Inappropriate frames — those which seem to clash inadvertently with the picture — may turn off the person looking at the art who, at best, will try to edit out the frame mentally. Many dealers report that badly stretched and poorly framed paintings work against the artists seeking sales and representation.

Not all pictures need frames all the time; frames are usually required when the works are being moved around (corners and edges may otherwise get banged up) and when they are being displayed.

Diane Burko, a Philadelphia painter, said that she sometimes exhibits her work unframed — in order to emphasize the edges in her all-over style of work — and other times framed. "It depends on whether the work is going to be traveling," she noted. "If the pieces are just going to stay in the gallery, I may leave them unframed. If they are going to travel to other galleries or to another city, as some shows of mine have done, I generally put frames on them for protection."

Another reason to keep works unframed or not to spend much money on the matting and framing is that a potential buyer may like the picture but not the frame (finding that the frame doesn't go with the decor in his or her house. "Some people like to do the framing themselves and they may not like the mat and frame that the artist put on it," said Carol Becraft, customer service manager at Westfall Framing in Tallahassee, Florida, a mail-order frame company. "It's better for artists to keep it simple and inexpensive."

Others note that many pictures don't look complete without a frame and find that an attractive frame can help sell the work. The prices of frames vary widely, based on whether the artist plans to fit a picture into an existing frame, whether the frame has to be built to a special size and whether the artist does the work him- or herself or uses a frame shop (these range widely in services and quality), which will do the entire job of matting, framing and setting behind a protective glass (possibly costing hundreds of dollars).

"It depends on where you're showing the work," Ronald Cohen, manager at MADD Frames in Philadelphia, which provides frames for a number of galleries in that city and Manhattan, stated. "The air of certain better galleries just seems to demand a high quality frame while, probably, a nice frame doesn't matter so much at an outdoor art show."

Artists who are unsure how best to frame a particular work may want to ask their dealers or show organizers for some advice, if their good favor is important to the artist, or check with a museum curator. In the past, dealers automatically took charge of framing the pictures that were going on display; now, fewer gallery owners are willing to pick up that tab. Dealers nowadays, however, still want some say over what kind of frame is used even when they don't (or only partially) reimburse the artist for the expense.

Increasingly, the gallery look in frames is stark and clean, made of thin pieces of hardwood (stained or varnished) or metal (black, silver or, rarely, with a gold color), and artists are generally leaning in that direction.

One of the simpler types of framing that is increasingly being recommended is a casing of four thin strips of lattice wood (one-eighth to one-quarter inch thick). Frequently, artists will also place another (although thinner) four strips of lattice wood between the outer perimeter of the picture and the strip frame. Those thinner strips are recessed (and sometimes painted black or some other dark color) in order that the paintings seem to "float" within the frame, and the distance between the picture and the strip frame keeps the artwork from looking visually compressed.

More expensive frames may or may not also have some sort of protective glass in front — that decision is usually based on how sensitive the artwork is to light and dust. Plexiglas or ultraviolet plexiglas, which filters out the most harmful of the sun's rays, is frequently used, although it is considerably more expensive than regular clear glass. Ultraviolet plexiglas may be as much as 10 times costlier than regular glass, and it also scratches easily. The major benefits of plexiglas (either regular or ultraviolet) over glass is that it is more shatter-resistant and doesn't carry a slightly green tinge.

Some artists use different types of frames for different kinds of artwork. Larger paintings may be given strip frames, partly because this is less expensive than buying big frames and, partly, because the paintings get pushed around and bashed a lot in galleries. An important consideration is that an artist may spend $200 or $300 for a nice frame and find that it gets damaged by the gallery, forcing the artist to pay to reframe it when a buyer decides to purchase the work.

Smaller pieces, on the other hand, may seem to call out for a real frame of some sort. Works on paper are almost always framed for their protection, with a protective glass (plexiglas) in front, although the work should never touch the glass itself but be separated from it by an acid-free mat. The backing for a work must also be acid-free, not cheap cardboard and not wood. Paper can easily absorb resins, pollutants and acids from its backing and mat. The only time never to use plexiglas is for a pastel drawing. Plexiglas has a static charge that acts like a magnet to draw dirt and dust to it. Pastels, which have a chalky consistency, can be problematic as the glass would tend to pull the medium off the paper.

With works on canvas or panels, the fragility of the surface of a painting may become a consideration in the decision of whether or not to frame. Of course, the framing question may be less pressing for artists whose work is generally the same size from one picture to the next since, if one buyer wants the art but not the frame, the frame can be reused for another painting.

Chapter 2.

Contracts with Dealers and Print Publishers

Landing a dealer, whether or not that person is a major figure in the art world, is not the end of an artist's art business concerns. If art dealers were as trustworthy as so many artists are trusting of them, there would not be a growing body of art law, nor would there be a growing number of lawyers specializing in artist-dealer conflicts. As much as artists want to be "just" artists when they finally find a dealer who will represent them, devoting their attentions solely to creating works of art and leaving the legal and business considerations of their careers entirely to people in other, less ethereal professions, artists must proceed with caution and a down-to-earth sense of their own rights.

Dealers come in a wide assortment. Some have strong contacts with established collectors and are able to sell most everything by artists in whom they believe; others may not sell very much, earning most of their money through framing pictures or consulting with private individuals and corporations on what art to buy and where to hang it; yet others are artists themselves who have set up a gallery for the primary purpose of creating a fixed venue for their own art, exhibiting other artists' work at the same time. Some dealers are personally and professionally supportive of the artists they represent, while others believe in letting artists find their own creative paths. Not all dealers are right for all artists.

Artists and their dealers may not be of the same mind on a variety of practical matters as well. Disagreements may arise over pricing, proper accounting, discounts, assigning of copyright, the frequency of exhibitions and a host of other legal and business issues. These differences are not necessarily the result of ill intentions on the part of a gallery owner; rather, it is the power imbalance between artists (especially the younger emerging artists) and their dealers that often forces artists to accept otherwise

unacceptable arrangements. To a degree, artists can only hope that success in selling their work will provide them with greater leverage for negotiating better deals later on. However, it is useful to have a firm idea from the start of what one's arrangement with a dealer is and to get that in writing if at all possible.

Written agreements can be broken as easily as verbal ones. Verbal agreements are legally enforceable, although disputes may be settled much more quickly when there is a clear agreement in writing signed by both parties. Certainly, the legal costs would be less, if the dispute reaches that stage, because it takes less time to enter a legal document into evidence in court than gathering hours and hours of conflicting depositions by both sides, disputing what was said when by whom.

A number of artist advocates recommend that artists and their dealers sign explicit consignment contracts as a means of fully clarifying their relationship and avoiding conflict. This is one of the most disputed topics in the art world, one that jars with the handshake tradition of the art world. Dealers generally look on the formal contract with considerable displeasure.

"A lot of the relationship between the artist and the dealer is based on trust, and you can't pin that down in a written contract," one prominent New York City dealer said. "In fact, the written contract may imply a lack of trust."

Coming to Terms

The threat of "turning off" a dealer may well make an artist reluctant to present any written agreement to his or her potential agent. However, artists and their dealers should speak with some specificity about how they will work together, and this should be written up by the artist in the form of a letter that the artist asks the gallery owner to approve and sign. Frequently, artists and dealers have a short-term agreement — a sort of trial marriage — to determine whether or not they work well together, and this may be renewed or expanded later on.

According to Caryn Leland, an attorney who frequently represents artists, "It could be a straight forward letter that starts out with, 'This letter will confirm our understanding of your representation of me,' and ends with 'If this is acceptable to you, please sign below and send it back to me.'"

The letter should address such issues as the term of the agreement, the nature of the relationship (exclusive or non-exclusive, for instance), an exact accounting of what is being consigned to the dealer, price arrangements (minimum amounts per work or prices for each work as well as

what sorts of discounts may be allowed), the percentage of the dealer's commission, the responsibilities of both dealer and artist (how promotional efforts for a show will be handled, where advertisements will be placed, who will pay for framing and insurance, whether or not the artist will be compensated for the loss in the event of damage or theft), the frequency and nature of the exhibits (one-person exhibits, group shows, once a year or less often, when in the year, how the work will be shown) and a requirement for periodic accounting (who has purchased the works, how much was paid for them, where and when have works been loaned or sent out on approval) and prompt payment by the dealer (sixty to ninety days should be the absolute limit, 30 days is preferable).

Some artists may want to have more than one dealer in the same city (rare for all but the most established artists) — for instance, a particular dealer for paintings and another for prints or sculpture — or for different areas of the country, in order to expand their market as much as possible. These situations should also be discussed directly with the art dealers involved since, in the very thin-skinned art world, hurt feelings and unhappy artist-dealer relationships may result from surprises. Possibly, dealers for the same artist will work together by coordinating exhibitions (when in the same city) or rotating an artist's works from one gallery to another, which makes it possible to keep artworks from sitting in the same gallery in perpetuity.

The problems for artists in maintaining more than one gallery relationship, of course, are significant: The artists must produce enough pieces to keep each dealer satisfied; the works cannot be better for one dealer than for another; the bookkeeping, insurance and specific consignment agreements with each dealer or gallery require considerable organization on the artist's part; and it may be much more difficult to arrange major shows in one specific location when pieces are spread around the country.

In addition, the artist may be able to sell his or her works privately, and this should also be discussed with the dealer. Some dealers don't mind, while others do. Dealers who allow their artists to sell privately demand that those prices not fall below what is charged in the gallery. Underpricing one's dealer will sour that relationship as well as diminish the overall value of one's work in collectors' minds.

While the artist automatically retains copyright (that is, reproduction rights) for his or her work even after a sale, some artists may want written contracts for the sale of each piece; such as a provision for "resale royalties" (requiring the buyer of the artwork to pay back some percentage of the profit when that person later sells the work).

Artists with greater renown or whose works sell well and quickly may

have enough bargaining power to demand from their dealers a nonrefundable stipend (a monthly payment, for instance, which is deducted from later sales) or a guarantee of annual sales that requires the gallery to buy a certain number of works if they don't otherwise sell.

Other provisions that might be discussed and formalized in a letter of agreement between artist and dealer include a mechanism for resolving disputes (such as presenting a disagreement before an arbitrator), protection of the artist in the event that the gallery goes bankrupt in those states where artist-consignment laws do not exist. If the agreement requires that all attorneys' fees be paid by the person who is in breach of the contract, this will encourage the dealer to act ethically.

The issues of bookkeeping and prompt payment are frequently the most troubling in the artist-dealer relationship. If the artist is selling throughout the year, the accounting should probably be monthly; at the very least, it should be quarterly. Artists should also carefully maintain their own records, knowing where their works are consigned or loaned as well as which pieces have sold and to whom.

It is wise to see the sales receipt for any consigned work after it is sold in order to ensure that the dealer has not taken too high a commission or paid the consignor too little. The practice of keeping two sets of books is not unknown, and artists are wise to check every step of the way.

Many art galleries are notoriously poorly financed operations that often use today's sale to pay yesterday's debt, and many artists have had to find recourse in the courts when a dealer withheld money owed to them. Twenty-one states around the country — Arizona, Arkansas, California, Colorado, Connecticut, Florida, Georgia, Illinois, Iowa, Kentucky, Maryland, Massachusetts, Michigan, Minnesota, New Mexico, New York, Oregon, Pennsylvania, Texas, Washington and Wisconsin — have enacted laws that protect an artist-consignor's works from being seized by creditors if the gallery should go bankrupt.

Even artists whose dealers are in other states than these have some protection from creditors seizing art on consignment in galleries. One recourse for artists is to file a UCC-1 form for works on consignment (available in the County Clerk's office, requiring a nominal filing cost), which stipulates that the artist has a prior lien on his or her own works in the event that the gallery has to declare bankruptcy. In the event that one's dealer disappears in the face of numerous creditors and leaves a warehouse full of art, the law permits artists who have filed the UCC-1 form to retrieve their work.

Another unfortunate possibility is that the artist's works may have been sold, leaving the artist owed money by a dealer who has disappeared.

However, the dealer may still have assets in the state, such as jewelry in a safe deposit box or a house, that can be attached by the artist.

"If there are assets, the artist may have a preferred right to them," Martin Bressler, counsel to the Visual Artists and Galleries Association, said. "You would show your consignment form, listing the works you've sent to the dealer, the works you've received back or have received payment for and the prices for all those pieces. You add up what you're owed and present that number."

In those instances where dealers have closed shop without returning consigned works to the artist or paying money that is owed and the dealer is still in the same state, the artist has some recourse to the law — contacting the city district attorney's office or the office of the state attorney general, or hiring a lawyer to recapture any works on consignment to the dealer or money owed through past sales. If the dealer has left the state, the legal possibilities become less clear and more difficult for the artist.

Sometimes, however, the reason that an artist has not been paid is quite innocent. Perhaps the artist has moved but neglected to provide a forwarding address to the gallery owner. The dealer, planning to retire and pay all outstanding debts, cannot locate the artist. Artists should always give notice in writing of any moves, even if only for six months.

Inquiring about the integrity of a particular dealer — finding out how long this person has been in business and whether or not the Better Business Bureau or state attorney general has received any reports about the dealer's business practices — helps artists make a critical decision. One way to check out the dealer is to find out how long the gallery has been in existence; another is to call a local museum curator for any information about the dealer; a third approach is to ask the dealer for a bank reference. Nothing is foolproof but, without some sense that the dealer is legitimate and in for the long term, the artist runs a potentially sizeable risk.

Knowing what to beware of in dealers is important, but it is equally valuable for artists to develop strong personal and professional relationships with their dealers. The dealer should be aware of which ideas the artist is pursuing, any changes in the work and other events in the artist's life (such as winning an award or receiving an honorary degree) that may help promote the artist's work. It is often the case that artists who don't communicate with their dealers are the ones who complain that their dealers do nothing for them.

Print Publishers

Print publishers offer different kinds of potential rewards to artists. Art prints clearly sell for less than original works but, because of their greater

numbers, are disseminated more widely. The lower prices of prints may also bring artists an entirely new clientele, some of whom may later purchase the more expensive original pieces, as well as provide money to tide them over until the larger works begin to sell.

A wide range of agreements may be made between artists and print publishers, and the differences reflect the broad range of publishers around. Some publishers, such as Tyler Graphics or Gemini which publish limited editions by some of the most renowned contemporary artists, allow artists maximum artistic control and guarantee income. Others, such as Franklin Mint, resemble mail order houses and offer artists what are actually work-for-hire agreements that take away copyright from an artist in exchange for a flat, up-front fee.

A number of points should be kept in mind when negotiating a contract with a print publisher: The artist should retain copyright and demand that the seller always plainly state the name of the artist and that the artist holds the copyright; secondly, the contract must state the number of copies that the company is permitted to sell.

Another point to be considered in a contract with a publisher is the time period during which the distributor may advertise and sell the works, since the artist may choose to make his or her own edition to sell at some future date — that, of course, is only possible if the artist holds copyright and the contract allows it. Another way in which artists may maintain their control is by selling only a certain number of prints to a distributor. For example, L.L. Bean catalogues contain descriptions of "limited quantities" for certain prints, which refers to the number of prints in stock and not the entire edition. In such cases, the artist has sold L.L. Bean a stack of prints but remains free to print up more for him- or herself to sell.

The percentage of the earnings from the sale of prints (or royalties) payable to the artist should be covered by the contract. It is important to stipulate that any advance paid to the artist is not refundable if the works do not sell, known as an advance against royalties. In addition, some artists may also be reluctant to proceed on an all-royalty basis. Certainly, none of the publisher's costs of printing, advertising, framing, taxes or distributing these works should be borne by the artist.

If the publisher wishes to purchase not only limited reproduction rights but also the original work itself, artists may try to divide this sale, offering the original for one price and the reproductions on a percentage basis. That may not always be possible.

A final point involves maintaining some artistic control over the reproductions whenever possible in order to ensure that the copies best represent the artist's intentions. Poor quality reproductions or any mal-

feasance, such as prints that have duplicate numbering or are misrepresented as being approved by the artist when they weren't, may reflect badly on the artist's reputation and diminish the value of the artist's other work.

"Signed by the Artist"

The art print market is one where signatures count for a lot. An artist's name on a print can bring up the price by two or three times, and artists generally view signing and numbering works as a valuable source of income for themselves.

That is not to suggest that signed prints have intrinsic value only to the autograph hound; many artists and their dealers contend that by signing a print the artist approves and endorses it and, implicitly, claims it as his or her own work. In some cases, however, the entire economic value of a print is in the signature. Salvador Dali and Marc Chagall, for instance, signed blank pieces of paper on which reproductions of their works were to be made. Picasso's granddaughter, Marina, also published a posthumous series of the artist's prints, to which she signed *her* name. In none of these instances did the artists ever see the finished works. Nonetheless, those prints were marketed at prices that would lead collectors to assume they were original works of art in some way.

The tradition of artists signing their prints is about a hundred years old — before that, they frequently used monograms. Artists such as Henri de Toulouse-Lautrec and Pierre Bonnard signed some and not others depending on the wishes and ego of the buyer. They signed works as they sold them, and those for which there was no demand in the artist's lifetime went unsigned. The value of their signed and unsigned prints is the same, as there is no question of the artists not authorizing or approving them for sale.

The more recent convention of artists signing all of the prints in an edition at one time is said to date from the 1930s when a Parisian dealer, Leo Spitzer, convinced a few of the major artists of the day, including Henri Matisse and Pablo Picasso, to produce elegant reproductions of their work that they would sign and he would sell.

Most artists are now well aware that their signatures mean more money for their works. Picasso did one series of etchings in the 1930s called "The Vollard Suite," which he began signing in the 1950s and '60s as a way of increasing contributions to political causes he championed. Norman Rockwell signed a series of prints to help support the Cornerhouse Museum in Stockbridge, Massachusetts which features his paintings, and Andrew Wyeth did the same on behalf of the Brandywine

River Museum in Pennsylvania where his paintings are on display. Other artists have less philanthropic uses for the money that they make from their signatures.

The high prices that these signatures mean to many people have led to fake signatures, signatures that are printed on the paper along with the image, and false or misleading statements about these works by their sellers.

One example of this is the Federal Sterling Galleries in Scottsdale, Arizona, which grossed more than $4.6 million dollars in the course of 18 months by selling phony Salvador Dali prints. The Federal Trade Commission of the United States Government closed the operation in the late 1980s because of misrepresentation. According to the FTC attorney prosecuting the case, Federal Sterling Galleries claimed that "Dali signed and participated in the creation of these prints." In fact, the attorney, added, "Dali had nothing to do with them. They were photomechanical images that were dated after Dali" — who died in early 1989 at the age of 84, following a long illness — "could have possibly been involved in any way."

While an artist may be altogether innocent of false and misleading claims being made about his or her work, prosecution of one's dealer or complaints by collectors can adversely affect the market to a significant degree. Such has been the case with Dali for a number of years, due to the large number of prints on the market that may or may not be "original."

Artists should carefully review any promotional material associated with their work as well as make certain that their copyright is noted (on the same or an adjoining page where artwork is reproduced) and, if this is a limited edition, that there is no duplicate numbering. Publishers sometimes print more than the stated number in an edition, in case there is a smudge or damage to the paper or something else. Extras may be sold accidentally or intentionally as part of the edition unless the artist sees that they are destroyed.

Copyright

Alexander Calder made it clear what he thinks of copyrighting works of art. Somewhere in the South of France, he constructed a large metal cow defecating small c's with circles around them — the universal copyright symbol. Ironically, it is the only work the artist ever copyrighted, but it is hardly an endorsement.

Many artists see copyright as a commercial issue, not something for fine artists, and don't bother finding out more. Of course, if artists ignore copyright, so do many other people. Every year, entrepreneurs make unauthorized use of artists' work in order to create prints, posters, clothing, dishes, pillows, rugs and bath towels with their imagery, and many

artists find themselves unable to stop this or even to receive any of the money that others are making with their imagery. Furthermore, unauthorized use of imagery may reflect badly on the reputation of the artist when, for instance, colors are different from the original or shapes are distorted.

An uncopyrighted sculpture Calder created for the city of Grand Rapids, Michigan was reproduced as an image on government stationery and also on the city's fleet of garbage trucks. Grand Rapids' city fathers were clearly proud of the work and viewed it as a civic logo, but their use of it was embarrassing.

Copyright is the right to reproduce one's own work, and it comes into being as soon as the artist completes his or her work. However, problems may occur when the piece is "published," that is, when it leaves the studio on loan, consignment or is sold. At this time, the copyright notice should be attached to the work, looking like this:

© Jane Doe 1991

The spelled out "Copyright" or abbreviated "Copr." is just as good as ©; initials or some designation by which the creator is well known ("Mark Twain" for Samuel Clemens, for instance) may be substituted for one's full name; the year, which can be spelled out (Nineteen Ninety-One) or written in arabic (1991) or roman (MCMXCI) numerals, refers to the date the object is first published and may only be omitted when the work is a useful article, such as a postcard, dish, toy, article of clothing, stationery or piece of jewelry.

Most artists are reluctant to deface or, at least, distract people from their work by sticking a copyright notice on it and, under the old Copyright Law of 1909, artists were obliged to put the notice in the most conspicuous place possible in order to assure the public that copyright was claimed. However, under the Copyright Law that went into effect in 1978, artists are permitted maximum discretion in placing their copyright notice, which includes the back of a canvas, frame or mat or the underside of a sculpture. The onus is now on the potential infringer to determine whether or not the work is copyrighted. Also, since March 1, 1989, when the United States officially joined the international Berne Copyright Convention, omission of copyright notice does not result in a loss of the copyright privileges. However, notice should still be placed on works so that maximum damages can be obtained from infringers.

The 1978 law clarified that copyright ownership and sale of the physical work of art have been separated. All a collector buys is the work itself. The reproduction rights remain with the artist. If the buyer wants the reproduction rights as well, he or she must now bargain for them, and smart buyers sometimes do just that.

The copyright is potentially worth money if, for instance, the image is used for prints, posters, tapestries or whatnot that are sold to the public. A painting may sell for $5,000, but an edition of 100 prints made from that image, each selling for $100, would bring the copyright holder $10,000. The copyright may be worth more than the original work (for which the artist received a one-time payment), and artists such as sports painter Leroy Neiman and Art Deco stylist Erte have become known more from prints than from their oil paintings.

Copyright confers several exclusive rights to an artist for the life of the creator plus 50 years: The first is the right to reproduce the copyrighted work; second is the right to make derivative works (making a motion picture from a book such as "Gone With the Wind," for instance, or a poster from a sculpture); third is the right to control the first sale of a work (of course, a buyer of a legally made copy may resell it); the last is the right to display the copyrighted work. The owner of a work has the right to display it to people who are physically present for the display, but people and institutions that borrow works have no right to display them without permission from the copyright owner.

The issue of how to publicize artworks has been a major area of tension among artists, dealers and museums. Dealers and museums frequently seek to advertise works in their collections through brochures, postcards and catalogues without regard for, and without displaying, copyright. The effect is to open the door for someone other than the dealer or museum to use the image to create reproductions without paying the artist anything or even asking for approval since the image has entered the "public domain."

There is, of course, "fair use" of a work of art, which usually refers to photographs of it that accompany a news article or critique or to slides that may be used in teaching. Fair use, however, does not lessen an artist's ability to earn money or control the use of the image.

"To many elements of the art market, artists are tolerated as necessary evils, but a lot of people would be just as happy if all art were done by automatons," said Martin Bressler of the Visual Artists and Galleries Association, which acts as an agent for artists in negotiating licenses for publication of art and policing unauthorized use of their work. "Museums are the worst in this regard. To them, the best artists are dead ones with no estates. They don't like to pay royalties, either."

Bressler noted that museums, which are constantly in search of new sources of revenues, often treat works in their possession as though they were in the public domain, regardless of whether or not the objects are copyrighted. He cited the Baltimore Museum of Art, which made dinner-

ware, t-shirts and tote bags using images from Matisse and Picasso without permission of the artists' heirs or estates, and the Chicago Art Institute which permitted a copyrighted scale model of a sculpture by Picasso to fall into the public domain when it exhibited the work without attaching its copyright notice.

Artwork can be registered with the federal Copyright Office (Library of Congress, Washington, D.C. 20559, tel. 202-287-9100). Registration prior to an infringement allows the artist to receive statutory damages up to $20,000 for each work infringed, plus legal fees and court costs. One may call or write to request an application (Form "VA" for visual artists), which should be filled out and returned with a check for $20 along with a copy of the work (two copies, if the work has previously been published). A cancelled check by the Copyright Office ensures that the work has been registered, and a copyright certificate will be sent out within four months.

While published works must be registered one at a time (and the $20 fee paid), unpublished works can be registered in groups for a single $20 fee. Also, valuable or unique art does not have be deposited with the Copyright Office — instead, slides or photocopies can be used. Contact the Copyright Office for its free Visual Artists Copyright Information Kit, which explains this in detail.

A variety of copyright questions arise over time in an artist's career, and a good source of information is the Visual Artists and Galleries Association (VAGA, One Rockefeller Plaza, Suite 2626, New York, NY 10020, tel. 212-397-8353) as well as any of the volunteer lawyers for the arts groups around the country (see Appendix). Information is provided to artists at no cost.

As the art reproduction and multiples market has grown more and more in a world already overloaded with images, there is a declining need for the original work of art, much less its creator. Copyright represents the main way for artists to ensure their relevance in the art world — if they will use it.

Bartering and Leasing Art

More than anything else, artists prefer straight sales of their work and prompt cash payment, but this doesn't always happen. At times, agreements can be made to barter artworks for something else; at other times, works may be leased. Potential problems abound with these situations, but there are also great benefits for artists in both.

Bartering: Bartering is probably the oldest form of economics — money, on an historical scale, is the new kid on the block — and artists who are

rich in canvases if short on cash have kept barter alive. A lot of people have benefited from bartering with artists. Jack Klein was Larry Rivers' landlord for a number of years and was able to retire and move to Paris on the paintings his tenant gave him in lieu of rent. Sidney Lewis, president of Best & Company, built up a collection of paintings by major and lesser-known artists swapped for washers, driers and other appliances.

Dr. Frank Safford is another. He tended to the health of Willem de Kooning during the 1930s and '40s, in the years before the artist's works began selling. He was paid in half a dozen paintings, one of which the doctor later gave to the poet and dance critic Edwin Denby, who sold it to buy a house.

In general, it is doctors and lawyers who do the biggest bartering business due, not surprisingly, to the fact that their fees are often beyond the reach of most artists.

Of course, many professionals will not accept artwork in exchange for their goods and services, and it is best to discuss methods of payment and how bartered objects will be valued in advance. Bartered property is taxable income and must be declared as such. For various reasons, the artist may give his or her work a high value while the recipient, wishing to keep taxes low, might pick a low value. Most artists who exchange their work for goods or services have not sold before, and there are few objective criteria available for valuation. An agreement must be made between the two parties, as discrepancies may pique IRS interest. This can be a testy area for negotiations.

Some people will accept art in total or in partial payment from some clients, but not all of the time. They, too, have to pay rent and employees' salaries, and the partners of a law firm cannot share art as they would a cash payment for services. The fact of not being able to accept art as payment does not imply that the professional thinks less of the artist and will not do his or her best work, but artists are free to shop around for people who will accept artwork as payment.

Dealers also from time to time accept something other than money for consigned works in their galleries, such as jewelry or other pieces of art. The artist, of course, should be paid only in cash and at the price level established between artist and dealer — not at whatever the appraised value of the jewelry or artwork is found to be.

Leasing: Renting or leasing works of art also provides the opportunity of greater exposure for artists' work and, more often than not, results in sales to private individuals and corporations. There are benefits for both

artists and dealers, because they are able to generate some income from works that haven't yet sold.

Artwork rentals can be arranged through a variety of sources, starting with artists themselves. One New York City real estate developer, for example, leased a wall sculpture from Jeffrey Brosk for the lobby of the Fifth Avenue apartment building he had erected "in order to give the place cachet for prospective tenants," according to the artist. It seemed to work, as the building filled up and the developer decided to purchase the sculpture.

Art dealers and corporate art advisors also arrange rentals and leases for clients who want to "try works out" for an extended period of time. Dealers often allow prospective buyers to take art home for up to 10 days without charge to see if it "works," and may also devise rental agreements for collectors who take longer to decide or whom they would like to cultivate as long-term clients.

"Some people need a breathing space of time in order to consider the purchase, and renting can allow that," Christopher Addison, owner of the Addison-Ripley Gallery in Washington, D.C., said. "More than half of the people who rent end up buying the work, partly because of laziness — they've grown accustomed to the work."

A number of art museums around the country, too, have established sales and rental galleries that permit collectors to buy or lease works in a variety of media. With certain institutions, such as the Wadsworth Atheneum in Hartford, Connecticut or the Whitney Museum of American Art in New York City, works of art from the institution's own collection have been loaned to certain corporate museum members, but the objects in most sales and rental galleries are separate and distinct from the museums' collections.

Both the sales and rental galleries at the Baltimore and Philadelphia museums of art have paintings and works on paper on consignment from local galleries and those in New York City, affording a mix of lesser-known and well-known artists (such as Jennifer Bartlett, Jim Dine, Jenny Holzer, Sol Lewitt, Robert Motherwell and Louise Nevelson). Other sales and rental galleries, such as those at the San Francisco Museum of Art and the Springfield (Massachusetts) Museum of Fine Arts, consign pieces directly from artists, most of whom are likely to be of the lesser-known variety.

The art rental field is generally one for younger, lesser-known or "emerging" artists since the more famous artists are likely to have waiting lists for their work and would have less incentive to let pieces go out on rental. Being associated with a museum, even though it is with the sales and rental gallery of the institution, does attach to the artist a museum imprimatur that adds stature to the artist's work.

Renting a work is usually a short-term event, lasting from one to four months, while leasing may range up to two years with payments applied to the sales price should the customer decide to buy. Fees for renting or leasing are usually based on the market value of the art, ranging between two and five percent a month, although it can go as high as 15 percent. Discounts for leasing more than one piece at a time can be negotiated with dealers, and sales and rental galleries frequently have discounts for museum members.

Some rental agreements stipulate that the renter provide insurance for the work for the entire term of the lease as well as pay for crating and shipping. In addition, the schedule of payment, perhaps monthly or in total at the outset, may be negotiated or specified in a contract.

Leasing has generally become more attractive to businesses since the enactment of the 1986 Tax Reform Act, which lengthened the period of depreciation for office equipment that a company buys. Art has usually been lumped in with "property, plant and equipment" for business accounting purposes, viewed as office decoration rather than a separate category of investment. The Internal Revenue Service has increasingly disallowed deductions based on a depreciation of corporate art (because, the IRS claims, art actually increases in value over time and isn't subject to wear and tear). Furthermore, the new, slower payback resulting from the 1986 law's extension of the period of depreciation has led companies to look more favorably on leasing telephones, automobiles and a host of office-related equipment.

"With leasing, a company can deduct all of the expenses now instead of waiting for years," Janice M. Johnson, partner at the accounting firm of BDO Seidman, stated. "Leasing lets you get around the depreciation problem. Leasing works of art instead of buying them also solves other problems: How long will the company managers have the same tastes? Some people just like change. How permanent are the company's facilities? Maybe, the company will move in a few years and will want different art. There's also the issue of the quality of the art — you may rent cheap stuff now while saving up to buy something more substantial later."

Not all art dealers and advisors are pleased to let work out on a rental basis, however. It can be a bookkeeping, insurance and inventory headache for dealers who must keep track of lease payments, establish rental agreements, protect these pieces from damage, arrange insurance coverage and arrange for the work to be returned at the end of the rental period.

"Facilities people" at many companies have no idea of how to care for artwork and may place pieces where they will fade from exposure to direct light or where employees smoke or where there is inadequate venti-

lation. Vandalism and theft are also concerns. In addition, because they are not buying it, the corporation is more apt to view the art as mere decoration and not shield it from damage in the same way as it would protect something the company owned. Other dealers and art advisors have mentioned that artists aren't as likely to lease their best work.

"There are questions you have to ask," Jeffrey Brosk said. "Who is renting it? Where is it going to go? How will it be protected? You have to be more selective when you're renting a piece but, if you are more selective, you can give better quality work."

For artists, there are a number of very clear benefits and practical concerns with renting and leasing their work. Their pieces may be seen by a wider range of people than the limited group of art gallery "regulars," stimulating interest in the work by those who may become future collectors.

Stephen Rosenberg, a New York City art dealer who has consigned work to the Philadelphia and Delaware museums of art, noted that "people have come in here when they're in New York to see the work of some artist they saw through a rental arrangement somewhere else. I've had quite a few sales that way."

The potential for positive exposure may also convince artists to loan works to banks or restaurants, or charge only minimal fees, stipulating that the work must be returned in good condition. If there is any damage, all restoration costs should be paid by the institution, not the artist.

Any contract between an artist (or an artist's dealer) and a renter should include specifics about the following: the length of the rental arrangement; the rental price (which the artist is likely to decide with his or her dealer who may know a lot more about going rates); how the artist or artist's dealer is to be paid; documentation that the art is insured for the entire period of the lease (by the renter or artist's dealer but not by the artist); that the artwork is credited to the artist (it also doesn't hurt to have information on the artist noted somewhere); that the art not be harmed but, if it is, that the renter must pay for all repairs (the artist should be given first refusal on making any repairs) or cleaning (if a lot of cigarette smoke or coffee splashes have discolored it); and that the renter (or the artist's dealer but not the artist) should bear all expenses of packing and shipping the work.

Artists may also wish to have some say over where and how their work is displayed and may want some veto power over certain companies with which they do not wish to be associated. In addition, the work should be available for the artist (or dealer) in the event of an exhibition.

"There should also be an affirmative obligation on the part of the renter to return the work after the lease has expired," Kate Rowe, a New York

City lawyer who frequently works with artists, said. "It must be stipulated on the rental agreement that the renter is obligated to return the work at the end of the rental period. It's not uncommon that no one takes responsibility, and the work just sits there indefinitely. If a long time passes or someone dies or the paperwork is lost, no one quite remembers who owns the work. This problem happens a lot with museums in their long-term loans."

When the work is rented through the artist's dealer or gallery (or consigned to a sales and rental gallery by the dealer), the contractual agreement between the artist and his or her dealer should resolve some of these same points. Specifically, it should indicate that the artist not bear any expenses and that any rental payments to the dealer will be split between the artist and the dealer on the same percentage basis as when a work is sold.

Some dealers consign works they represent to the sales and rental galleries of museums as a way to help out the institutions, which use the sales and rental galleries as fundraising tools. A painting consigned by the dealer may be sold at the sales and rental gallery; the artist receives the same percentage (for instance, 60 percent) as if the picture had been sold regularly by the dealer, with the dealer and sales and rental gallery splitting the amount of the customary dealer commission (40 percent) — usually, that gets divided in half.

It should also be remembered that an artist receives no tax deduction for renting a work of art to or through a museum. Tax deductions are, for artists and everyone else, available only for outright gifts to nonprofit institutions.

Alternatives to Dealers

Success in the art world may lead to critical acclaim and financial rewards, but many artists find the process of currying favor with dealers and even spending so much of their time in the large cities where the major art dealers are to be grating on their nerves, contrary to why they sought to be artists in the first place.

There are alternatives, opportunities for artists to sell their work outside of the gallery structure, and many artists have been able to make a living this way. The French Impressionist exhibitions in Paris of the 1870s and '80s were all organized by the artists involved (one of Mary Cassatt's main values to this group was in convincing wealthy American collectors to come take a look). The German Expressionists of the 1910s published their own *Blue Rider* almanac to promote their work; Dadaist artists in the 1920s created "Manifestations," and Pop Artists of the early 1960s put on

"Happenings." Eventually, many of those artists found their way into mainstream galleries, but they made their start outside of them, and they did it by uniting themselves for a common effort.

One of the most prevalent alternatives to the entire commercial gallery world is the sidewalk art show. There are reportedly 22,000 or so arts and crafts shows held somewhere around the country each year, usually during the summer months in the North and during the Winter in the Southern states. Many of the larger shows are listed in such publications as *American Artist* magazine, *Art Calendar* (available by subscription for $29 a year: P.O. Box 1040, Sterling, VA 22066, tel. 703-430-6610), *ARTnews, The Artist's Magazine, Art Now Gallery Guide* (available by subscription for $35 a year: Art Now, Inc., P.O. Box 888, Vineland, NJ 08360, tel. 201-322-8333), *Art Paper* (available by subscription for $20 a year: Visual Art Information Service, #206, 2402 University Avenue West, St. Paul, MN 55114, tel. 612-645-5542) and *Sunshine Artists USA* (available by subscription for $22.50 a year: 1700 Sunset Drive, Longwood, FL 32750, tel. 407-323-5927). Another pair of booklets, *Fairs and Festivals in the Northeast* and *Fairs and Festivals in the Southeast,* may be purchased from the Arts Extension Service (Division of Continuing Education, 604 Goodell, University of Massachusetts, Amherst, MA 01003, tel. 413-545-2360) for $7.50 apiece or $13.00 for the pair.

Artists who follow the outdoor show circuit paint for part of the year and travel their works to art shows around the country for the rest. It is a hard life, but a different sort of hard life than one generally associates with artists. One thinks of artists alone in their studios, attempting to express some idea or feeling in a two- or three-dimensional work. Keeping their works dry from the rain, steady in the wind, and not scraping against each other in the back of a station wagon are quite different worries.

Sidewalk artists generally don't feel themselves in competition with the commercial art galleries but, rather, exist in a different dimension. Their market is the people who may feel nervous about going into art galleries, who like to collect and are happy to bypass the middlemen in order to meet the artists and (quite likely) pay less money for works.

"Galleries are a dead-end," said Lafayette Ragsdale, a Memphis, Tennessee painter. "The overhead is fantastic, and the dealers have to take a large commission to pay for it. This means that the price of each picture has to go way up, and that means you don't sell your works very often. You can make a living at outdoor shows where you can't at galleries."

Art fairs are a related, somewhat more high-toned version of the sidewalk art show, which tend to take place on a state or regional level and which are usually juried (many sidewalk shows are not). The jurying in-

creases the prestige of these events, drawing collectors from a wide area. Some art fairs are also thematic, devoted to western (cowboy) art, miniatures or something else, and as such draw a very specific group of potential buyers.

Some artists are able to support themselves through these direct sales and by getting commissions from the people visiting these fairs. In all cases, artists should establish a file of names and addresses of those visitors who have expressed interest in their art in order to inform them of new work and upcoming shows (or exhibitions) where they will be on display.

"I have a list of 600-700 people on my rolodex," Peyton Higgison, a Brunswick, Maine artist, said, "and when I am going to be doing a show in, say, Buffalo, I get out my Buffalo file and send out cards to people there, telling them when I'll be there. I've thought about getting a computer to print out cards to people, but most people seem to prefer a personal note."

Different artists send out different types of mailers to potential buyers. Some use postcards, with a reproduction of a new work on one side and information about a show or the work on the other. Others include more narrative, discussing the work or a new direction that the artist is taking. Still others send out whole brochures, some the size of a small L.L. Bean catalogue, filled with reproductions of available pieces.

Selling one's art directly to buyers, without the intercession of a dealer, has some clear advantages and some clear drawbacks. Selling directly to buyers may help artists stay more attuned to what collectors prefer and look for — that is both advantageous in terms of meeting a market and potentially compromising. Without a "third person," such as a dealer, to locate buyers, the artist must devote more time than the gallery-represented artist to strictly marketing concerns. Unlike the German Expressionists, Dada and Pop artists, there is less likelihood for later fame because sidewalk and art fair painters as well as those who offer artworks through mailers never get reviewed in magazines, included in museum exhibitions or mentioned in art books. And, because fame quickly translates in the gallery world to ever-increasing prices, the sidewalk artist is unlikely to get rich. Direct sales, however, gives back to the artist control over his or her market. For some artists, that's reward enough.

Making Direct Sales

"Everyone is a potential client," said Walter Wickiser, an artists' advisor. "The important thing is to let people know that you are an artist because you never know who might become a collector."

For that reason, artists need to develop a client list, one that changes and (it is hoped) grows over the years, that will be used to contact people about art exhibitions or an open studio event. Initially, that list includes immediate friends and family as well as business acquaintances (those the artist meets at work), other artists and even one's dentist, lawyer or grocer.

That list can grow with the help of some of those friends and family members who suggest other people to be contacted (their friends and business acquaintances, for instance), and those friends and family members may be persuaded to write or call on the artist's behalf. Using people the artist knows to locate new prospects is a pyramid approach that ensures that more than the same group of potential collectors show up at each exhibit.

Barbara Ernst Prey, a watercolor artist in Prosperity, Pennsylvania, began selling work by finding buyers from people she knew. Her mother's friends were some of the first collectors, quickly followed by the friends and associates of her husband's parents, and later friends from college became buyers.

Her brother, who lives in Manhattan, also set up a show of her work in his apartment, and other friends in Boston and Ligonier, Pennsylvania did the same — all of which resulted in sales. Word-of-mouth advertisement and people she met at art openings and other social get-togethers also increased her client base. Eventually, an artists' representative in Washington, D.C. took her on as did five galleries. "Between them all," Prey said, "I'm selling everything."

It is advisable for artists to be always on the look-out for potential buyers, attending the kinds of social events and activities where they would likely be found, such as art exhibition openings and parties. Artists should keep a pen and paper on them at all times in order to write down these people's names for the client list.

According to Nina Pratt, a New Yorker who teaches sales techniques to artists and gallery owners, "the artist should then send a letter to these new prospects, following up with a telephone call within 10 days in which the artist says something along the line of 'Hi. My name is Nina Pratt and I am a painter. So-and-So suggested that you might like to come to my studio — or come to such-and-such gallery where an exhibit of my art is taking place — to see the work I am doing now.'"

It may be advisable for artists to set a goal of contacting so many prospective buyers, or arranging a certain number of studio visits, per week or month.

Getting someone into the studio is a large first step, and the artist will have already passed through a major stage of awkwardness. Talking about

their work or listening gracefully to others make comments about it, however, may be no less difficult. Pratt feels that artists "need to know how to shut up. You want to draw out the client, because most people like to talk while they look at something new, by asking leading questions, such as 'How do you feel about this? What's your reaction to that?' You want to get the buyer to thaw out. If the artists do all the talking, it feels like they are imposing their own views, and potential buyers don't want to commit themselves to anything."

She added that "comments may frequently be inane, such as 'Well, it certainly is a large painting,' and the artist should respond with something like, 'I'm glad you noticed that. What else do you see in my work?' You have to decide which is more important, a wounded pride or one's pocketbook. Most artists prefer their pocketbook."

The last major area of awkwardness is the actual sale, as the subject of money often makes everyone a bit squeamish. Again, the artist needs to take the initiative in closing the deal, although it may be easier to soften the sell by focusing attention on which piece(s) the collector seemed to prefer as well as how, when and where the art should be delivered. The payment question can be brought up in the form of "Do you want to pay me now or upon delivery?" Other possibilities include being paid half now, half later or some form of barter.

Some written document should accompany the transaction, either a straight bill of sale or a sales agreement. The bill of sale will indicate all relevant facts about the transaction, such as the artist's name, the name of the artwork, the work's medium and size, the year the work was created and if it is signed (and where), the price of the piece and the date of sale. A sales agreement will include all those facts as well as add some points that are advantageous to the artist, such as reminding the buyer of the artist's rights under the copyright law as well as allowing the artist to borrow the work (at his or her own expense) for up to 60 days once every five years in the event of a gallery or museum exhibition and permitting the artist access to the work in order to photograph it for his or her portfolio.

Artists who sell directly to customers should obtain a sales tax number through the state department of taxation (the number usually is one's social security number, and there is rarely any charge for receiving this number) and add a sales tax to the price of the artwork they are selling. Every state has its own percentage tax for sales. An added benefit of having a sales tax number is being able to either deduct the sales tax that one pays for art materials or not pay sales tax at all if the materials are incorporated into a work for resale. The artist should contact the sales tax

bureau in his or her own state concerning the sales tax laws.

Selling directly to the public, bypassing commercial galleries, does not eliminate the need for artists to rub elbows and socialize with critics and customers. In fact, the successful ones usually find themselves doing more of it. Dealers and their commissions are truly the only things sure to be avoided. Selling directly involves a greater interaction with one's audience and, for some artists, that is beneficial both for the art and the sales

Pursuing a Career in the Sticks

It's not easy for artists anywhere to develop their art and promote their careers but, at least in larger cities, the recommended road to success is better marked. There are often a variety of art spaces in these cities where artists may show their work, hoping to attract buyers and opportunities to exhibit in more prestigious commercial galleries.

Again, that's not easy but it can be done. The problems of exhibiting and marketing artwork, however, are magnified with artists in rural areas. There is often a dearth of interest and art galleries in the community, few places to find certain art supplies as well as basic information about opportunities for artists, a lack of peer feedback or support and discrimination against artists both within the rural setting (where they may be viewed as oddballs) and in the larger cities (simply because the artists live in the boondocks).

These artists have chosen where to live — because they like the location or the people — over where best to advance their careers, but that choice makes other decisions for them. It may be less possible too for those without an established clientele to avoid being a major participant in the marketing of their work, such as taking part in outdoor art shows, sending out brochures with photographs of new work, organizing local exhibitions and otherwise being active and visible in the community.

Sculptor Larry Ahvakana and his wife, for instance, live in a Native American settlement in Suquamish, Washington because "I believe in being close to my roots," he said. The price of that belief is having to travel between 6,000 and 7,000 miles every year to show or bring his work down to the art galleries in Arizona and California that represent him. (When he brings work to his gallery in Alaska, add another 3,000 miles to the total.)

"I certainly couldn't sell any here, even to the people who come during the tourist season, and support myself," he stated.

Covering vast expanses in the American West is not the only concession he makes to living away from cities and his markets. Buying the

materials in Seattle for his wood and stone sculptures, porting it back by ferry across the Puget Sound, is an all-day affair, and the problems of shipping work from Suquamish in general have led him to downsize his pieces and concentrate on smaller wooden carvings.

Living in Redway, California, 250 miles north of San Francisco, also affected the artwork of painter Peter Holbrook. "It is so much trouble to mail canvases out of here and so much easier and cheaper to send out a watercolor that I largely gave up on oils and stayed with watercolors," he said. "The companies that are able to transport art are not convenient, and it was just a nightmare experience the time I tried to get a van to move a big canvas. They didn't send, or they didn't have, a big enough truck and, if you want to ship a big painting, you have to build a big crate. You can end up spending half your life building crates."

Another watercolorist, Larry Kent Stephenson in Ponca City, Oklahoma, also chose his medium based on living where he does. Stephenson doesn't ship his work far — most of his sales are to collectors in Oklahoma or Wichita, Kansas (90 miles to the north) — but, "for buyers in Oklahoma and Kansas, you have to sell your work for less than you might get in, say, New York or Chicago. You have to think about a painting's marketability. Watercolors are spontaneous and don't take a lot of time and, because of that, they can be priced for the buying public here. An oil painting or an egg tempera is more time-consuming and, for the money, I can't afford to do them like I can the watercolors. That's really how I decided to concentrate on watercolors."

Few artists living in outlying areas find that they can simply retire to their studios in order to create without a thought of where to show and sell their art. Some discover that teaching art itself brings them local attention, which may eventually be translated into a sale at some point in the future. Lillian Montoya of Rocky Ford, Colorado, for example, holds demonstrations of oil and watercolor painting techniques at area libraries and local clubs, which helps make her own work better known and occasionally leads to a sale. "What you're doing is advertising yourself," she said. "You can't be a hermit out here."

Others become aware that the solitude of an area where neighbors may be miles away and don't just drop in requires greater discipline and stick-to-itiveness on their part. Many join clubs and artist membership organizations as well as get on the mailing list of the state arts agency, which sends useful information about art competitions and news in the field.

It was through participating in juried art shows sponsored by the New York City-based American Watercolor Society, the Los Angeles-based National Watercolor Society and the National Academy of Western Art

in Oklahoma City, Oklahoma that Gerald Fritzler of Mesa, Colorado was able to find a gallery to represent for his paintings. Mesa, whose population, Fritzler said, "takes up a page-and-a-half in the phone book," wouldn't be able "to support me for a week."

Juried competitions are coveted events among rural-based artists, allowing their work to be seen by a wider audience, examining the current work of their peers and learning from friends and other contacts at these shows where opportunities exist. Networking and meeting prospective buyers and art dealers wherever possible becomes an important part of their lives.

It is especially important because there may be few peers from whom to receive comments and advice about one's artwork. Noting that "people look at me strangely here when I mention that I'm an artist," Richard Copland, a painter and sculptor who lives outside the small town of Billings, Oklahoma stated that "I've never had a discussion with anyone around here about what I do."

Stephanie Grubbs, a fiber artist in Purcell, Oklahoma, also said that "there are no other fiber artists in Purcell, and I guess there aren't any artists of any other sort here, either." She belongs to a fiber artist group in Oklahoma City, however, and travels there once a week for meetings."

Artists residing in rural areas and conscientiously seeking to promote their work live where they do by choice. Their need to travel often great distances (frequently measured less in miles than by the number of hours in the car) certainly makes them aware of the career opportunities, and benefits of living, in the larger cities where there is more of a market for art, more and better feedback on their work and fewer difficulties in purchasing supplies or shipping their art.

"As long as I can make a living selling work in places where tourists and collectors go to buy art," Gerald Fritzler said, "it doesn't matter where you live, and I love living here."

Selling to Corporations

Just as artists need to research potential galleries that might show their art, those looking to sell work to, or have it commissioned by, corporations must find out which companies are buying and what kinds of artwork they purchase.

One of the ways to discover this is through some of the publications in this field. The American Council for the Arts (1285 6th Avenue, New York, NY 10019, tel. 212-245-4510) publishes *Corporate Giving to the Arts* ($30, plus $4 for shipping and handling), which is also available at many libraries around the country.

The most often used book for corporate collectors, however, is *ARTnews' International Directory of Corporate Art Collections* ($109.95, which can be ordered from ARTnews, 48 West 38 Street, New York, NY 10018, 212-398-1690), which is revised biannually on even numbered years and contains names, addresses, telephone numbers, contact persons and both general and specific information on the collecting practices of almost 1,200 companies around the United States and Europe. This book is a favorite among artists' representatives who use it as a way to place the work of artists they represent in these collections, and it can be found in many libraries around the country.

Since corporations do not list separately on their ledger books how much money they spend acquiring works of art, it is impossible to get a complete picture of the total aggregate value of corporate art buying. However, the New York City-based Business Committee for the Arts, a nonprofit group that keeps tabs on corporate financial involvement in all areas of the arts, estimates that companies annually bought in excess of $1 billion in art over the past few years.

Corporate Art Advisors: When looking through books on corporate collecting (or more directly viewing these collections), the largest questions that may arise for artists are which companies have a serious commitment to buying and displaying art, and how can an artist judge.

One answer to both questions is the corporate art advisor. Most companies spending sizeable amounts of money look for help in making decisions, and they either hire on staff or (more often) retain the services of an outside art advisor or art consultant. These advisors assist the company executives on which works to buy, how many, where they should be purchased and how they ought to be displayed in the corporate offices.

Art advisors are a group forever on the move, visiting galleries and artists' studios in search of something that might please a potential or current corporate client, and they welcome receiving letters and slides from artists about whom they've never heard. As a rule, advisors don't purchase work from artists and then proceed to market it to corporations as that would constitute a conflict of interest. They will represent to their clients their interest in a particular artist, if an artist's work appears to match what the corporation is looking for, but never individual works. An advisor may eventually buy a work from an artist if that person is acting as the company's agent (and given an acquisitions budget) or else set up a time for the art buyer within the corporation to go to the artist's studio for a viewing. A sale may take place at that time or later.

How serious the company is about its collection is often reflected in the person who is in charge of buying works or maintaining them in good condition. It is clear that the First National Bank of Chicago was committed to high standards because it chose Katharine Kuh (for many years the paintings curator at the Art Institute of Chicago) to buy its 3,000-piece, $5 million collection, and Dr. John Neff, former director of the Chicago Museum of Contemporary Art, to be its on-staff art advisor. Similarly, Sohio of Cleveland reflected its high-mindedness by asking Evan Turner, director of the Cleveland Art Museum, to be on its art advisory committee when that oil company created an 800-piece contemporary art collection for its corporate headquarters built in the mid-1980s.

With other companies, however, the people in charge of the collections may have few art qualifications — some are interior decorators who have upgraded their titles — and have little to do with the works under their care, save for maintaining an occasional inventory or arranging where pictures hang in a company's cafeteria. At many companies, the people handling the art collections are found in the public relations, advertising or marketing departments.

Among the ways to locate an art advisor is through the Association of Professional Art Advisors (P.O. Box 2485, New York, NY 10063, tel. 212-645-7320) or in *The Fine Art Representative Directory* ($45), which can be purchased from Directors Guild Publishers (P.O. Box 369, Renaissance, CA 95962, tel. 800-383-0677). In addition, *ARTnews' International Directory of Corporate Art Collections* notes who is the art advisor for each collection.

Artists Making Their Own Pitch: Still, some businesspeople prefer their own opinions to those of outside art advisors. It is wise for artists to find out who in a company is in charge of purchasing art and make contact with that person, if possible.

Occasionally, the collection is the baby of the chief executive officer. Most art advisors who work for corporations prefer to deal with just one top person rather than a committee because groups are less clear about what they want. "I tried to do some work for a five-person committee at a law firm in Boston once," said Bruce St. John, former director of the Delaware Art Museum and a consultant for many years. "They all had different ideas about what they wanted, and they kept throwing out suggestions but wanted to change them right away. 'Oh, no, that's too expensive,' someone would say when I'd recommend something. But I'd say to them, 'I thought you had a budget of so-and-so to buy this sort of work.'

'Yes,' they'd say, 'but we've decided we don't want to spend all that.' What in hell do I want that sort of nonsense for?"

However, when there is only one person in charge of the collection, what happens when that person steps down? Union Carbide sold off a large portion of its collection at Sotheby's in 1982 after the top man resigned and the company moved its headquarters to Danbury, Connecticut. A similar action occurred in the 1970s in France when Jean Dubuffet was commissioned by Renault in 1973 to build a 2,000 square-yard sculpture at the company's headquarters near Paris. When the president of the company, Pierre Dreyfus, stepped down in 1975, his successor wanted the project abandoned, claiming that "the automobile business has nothing to do with art."

More recently, Sohio of Cleveland's chairman Alton W. Whitehouse Jr. commissioned Pop Art sculptor Claes Oldenburg to create a giant rubber stamp called "Free Stamp" in 1985. However, Whitehouse was soon after ousted by British Petroleum, which bought a 55 percent share in Standard Oil at that time, and his successor, Robert B. Horton, cancelled the commission, reportedly interpreting the sculpture to suggest that Standard Oil is a "rubber stamp" for British Petroleum. After a period of considerable embarrassment for the company over questions of censorship, Horton finally paid Oldenburg for the piece and arranged for the sculpture to be completed and sited elsewhere in Cleveland. Perhaps, the reason for the commission in the first place was to cause the embarrassment.

The retirement of the chairmen of the First National Bank of Chicago and the Chase Manhattan Bank in New York City, both of whom were the guiding forces in their banks' collections, however, did not result in a diminution of the collections. Their successors have continued the acquisitions policies. In these latter companies, it is clear that the art collection has become, not a symbol of one person's interests but, a part of the entire corporation's self-image.

Corporations, unlike governmental agencies and foundations, generally have no standardized applications for artists and arts organizations seeking commissions, sales and project or general operating support. Also, unlike agencies and foundations, there is rarely an independent or professional review committee at businesses to evaluate art patronage; instead, an individual or two is often in charge of reading letters from artists and arts groups and then deciding whether or not the company is interested. That person may be the chief operating officer of the company or the head of public relations — every business treats this are differently. Artists enter a realm that is not accountable to the public (unlike governmental agencies and private foundations), and their success in selling to corporations

is dependent on how they present themselves, their works or projects to the person in charge of the art collection or budget.

Artists should look carefully in the available books at what kinds of pieces a corporation collects in the same way they would when looking at prospective art dealers or galleries. A collection of abstract paintings and minimalist sculpture would be an unlikely market for a realist watercolor artist, for example. Some companies also do not provide money for individuals (there's no tax deduction for that) but will offer project money through an umbrella organization or in-kind services to artists. Corporations prefer giving money where exposure (for the corporation) is greatest — their altruism isn't wholly selfless — and tend to contribute to very public activities.

Books about corporate art buyers generally list the largest collectors, those with established annual art budgets and even full-time staff to care for the objects. More companies than those purchase art, although they may not do so regularly. Businesses in the artist's own area — large or small, headquarters or branch offices — are reasonable places to try to sell artwork, although this is a hit-or-miss affair. It's hard to prepare since, if art hasn't been purchased in the past, an artist cannot know what company executives will like.

A letter or telephone call is the best approach to take, describing succinctly what the artist has in mind (sell a work, be commissioned, receive a donation), who will benefit and how, what the work looks like (stated as graphically as possible), the cost, when the project might take place, how it is to be publicized and the artist's own background and qualifications for this work.

Even after a telephone call, this information should be put in a letter to either the person with whom the artist spoke or to whomever in the company makes the decisions about artwork. Check for typos, grammatical errors and the need for a new typewriter ribbon — businesspeople look for professionalism, not quaintness.

Of course, corporate employees are not generally as immersed in the arts as the creator, and the work or project should be described in very lay terms that would be understandable to a wide audience. Additional materials, such as reviews of past exhibitions by the artist, published profiles of the artist and slides or good quality photographs of the artist's work, should be included with the letter. Pictures often explain better than explanations, and the reviews of a newspaper critic — another non-expert — are likely to be closer to the company executive's level of understanding than the commentary of the artist. A resume is optional, depending on the strength of the other materials.

Also, ask for a personal interview and call a day or so after the expected receipt of the letter to set up a meeting. It's easier to reject someone unmet than a person with whom a personal rapport may have developed.

In any meeting, an artist must present him- or herself as a professional, someone who deserves to be accorded respect, rather than as a supplicant. Self-respect garners respect from others. Many people secretly (or not so secretly) wish that they were artists, and artists should understand that this vicarious feeling about art and artists is part of the reason the company sponsors cultural activities or a collection in the first place.

Chapter 3.

When Does Investing in One's Career Become a Rip-Off?

In the beginning (of the art world), there were just artists and patrons. Then along came art dealers, critics, museum officials, arts funders, art advisors (to patrons) and artists' advisors (to artists) as well as artists' representatives, all of them making a living off that primary artist-patron relationship.

There are many go-betweens and various services that have become available to artists, some quite expensive, which may or may not help advance a career.

Artists' Representatives

Among the most nebulous of the middlemen are the artists' representatives. Unlike art dealers, they generally have neither gallery space nor inventory of art and, instead, send photographs (or slides) of their artists' work through the mail or deliver individual pieces to potential buyers. Unlike art advisors, who are often hired by corporations to build a collection, they represent certain artists rather than potential collectors. Unlike artists' advisors, who are hired at an hourly rate by artists to help focus their careers (creating a press kit, resume or portfolio as well as examining potential markets and career goals), they are more involved in selling than packaging.

Artists' reps act as agents for commercial and fine artists, soliciting buyers or consigners and taking a percentage of whatever sells. They are more of a presence in the realm of commercial illustration, where reps use their contacts among art directors of magazines, book publishers, corporations and advertising agencies to drum up business, but a sizeable number exist in the area of fine arts.

"The majority of artists find it very difficult to hustle on their own," said Doyle Pitman, director of The Management Team in Universal City, California, a company whose roots go back to the days when Pitman first began promoting the work of his wife who is a painter. "What we do that the artist cannot do is brag about their work."

The Management Team signs artists to five-year exclusive contracts during which time it markets their works to art print publishers, private collectors and art dealers. "We do all the legwork and generate all the prices," Pitman stated, adding that neither he nor any of his three colleagues "make a cent" unless the artist's work is sold.

Besides bragging about their artists, reps emphasize their skills at presenting an artist's work to a potential buyer in a particularly positive way. "There is an incredible amount of telecommunicative sales," Kathy Braun, a commercial art rep in San Francisco, said. "I can do that much better than some of these kids right out of art school who sound like the village idiot on the phone."

She pointed out that a good rep needs a high quality copier and a FAX machine "to get the communications across" since potential clients are often well beyond driving distance. Braun also stated that the rep "can become a liaison between the artist and the art director, smoothing rough edges. A job may be worth, for instance, $5,000, but the art director only has $2,000 to spend. The artist may start feeling that he's being used and not do his best work or bring things in late. I can get the artist to do his best work on time by explaining why this job is important and may lead to others."

Artists' reps don't so much supplant art dealers as help find more markets and individual buyers for their clients' work. They often advertise their services in art magazines (for fine artists) and commercial directories (for illustrators), but artists frequently hear of them through word-of-mouth. Reps ask to see examples of an artist's work (tearsheets or promotional brochures for commercial artists, slides or photographs of paintings and sculpture for fine artists) that will be test marketed if the agent feels a relationship is possible.

There are various issues that will have to be negotiated between artist and rep, involving a fixed period contract, varying methods of payment (a percentage or hourly rate), geographical coverage and a method of sharing costs (advertising brochures or spots in magazines, for example). In addition, the artist's current needs (more commercial work) or career aspirations (getting into a fine arts gallery) will be discussed and planned for. The rep's job is to take care of the details.

"It can be very frustrating and time-consuming for an artist to try to

get into a gallery," Karen Spiro, a rep in Philadelphia who specializes in portrait artists, said. "You may get 100 rejections before a gallery finally takes you on, and lots of artists just don't want to go through that process. I'll handle the rejections so the artist doesn't have to."

Spiro noted that she charges an hourly rate of $50 when attempting to place an artist with a gallery — her average fee is between $2,000 and $4,000 — but obtaining gallery representation is generally not what she or most other reps concentrate on. Rather, their aim is generating direct sales.

There are some reasons for that. Gallery dealers are often unwelcoming and even hostile to agents whom they see as one more layer between the artist and the buyer, and both the dealer's and rep's percentage on any sale is less when the other is involved. A dealer, for instance, usually takes between a 40 and 50 percent commission for sales while the rep's commission is closer to 25 or 30 percent. When a gallery consigns an artist's work through a rep, the dealer's take often goes down to between 30 and 35 percent while the rep makes closer to 15 percent.

Artist reps can be anyone and frequently are friends or family members who believe in the artists and want to move their careers along. They may have fewer professional art world contacts to draw upon but make up for it with extra ardor.

There is no association of artist representatives, but Directors Guild Publishers (P.O. Box 369, Renaissance, CA 95962, tel. 800-383-0677) offers a *Directory of Fine Art Representatives* that lists a number of the people who do this kind of work full-time.

Publicists

A growing number of artists have also turned to publicists and public relations firms to assist them in their careers. Again, as with artists' reps, the intention is not to replace dealers as the primary sellers of work; rather it is to increase the artist's (and the work's) exposure to the public. Publicists may not be for everyone, but they do represent a positive effort by certain artists to take greater control over the business aspects of their lives.

"There are just not enough hours in the day to do everything," said Edward Ruscha, a Los Angeles artist who hired the New York City firm Livet Richard to help promote his work in Europe. "If I had tried to do all the business stuff — the letter writing and contacting people — I would not have been able to create as much art. I'd have to cut up the pie, as it were, of the facets of being an artist. I also wouldn't have been as successful if I had tried to do it all on my own. The thing about public relations people is that they're so tenacious about it. I couldn't do what they do; I wouldn't want to do it."

The range of services publicists provide is vast, depending on what the particular artists are looking for. Usually with lesser-known artists, the need is to "package" the artists by putting together a comprehensive press kit so that they can present themselves more professionally. In fact, many newspaper art critics and art magazine editors first find out about new artists through receiving a press packet from some public relations company.

That often involves the publicist getting to know the artist in order to write a biographical statement that also discusses the art, pulling together published write-ups of the artist's work, preparing black-and-white glossies or color slides of the art and writing either a press release or cover letter for this press kit that lets the critic, curator or dealer (or whomever is being targeted) know what the artist is about.

Knowing how to put one's life and artistic ideas into words is an important skill. "Some artists can speak and articulate their ideas very well, but they are definitely in the minority," Susan Hewitt, a freelance publicist, said. "The people you want to be contacting — the dealers, editors, curators — come from an academic background. They are 'word people' who are accustomed to people who are good with language. I try to help artists find the right words for who they are and what they are doing, and that usually goes a long way."

Some publicists also help artists in other, larger aspects of their careers, such as analyzing the strengths and weaknesses of their development, what collections the artist's work is in, who is buying the work, where the work is being shown and who represents the artist.

At other times, publicists can focus attention on something newsworthy happening in an artist's career, such as an exhibition of new work or the completion of a major project. Peter Max, who is best known for his psychedelic posters of the late 1960s, hired Howard J. Rubenstein Associates in New York City to publicize a 1988 exhibition of his paintings that showed a change in style from his customary hard-edge figurative to a more abstract, painterly look. Robert Rauschenberg sought out the international press contacts of Washington, D.C.-based Hill and Knowles for his 1985-86 "Rauschenberg Overseas Cultural Interchange," which took the artist and his work to various countries.

Another Washington, D.C. firm, Rogers & Cowan, was hired by the Portland, Oregon-based dealer of painter Bart Forbes to inform the press that the artist had been selected to create 31 paintings for Seoul's Olympics Museum. The dealer, a publisher of art prints, hoped that the publicity would generate a demand for the artist's prints.

Dealers have traditionally taken care of all of the promotional work

relating to their artists but, increasingly, these artists are complaining that their dealers do too little or nothing at all. Possibly, their understanding of the business aspects of the art world has made them impatient with the limited activity of these dealers.

Joseph Kosuth, the conceptual artist who is represented by the high-powered Leo Castelli Gallery in New York City, noted that "Castelli has a lot of artists to publicize, and it's hard to keep track of everybody, making sure every one of his artists stays in the public eye. Keeping photographs of all my work, letting people know where I'll be shown next, answering questions about me — they just can't do it all."

That realization brought him to Livet Richard in order to "generate good attention to what I'm doing or to projects I've done that have been ignored." He added that "there is a real need to take responsibility for how one's work is presented and made meaningful to the world, and that's what I need a public relations firm to help me do."

The price for this help is not cheap. Publicists and public relations firms charge anywhere from $45 to $150 an hour, and their work can be time-consuming. At Rogers & Cowan, promoting an artist's exhibition, which includes preparing and sending out a press release as well as following it up with telephone calls to critics, radio and television stations, would run $1,200-2,000. William Amelia, president of Amelia Associates in Baltimore, Maryland, stated that his firm charged the late Herman Maril ("the dean of Baltimore artists," Amelia said) $5,000 a year to publicize his exhibits in Baltimore and around the country.

At these rates, many artists would need to see some demonstrable increase in sales to offset the fees, but that is something which cannot be guaranteed. Neither publicists nor the artists who use them claim that there is any cost-benefit ratio between the amount of money spent on public relations and additional sales that they can identify. For everyone involved, this is a matter of faith.

"We can't say to some artist, 'We're going to get you on the cover of *Time* magazine,'" Amelia said. "All we guarantee is our best effort." Amelia Associates took on the account of one painter, a health care consultant who was completely unknown to the art world, but was unable to interest a single art dealer or museum curator in exhibiting or purchasing his works. The health care consultant spent $1,400 for that experience of rejection.

Another artist, San Francisco watercolorist Gary Bukovnik, spent over $2,000 between 1982 and '83 with the large public relations firm Ruder and Finn to promote his work but only found himself in debt at the end of the experience.

"I had been working for a museum for a while and got to be familiar with Ruder and Finn through that," he stated. "They did the publicity for the King Tut show. I figured, if they could move King Tut, why couldn't they move a few Gary Bukovnik watercolors?"

They didn't or couldn't. Bukovnik felt that he was the smallest account in the agency and that his work received minimal attention. He also said that he found careless factual errors in press materials on him that were prepared by the agency.

Artists can certainly come up with ways on their own to generate publicity about themselves or their work. They can write their own press releases, put together their own press kits and create their own events. A typical approach is for an artist to offer a free "demonstration" of artmaking in his or her studio or at a community center. Another is to offer a talk on some aspect of the arts; yet another is to make a donation of work to a hospital or some other charitable organization. Any number of activities give an artist public visibility.

A press release simply needs a "heading" — a name for the event, which needn't be overly catchy or cute — and straightforward information on what is happening. That entails listing what will take place, when and where.

By calling local newspapers or magazines, artists can find out the names of the person or persons (managing editor, features editor, Sunday editor, assignment editor, Weekend editor, arts and entertainment editor, listings editor, art critic) who should receive the announcement. Press releases, which need to be sent out a few weeks before the actual event (a little earlier than that if the activity is tied to a holiday, such as Memorial Day or Christmas, for which special sections or supplements are likely to be created), ought to be followed up with "reminder" telephone calls to the appropriate editor a week before the event takes place.

Artists' Advisors

The final group of career helpers for artists are artists' advisors who, like artists' reps and publicists, sometimes advertise their services in art magazines or can be found through word of mouth. They generally charge between $30 and $150 an hour. A less expensive form of this service is the nonprofit New York City-based Art Information Center (280 Broadway, New York, NY 10007, tel. 212-227-0282), which charges between $35 and $50 per artist for all consultation and assistance.

Artists' advisors can be distinguished from reps (whose aim is to sell work) and public relations firms (whose aim is to publicize) by the fact

that their primary goal is to set the artist on a career path. Part of this includes an evaluation of the artist's work in order to determine its strengths and weaknesses as well as who would be its likely buyers (and dealers). In addition, they will help artists set up simple bookkeeping procedures, establish a basic price structure for the art, provide rudimentary instruction on copyright and other legal protections for artists and assist in negotiating any agreements with dealers or print publishers.

Beyond that, there tends to be a certain overlap in the activities of the three and, in fact, some wear more than one hat.

Can a Slide Registry Lead to Sales?

In various publications where artist groups and arts organizations are listed, many of these associations claim to maintain a slide registry, which is available for viewing by individual and corporate collectors, art gallery owners, architects and anyone else. Presumedly, having a slide registry is a good thing, but is it?

Artists submit one or more (sometimes 10 or 20) slides of their work, hoping that they are looked at and generate interest. Few registries, however, do more than take up space in an organization's filing cabinets. Rarely promoted, they are unknown to the very people whom artists want to see their work. Worse, these registries are frequently unknown to many of the staff members of the organization, making it more difficult for interested people to gain access to the work of artists, increasing their overall invisibility.

Slides are expensive, and there is no reason for artists to uselessly expend their money and hopes for a service that is created simply because it seems like a good thing to do for artists.

That is not to say that slide registries, effectively publicized and made a part of an organization's primary focus, cannot prove quite valuable to artists. An example of a slide registry's central importance to an arts organization is Wisconsin Women in the Arts, in Brookfield, which not only maintains a slide registry in its offices (visited, perhaps, once a month by area gallery owners and interior decorators) but periodically places them in a slide carousel which is taken by members of the group (along with a projector) to show museum curators, gallery owners and directors around the Midwest.

One of the art galleries at Northwestern University in Evanston, Illinois, for example, created two exhibitions from viewing this slide show, and a commercial art gallery in West Bend, Wisconsin assembled a year's worth of shows based on it.

Another slide registry success story is The Copley Society of Boston where "hundreds of people come in every year to look at the slides," according to Georgiana A. Druchyk, director of the Society. "We view the slide registry as a critical point of reference, which we use for presentations to corporations, individual collectors, art associations and even art galleries."

Richard Love, director of R.H. Love Galleries in Chicago, selected three pastel artists whose work he had never before seen for exhibitions after combing The Copley Society's slide registry.

Yet another example of a slide registry assuming an integral part of an organization is the slide bank of the Connecticut Commission on the Arts. The state arts agency established a policy of only selecting artists for public art projects through Connecticut's Percent-for-Art law from those included in the slide bank, and almost 2,000 artists have sent in more than 20,000 slides. In addition, the arts commissions chooses work for exhibits in its offices from this pool of slides.

The slide bank has also been used by area galleries, collectors, architects, museums, art consultants and even other artists (who want to see what others are doing). Peat, Marwick, the accounting firm with offices in downtown Hartford, sought to buy the work of Connecticut artists and sent over an art consultant to look through the commission's slide bank. From that, $100,000 of artwork was purchased.

However, these successes appear to be more the exception than the rule. The slide registry of Associated Artists of Winston-Salem (North Carolina), for example, is looked at only "several times a year" by someone or another, according to the group's director, Marietta Smith. Rock Kershaw, executive director of Artspace Inc. in Raleigh, North Carolina, said that visitors ask about his organization's slide registry "less than once a month. We don't promote the slide registry because we don't have that much call for it. It's just an extra effort."

Even potentially viable slide registries are made less useful when the organization has no light tables, requiring someone to hold up the slide to a fluorescent light fixture at the ceiling. Carousels containing only a few slides are equally frustrating. In addition, the failure to sort slides according to specific categories (discipline, media, scale and style of work), as well as the lack of additional information, such as the artist's full name and address or a resume, may make the experience of examining a pool of slides a tedious and meaningless chore. As the organizations that maintain registries often require artists to pay a membership fee to join in order to be included in the slide bank, artists should look carefully at the physical presentation of the slides and information; they should also ask

questions about who uses the registry, how often and how the community is made aware of its existence.

Some registries have been computerized, such as the Georgia Artists Registry, which is located at the library of the Atlanta College of Art, for instance, enabling potential users to make very specific searches, such as female watercolorists or artists living in a certain town. In late 1988, The International Sculpture Center in Washington, D.C. created a computerized Sculpture Source System that has placed types of work as well as information on its 1,800 members into 110 categories. The center, which promotes its registry through advertising, direct mailings to architects and interior designers and by attending regional art fairs, created videodiscs of members' works for visitors to view as well as sends photographic images of work in its slide registry and provides biographical information for potential buyers who write in.

The center is also looking at the possibility of a national registry of all fine artists that would begin in the mid-1990s. It has contacted all of the state arts agencies and some artists groups about the feasibility of this plan.

Do Business Cards and Stationery Make the Professional?

What defines an artist as a professional? The Internal Revenue Service of the federal government has one definition, based on an artist making a profit in three out of five years, and dealers use the yardstick of having sold work in the past. Yet others speak of that ethereal thing called seriousness of intent or artistic quality.

For a growing number of artists, however, professionalism means having a business card which, besides noting the artist's name, address and telephone number, lists that person by the title "artist."

To some artists, a business card puts everything on a more professional basis because other people associate business cards with professionalism. It might suggest that the artist is making money from his or her art, and that aura of success would impress others. Besides, a number of artists claim, everybody and his cousin seems to have a card these days announcing what they do, so why shouldn't artists have them?

These cards are often as individual as the artists themselves. While some are quite plain and matter-of-fact (a simple white card with one's name, address and telephone number), others are decorated with pictures of paint brushes or designs that indicate something about the artist. Certain cards also reproduce whole paintings or details from them.

"When someone says to me, 'Gee, I love your paintings. I'd like to see

more,' I hand out a business card," Richard Whitney, a painter in Marlborough, New Hampshire, said. "They look at the card and the design on it. They see the gold-embossed signature and think, 'Boy, this guy must be really good.'"

Artists point out that passing out a card is a more effective way to make oneself known than hunting around for a pen and a piece of scrap paper to write down a name and address. The card itself, they claim, is easy to hold onto and may keep the artist from being forgotten.

A number of artists state that they have handed out cards to people who have looked at their work at juried shows as well as to friends who may in turn give them to potential collectors they know. "I know that cards have helped sell a couple of my paintings," one artist stated. "People whom I have given the cards to have called me to buy something. The cards pay for themselves."

Not everyone who receives artists' business cards thinks well of them. Many dealers are turned off by the "commercialism" of the card, especially those with artistic designs or the title "artist" by the name, and may discriminate against artists with business cards. "I'm confounded when I get a card that gives the person's name and, above that, 'artist,'" a dealer complained. "The person proclaims himself an artist, and I may not agree." Other dealers noted that it is the quality of the work and the ability to attract buyers that define both the good artist and the professional, not a business card that says "artist."

"An artist's business card is just a waste of money," said Sigmund Wenger, a Los Angeles art dealer. Linda Durham, a dealer in Santa Fe, New Mexico, noted that cards "say 'inexperienced' and 'commercial' to me," and Ivan Karp, director of New York City's O.K. Harris Gallery, stated that "avant-garde artists never use business cards. The kind who gets a business card printed up is usually a watercolorist over the age of 60 or someone who lives in the boondocks."

Business cards are not the only sign of the quest for outward professionalism. Artists' business stationery and brochures as well as periodic newsletters to collectors (the artist's version of the annual report) are becoming increasingly common. Cards and brochures may actually arouse some curiosity about an artist's work. They clearly are not welcome everywhere, and it is rare that a direct connection between handing out cards or brochures and the sale of works of art can be established. They may permit artists to feel better about themselves and their desire to market their work in a professional manner — perhaps, that is value enough — but artists may not want to invest in what only has psychological value.

Entry Fees for Juried Shows

To some people, professionalism can be identified by having a business card; professionalism may also mean investing in one's career. Many people attend professional schools, apply for state licenses and join professional organizations, and they all usually cost money. The benefits, however, outweigh the expenses and can be justified. Expenses for other professional activities may not be as easy to swallow, as their benefits are less tangible and their costs somewhat high.

There are certainly a variety of ways that fine artists must pay for their career opportunities (see "Paying to Play the Art Game" below), and one of them is the entry fee for juried art competitions.

No one would expect a dancer or actor to pay in order to audition for a part, nor would a writer be asked to send in a check along with the manuscript for a publisher to read it. The visual arts, however, are different. Visual artists must often pay an entry fee to be considered for a juried competition. Whether they are selected to be in the show or not, they have to pay. People don't look at their work for free.

The thousands of invitational arts and crafts shows (many of which charge entry fees) taking place somewhere in the country throughout the year — held by private companies, nonprofit groups and small towns — enable lesser-known artists and craftspeople to show their work to the public. A growing number of artists, however, have been voicing their objections to the entry fees which, they feel, place the financial burden for these shows on the shoulders of people who have little money to begin with. The fact that almost none of these shows pay for insurance on the shipment of the objects in their displays or provide any security measures to protect them while the exhibition is up is rubbing salt in artists' financial wounds.

"Entry fees are a bit like a lottery," said Shirley Levy, an official of National Artists Equity Association, the membership organization of visual artists based in Washington, D.C. "You pay for the privilege of having someone look at your slides, even if they are rejected. Emerging artists are told, 'Pay your own way until you've made it.'"

Levy and others noted that most show sponsors believe that artists should contribute something for these shows, since they're the beneficiaries of them, but that is a faulty assumption. "Artists don't generally benefit all that much from a given show, but the organizations that put on the shows often make a great deal of money by exploiting artists who need to show their work somewhere," she stated.

Originally, entry fees were established as a means both to control the number of participants in juried fine art competitions — it was assumed

that rank amateurs could not afford the fees — and to provide organizations with upfront money with which to rent a hall, pay some notable art expert to evaluate the artists' work (or slides of the work) and to create prize money. Times have changed, however.

George Koch, former president of Artists Equity, complained that "the money a lot of these show sponsors are raising is far more than needed to meet their expenses." He added that they could easily earn this money in other ways than taxing artists, including soliciting contributions from local companies, charging admissions, creating prints of works on display, marketing a catalogue of works in the show and holding an auction of some of the pieces.

Artists Equity has been uneasy with the existence of entry fees since the organization came into being in 1947 and, in 1981, it wrote up ethical guidelines for its membership, stipulating that artists should refuse to participate in events where there are these fees.

This issue has caught on. Other artists organizations in the United States and Canada have adopted similar guidelines. A statement by the Boston Visual Artists Union, for instance, notes that "Exhibitions do take money to mount. However, it is inappropriate for artists (accepted or rejected) to be a source of these funds," and Canadian Artists' Representation/Le Front des Artistes Canadiens in Ottawa also claims that its membership "does not consider that the payment of entry fees is appropriate to an exhibition of work by professional artists."

Artists Equity has pressed agencies of the United States government to develop a policy prohibiting them from funding groups that put on juried art shows requiring artists to pay an entry fee. So far this effort has met with limited success.

The National Endowment for the Arts has been reluctant to create a policy of this kind although, on a practical level, it has generally refused funds for groups charging entry fees. Many of the applicants to the NEA's visual arts program are exhibiting organizations that put may put on 10 shows a year, one of which might be a regional juried show that requires a fee. It's unlikely that the panelists would deny a good organization funding because of the one show, although they are apt to decide that none of the money that's given to the organization can be used for that one show.

Artists Equity has also attempted to pressure the U.S. Interior Department to drop the $50 entry fee it requires for its annual duck stamp competition. This is the only annual juried art competition sponsored by the federal government, and over 1,000 artists a year pay the fee to submit drawings for a duck stamp commissioned by the Fish and Wildlife Service of the Interior Department. "Why," Koch said, "does the Interior

Department need to make money off artists?"

The case against entry fees has found more sympathetic ears on the state and local level, as both the Oregon Arts Commission and the New York State Council on the Arts as well as the D.C. Commission on the Arts and Humanities in Washington prohibit funds from going to organizations that charge entry fees. The Berkshire Art Association in western Massachusetts decided in 1985 to eliminate its entry fee, and other small town-sponsored events around the country have done the same, looking for money elsewhere. Many other show sponsors have chosen to maintain the entry fee system, however, realizing that there are so many artists around who are willing to send in money in order to have the chance to be shown that they might as well let them.

It may be too much to ask that artists individually refuse to take part in juried exhibitions that demand entry fees as that may be tantamount to cutting off one's few opportunities. Artists Equity's ethical guidelines are not intended to browbeat anyone into harming his or her career. However, artists can be effective in eliminating these fees by discussing their objections to them with show sponsors and, failing to find success there, organizing others to protest the policy.

Paying to Play the Art Game

Visual artists, unlike artists in other disciplines, are people who have to pay for their career aspirations. According to one National Endowment for the Arts study, the average artist's costs (materials, studio space) are a little more than twice his or her earnings from the sale of works. With this in mind, it is especially important for artists to know what they are buying.

And there is a lot out there for them to buy. The past number of years have seen the emergence of various services catering to artists — artists' advisors, publishers of artist directories and how-to-make-money-as-artists books, for-rent exhibition spaces, mailing list sellers — whose benefit to artists is not always measureable. Perhaps, this benefit does not even exist. More than anything else, most artists are desperate to find some way to show and sell their work, and they will often pay for these opportunities. Many people seem to know that, and they are feeding that desperation.

Take, for example, mailing lists. A number of companies sell lists of dealers, corporate collectors, art publishers, museums that show contemporary artists, art competitions and other groups and organizations of interest to artists. These lists have hundreds, sometimes thousands, of names and addresses of potential buyers or contacts who have shown a specific interest in works by living artists.

Announcements about upcoming exhibitions or the completion of new works of art can be sent to the people on these lists and, perhaps, some sales may result. Companies specializing in direct mail solicitations claim to average a three or four percent return; for artists sending out material to 1,000 art galleries where their work might be represented, that suggests between 30 and 40 positive responses.

The reality is less promising. The names on the mailing lists are not so carefully weeded through by the companies selling them that they don't include a lot of frame and card shops. Outside of major cities, lots of furniture stores call themselves galleries, too. There is also no explanatory information with the labels to indicate which actual art galleries are primarily interested in abstract or representational works, the kind of media they prefer to show and who are some of the other artists shown.

These companies don't check with the people on their lists to see if they want to be included (or are appropriate for inclusion), and they might only delete a name if an art dealer wrote or called to say that his or her gallery shouldn't be on it.

It is wiser for artists to market their works with greater precision than with random mailing lists; instead, as noted above, they must become familiar with their markets. As tedious as it may be, there is no getting away from artists having to research galleries.

That kind of research is largely identical to, but more meaningful than, what the mailing list sellers do themselves. "There are two or three books in libraries that tell you which corporations collect art," the manager of Directors Guild Publishers said. "For galleries, we also look in art magazines for ads by galleries."

Considering the fact that the prices for mailing lists range from $27 to $160, depending upon how large they are, a few hours in a library looking at those same books and magazines might well save artists money and headaches.

By the way, any artist who orders a list from these list sellers is automatically placed on the company's artist mailing list, which is available to anyone wanting to sell something to artists.

For some artists, their reasons for paying to get work into the market reflect a misconception about how the market works. Most dealers, for instance, would agree with New York City art gallery owner Stephen Rosenberg who stated that he takes a look at an artist's work or thinks about representing that artist "through recommendation of other artists in my gallery, or other dealers or critics. I wouldn't respond to an ad by an artist looking for a dealer." However, Andre Bogslowskiy, a painter and sculptor, paid to run small advertisements in various art publications for

himself: "WANTED: Extremely Talented Russian Artist is looking for art dealer. Only seriously interested call...."

"I wouldn't do it again," Bogslowskiy stated. "I didn't find a real dealer. What I got were two calls from Russian artists like myself, who didn't really understand English that well and thought that I was a dealer in Russian artists."

Another way in which artists might pay in order to sell is by having their work included in a catalogue, such as Admax's Art Data Service catalogue. For $159, a work of art (or $100 per work if more than three) can be listed in this Florida-based company's catalogue, which is sold for $25 to people who call the toll-free number and buy it.

The catalogue doesn't include any pictures of the art for sale; rather, it contains descriptions of it (medium, size, subject, name of artist, whether or not the work is signed and where the signature is located) as well as the name and address of the person attempting to sell it. An interested potential buyer would contact the owner of the artwork (or artist, in this case) to discuss purchasing the piece directly.

Yet another service that is increasingly being offered to artists, sold to them as being as important to painters as their canvases and brushes, is a place in an artist directory.

An artist directory is a who's-who book or catalogue listing artists (often those working in the same general medium), their addresses (sometimes telephone numbers), gallery associations, background, awards or other professional recognition, major exhibitions and, possibly, representative samples of their art. Their value is two-fold for the artist: On the one hand, they provide exposure and information for prospective buyers; on the other hand, they have a "resume" value in outwardly suggesting professionalism and acceptance (artists are in the directory presumably because of their accomplishments and the level of their work).

There are many such publications, from *Who's Who in American Art* to those aimed specifically at the commercial art field. Some list artists for free, others don't; some "jury" artists applying for inclusion, others appear to take all comers; some are carefully distributed by the publishers to the most likely buyers, others send out their directories more haphazardly, based on mailing lists from art magazines, museums and other sources; some can be found in libraries and book stores, others seem only intended to be purchased by the very artists who are afforded space in them.

One of the entrants into the artist directory field, Art Services Association, has received mixed reviews from those who bought space — $900 for a half page, $1,500 for a full page — in its regionalized catalogues (*Artists of Alabama, Artists of Central and Northern California* and *Artists of*

Southern California). One artist complained of "guilt by association" with some artists' work in the Southern California catalogue that he felt was of low quality: "There's good and bad art in it, and that immediately averages out the quality. On a scale of one to 10, I would give it a two or three at most." Another painter who bought a half-page listing also noted the mixed quality as a drawback, adding that "for those who already have galleries, the catalogue doesn't have a lot of value."

However, David Linton of San Diego stated that he has received inquiries for his pastels from a few artist representatives around the country who saw his half-page listing, and Janet Lee Parrish of Vista, California noted that the catalogue "got two galleries to pick us up," based on the notice she and her husband paid for.

The Art Service Association catalogues are a bit more free form than some others, as the artists not only buy space but write their own copy — they can even design the page layout if they choose. American References Inc. (publisher of *American Artists, The New York Review of Art, The Chicago Review of Art, The California Review of Art, The Southwest Review of Art, American Photographers and American Architects*), on the other hand, is more scrupulous about editorial content. Applications are sent out by this Chicago-based publisher to 200,000 visual artists around the country for the 1,500-page American Artists book, and 5,000 artists are finally included.

According to Les Krantz, publisher of these directories, an artist qualifies for inclusion based on certain criteria: An artist's work has been exhibited at, or is in the permanent collection of, a major museum; the artist is represented by a well-known art dealer; and the "immediacy, frequency and general stature of an artist's exhibits" — that is, how well-received or up-and-coming an artist appears to be. Krantz and his staff make the final decisions on who gets in.

Those accepted for inclusion in American References' books need not pay any fee, although between 40 and 50 percent purchase the publisher's "reproduction package" ($695) that provides the artists with 1,000 postcard reproductions in color of the work that was submitted with the application and appeared in the particular directory. They also receive one complimentary copy of the book. For its part, Art Services Association provides 50 or 75 copies of its directories to each artist, depending on whether a half- or full-page listing was purchased, and 1,000 tearsheets of that page. Artists seem to pay one way or the other, and it is implicitly assumed that the artists will do much of their own distribution, by mailing or handing out the tearsheets or postcards with their images and addresses on them to prospective collectors.

On the high end of the directory cost scale are those for commercial artists. *American Showcase of Illustrators* and *American Showcase of Photographers* (published by American Showcase Inc. and distributed by Watson-Guptill) both charge $3,500 a page for inclusion in these annual volumes, although there are small discounts for sending in one's page early. An artist receives one copy of the book for each page he or she buys as well as 2,000 reprints of that page, but the real factor that may make this expense acceptable for the illustrators or photographers is that the publisher mails them free to the very people who might hire them, such as art directors in publishing houses or advertising agencies, design studios, corporate in-house advertising departments and other likely buyers. Of all directory publishers, American Showcase's mailing list may be the one that is most on-target as far as artists are concerned.

Placing one's trust in some publisher's mailing list, or paying to be in a directory in the first place (shouldn't they be about quality and not just the ability to afford the space?), may turn off some artists. Those who feel that these books can lead to fruitful contacts or commissions or who believe that exposure somewhere is better than nowhere should ask hard questions of those publishers sending out applications for inclusion. An easy type of research about these publications for an artist is simply to check in at a library or two (or at an art library of a museum or college) to see whether or not these books are on file. If no one has ever heard of the book or the publisher, it is unlikely that it can be of any use professionally to an artist. A lot of money is at stake, which is why some publishers got into this field in the first place.

Vanity galleries are no better for an artist's career than vanity directories. Many artists are willing to rent a space in which to hold an exhibit of their work. As with commercial art galleries, walk-in sales to collectors generally cannot be counted on to cover the overhead. Rarely do these kinds of shows result in sales — potential buyers who aren't friends or family members generally prefer to buy from third parties, such as dealers, who are putting their reputations on the line with the particular artist — but the point of the vanity gallery show for the artist is not necessarily to sell; rather, it is to have something to include on a resume.

The growth of these services is, in fact, the reflection of a newly-developed resume-building industry, and many artists will pay to load up their resumes with apparent accomplishments. Why? Because there are too many artists and not enough galleries and museums to show their work. As a result, artists have had to change their orientation from seeking to make a living from the sale of their work to trying to convince other people (and, possibly, themselves) that they are not simply Sunday paint-

ers or hobbyists. No one would have ever thought to ask young Jackson Pollock about his resume, but now serious young artists are led to believe that they should keep a resume up-to-date and packed with experiences and achievements.

And, like the resumes of other professionals in our society, the importance of these activities and achievements tends to become somewhat inflated. Unimportant exhibits and unread directories loom in significance as artists hope that someone will believe that their careers have truly progressed and that their work has received critical recognition. Paying for a show or a number of shows to include on a resume might suggest to someone that the artist's career is progressing, even when none of these shows breaks even for the artist.

It's fair to say that Jackson Pollock set out to make paintings, not to build a resume as a professional artist. Today's artists, however, feel that they have to do both.

"Being an artist today is a lot harder than it was in the past," painter Chuck Close said. "There is a sense of raised expectations today, due to art schools and other institutions with which artists are associated. You see Frank Stella have a one-man show when he's 21, or Julian Schnabel have a retrospective when he's 30. If you've been hanging in there and haven't achieved any measurable success, you begin to ask yourself, 'What do I have to point to that shows I'm a professional, too?' An enormous resume can help someone deny the reality of his situation. I mean, Why am I an artist? I guess it's because I have a resume that says I'm an artist."

Ultimately, the largest change in the art world since the end of the Second World War is the idea that artists can consider themselves failures if they don't achieve some quantifiable measure of success. Over the past few decades, although there has been a great increase in the number of people who are able to support themselves from the sale of their work, most do not. That majority continues to hold various "day jobs" (the lucky ones teach) and dream through their resumes.

A lengthy resume may reflect an artist being in great demand when the entries on it have importance in themselves. A resume is ultimately a way for artists and others to keep track of their careers, and no quantity of listings on it will substitute for high quality exhibitions and a market. When a resume is filled with group or one-person exhibitions that turn out, on closer inspection, to be a few pictures that a bank placed in its windows or are gallery shows in which the artist rented out the exhibition space, when there is a vanity element to many or most of accomplishments listed, the resume becomes a statement of failure. And, the fact is, the very people whom the lengthy resume is intended to impress can see

that quite clearly. It is wiser to have a shorter resume that lists events that are truly meaningful — perhaps, in a category of "Selected One-Person Exhibitions" — than a massive hodge-podge of good, bad and indifferent. Artists have good reason to put together a well-presented resume, and there are various consultants (career advisors, artists' advisors) who can assist them in this effort. It is time, however, for artists to de-emphasize the resume as the barometer of how their careers are going.

Art dealers, for whom these resumes are often intended, are usually not impressed by the number of exhibitions an artist has had — once again, they select artists based on recommendation of others whom they trust — and who has bought that person's work in the past. No artists have ever been rejected by a dealer for having too short a resume, although many dealers dismiss artists out-of-hand who have previously paid for shows, considering them not to be professionals. These days, artists have to be professionals from the word go.

With everything that an artist might pay for, the costs need to be weighed against the potential benefits. The costs are certainly real but, if the benefits are only a dreamy impression of good things, one may want to hold off for something more solid.

Some of these services do nothing more than play off the desperation of artists for whom finding a way to show and sell their work is inordinately difficult; others exist because someone thought up a solution and tried to convince others that they had a problem. Consumer advertising is full of success stories in this area, but the art world tends to act differently. Direct mail fliers, vanity galleries and classified advertisements don't usually lead to fame and riches in the art world. Changing the way success is found in the art world may be, in the future, another service to add to the list.

Chapter 4.

The Benefits of Art School

The most meaningful things we learn are usually what we've taught ourselves, but most people look to the four walls of a school for a head start. High school students who are interested in making art, for instance, think about going to art school or majoring in art at college, while those in college give thought to going on for a Masters of Fine Arts degree.

Theoretically, such training should lead to greater success in terms of the quality of an artist's work and the ability to sell it. Unfortunately, with both quality and sales, there is no evidence that the quantity of one's education makes any difference. This is most apparent in the amount of money an artist makes.

According to a 1986 study of 900 artists applying for fellowships to the New York Foundation for the Arts for the year 1985-86, 95 percent had completed college and another 59 percent had graduate art degrees, yet 20 percent of them had pretax household incomes under $10,000 and 56 percent of the total had household incomes between $10,000 and $30,000. The median was slightly under $20,000, and only a small percentage (if any) of that derived from selling actual works of art.

The percentage of artists with college — Bachelor of Fine Arts or Bachelor of Arts — or graduate school degrees has increased over the years, as has the amount of money artists may earn from their art. However, that money usually adds up to only a small fraction of their total income. A 1978 survey of artists in Houston, Minneapolis, San Francisco and Washington, D.C., conducted by the National Endowment for the Arts, found a median household income of $20,000, only $718 of which came from the sale of works of art. As the cost of their materials topped an average of $1,500, art was clearly a losing proposition.

A 1989 study by Columbia University's Research Center for Arts and Culture of artists in 10 United States locations found that 61 percent of the artists had a gross income (from all sources of employment) of less than $20,000. While improving economically over the span of two decades — the 1970 Census reported a median income for painters and sculptors of $12,400 — artists remain among the poorest paid economic groups, despite the fact that two-thirds of the artists in these surveys had college or graduate school degrees.

A main reason for the continued difficulty of artists as a whole to earn enough to support themselves is that there are so many of them. According to one report, the U.S. work force increased 43 percent between 1960 and 1980, while the number of artists, writers and entertainers shot up 144 percent during that same period. The increase in prices for art over this period and the widening art market have not been able to overcome the massive infusion of artists.

Many of the real world problems of pursuing a career as an artist would be better known to young artists if more art schools offered what are frequently called "survival courses." These classes are designed to teach everything from protecting copyright and writing up consignment agreements for art galleries, to how to put together grant proposals, preparing a portfolio, and even how to find and keep a loft. The absence of this body of information tends to result in a fresh crop of psychologically unprepared artists who are released into the world every year.

Finding a Job as an Art Teacher

Clearly, the decision whether or not to obtain an art degree on the Bachelor's or Master's level is not an economic one. Many college students believe, however, that the MFA is the road to a teaching position at a college or university, where salaries are better than what most artists are able to earn by selling their work. They imagine only a few hours per week of required teaching with the remaining time open for artmaking. It is true that most art instructors have that degree and that few art schools or departments will hire someone to be an instructor without an MFA. However, there are so many MFAs around these days — more than 68 for each available teaching position at the college or university level, according to a 1991 survey by the College Art Association — that the teaching prospects for an art student today are poor at best.

The 68-to-1 ratio may not sound hopeful to most artists, but it is better than the situation at Yale University School of Art in New Haven, where 200-300 applications come in for each available job, or at Pratt Institute

in Brooklyn, New York where, according to Mel Alexenberg, chairman of the fine arts department, "we may save one resume out of 100. We never really hire anyone unless someone on our faculty knows the person."

About half of all college art teaching positions are fixed-term, or non-tenure track, and the artist will soon have to look for elsewhere for employment.

Pratt Institute may truly embody the dilemma facing artists. The school gives out more MFA degrees — 500 a year — than any other institution in the country, yet it would be unlikely to hire any teachers unless they were "at least 10 years out of school" and "had gone out into the world and made it as artists" while "gaining teaching experience" somewhere along the way, Alexenberg said.

The prospects for teaching are not wholly dire for artists. Moving away from Modernist canons of art, most schools are looking to maintain a wide range of styles and artistic ideas — from realistic to conceptual — in their departments, and they are also increasingly hiring women and members of minority groups for teaching positions.

The College Art Association has also found an increase in non-university teaching jobs for artists, such as at museums and nonprofit arts centers, as well as teaching opportunities at less prestigious institutions, including junior colleges, summer retreats (art camps, cruise line art classes), senior citizen centers, Veterans Administration hospitals and YMCAs. One finds these jobs through contacting the individual institutions, as each has its own availabilities and budgets.

Another growing area of hiring for art teachers, according to the National Art Education Association, is the nation's public schools where 29 state boards of education across the country now require high school students to take at least one art course in order to graduate — a requirement that did not exist before 1980. In addition, 58 percent of the country's elementary schools have full-time or part-time art teachers, a substantial increase since the early 1980s.

There are approximately 50,700 public school art teachers working in the nation's 15,600 school districts, with a turnover rate of between two and five percent, or between 400 and 1,000 jobs, a year. These jobs, however, are available only to those holding state teaching licenses or certification (or both), and requirements differ from school to school or from district to district. Nowhere is the road to relevant employment easy for artists.

Private schools, which must be contacted individually, do not have the same requirements for teachers and may be worth pursuing.

The benefits of teaching are clear — long vacations and having to teach

only part of the day — but they may also be overstated. Artists have not always felt at peace with the academic life, and many find themselves uncomfortable with it now. In the past, there used to be a lively tradition of artists meeting in a few central locations (at a studio or tavern, perhaps) and hashing out ideas and comparing notes. They were able both to create art and live in the world more immediately. With the growth of teaching jobs in art around the country, the result has been to separate and isolate artists in far reaches of the country, limiting their ability to converse and share ideas.

Looking at this very issue, the critic Harold Rosenberg wrote that "If good artists are needed to teach art, the situation seems irremediable. Where are art departments to obtain first-rate artists willing to spend their time teaching, especially in colleges remote from art centers. And, thus isolated, how long would these artists remain first-rate?" The result, he found, is that many artists lose their sharpness and their students begin to get more of their inspiration and ideas from looking at art journals than by paying attention to their instructors.

The academy has become the main source of employment for artists in all disciplines, and the entire structure of art in the United States has been affected by this.

When artists are spread out around the country, removed from the major art markets and critical notice, their ability to exhibit their work becomes much more limited and the desire to show their artwork grows more intense. Members of college or university art faculties frequently find themselves at war with the directors of the institution's art gallery over whether or not their work will be exhibited.

The division between the two is obvious. Artists want to use the available space to show what they do, which is the principal way they can maintain their belief in themselves as artists first and teachers second. On the other hand, university gallery directors don't want to be simply booking agents for the faculty, but prefer to act as regular museum directors, curating their own exhibits and bringing onto the campus the work of artists (old and new) from outside the school. Each side has a point, but it is often an irreconcilable area of contention unless, as at some colleges, there is more than one gallery for art shows on campus. Some schools have galleries that are student-run or that are principally for student exhibitions, while other spaces exist for the faculty and out-of-town artists or traveling shows. When there isn't this multiplicity of art spaces, a state of war may develop at a college that embitters the artist and exhausts his or her time not in artmaking but in departmental in-fighting.

Away from the major art centers, stimulation may be lacking for art-

ists who need things going on around them, and academia tends to have its own special set of concerns. "In the hinterlands," Robert Yarber, a painter who has taught in California and Texas, said, "all the other artists you meet are teachers, and that can be inhibiting." Bill Christenberry, a painter and photographer at the school of the Corcoran Art Gallery in Washington, D.C., noted that he was offered tenure at Memphis State University and was making a good salary there "but I thought, 'Heck, if I'm not careful, I'm going to be trapped here.' I never regretted leaving Memphis."

When there is not a community of artists but, rather, an art faculty, discussions about art become more diffuse and may be limited to formal settings, such as the annual meetings of the College Art Association (where teachers otherwise convene to look for jobs) or are put into the form of critical articles in specialized journals.

Can artists teach and give an analytical presentation of works by the old and new masters (and by their students) and then go home and be inspired to make their own art? This is an age-old problem for artists, one that will continue as long as artists also teach.

Another problem for artists who teach is balancing their own professional careers with what they do for their students. Artist-faculty members, as faculty members in every school department, are required to hold office hours for their students, attend staff meetings and participate in some campus activities. This is essential for both the students and the college or university as a whole, although it does take time out of the artist's day. It is unlikely that someone would be hired for a teaching position who made his or her lack of interest in these activities known.

Making Peace with the Academic Life

It is said that when the Italian Renaissance artist Verrocchio saw the work of his student, Leonardo da Vinci, he decided to quit painting since he knew that his work had certainly been surpassed. The story is probably apocryphal — it is also told of Ghirlandaio when he first saw the work of Michelangelo, of Pablo Picasso and his father and of a few other pairings of artists — but the idea of a teacher selflessly stepping aside for the superior work of a pupil is thrilling.

More likely, many artists who teach today would tend to agree with Henri Matisse who complained during his teaching years (1907-09), "When I had 60 students there were one or two that one could push and hold out hope for. From Monday to Saturday I would set about trying to change these lambs into lions. The following Monday one had to begin

all over again, which meant I had to put a lot of energy into it. So I asked myself: Should I be a teacher or a painter? And I closed the studio."

Most artists fall somewhere between Verrocchio and Matisse, continuing to both teach and create art but finding that doing both is exhausting. Giving up sleep is frequently the solution.

"My schedule was very tight," said painter Will Barnet, who taught at the Art Students League and Cooper Union in New York City for 45 years and 33 years, respectively, as well as over 20 years at the Pennsylvania Academy of Fine Arts in Philadelphia. "It was tough to find time to do my own work, but I could get along on very little sleep and was able to work day and night on weekends. Also, I never took a vacation."

Many, if not most, of the world's greatest artists have also been teachers. However, between the years that Verrocchio and Matisse were both working and teaching, the concept of what a teaching artist is and does changed radically. Verrocchio was a highly touted 15th century painter and sculptor, backed up with commissions, who needed "pupils" to be trained in order to help him complete his work. Lorenzo di Credi, Perugino and Leonardo all worked directly on his paintings as the final lessons of their education. It would never have occurred to Matisse to let his students touch his canvases. In the more modern style, Matisse taught basic figure drawing rather than how to work in the same style as himself.

Teaching now obliges an artist to instruct others in techniques and styles that, at times, may be wholly opposed to his or her own work. Even when the teaching and creating are related in method and style, instruction requires that activity be labeled with words, whereas the artist tries to work outside of fixed descriptions — that's the difference between teaching, which is an externalized activity, and creating, which is inherently private and personal. Anyone agreeing with Ernest Hemingway's comment, "When you talk about it, you lose it," would likely feel uncomfortable in the academic environment.

Teaching, which has long been held out as the most sympathetic "second career" for artists who need a way to support their principal interests, may work insidiously at times to destroy or undermine an artist's vocation. Hans Hoffman, for instance, gave up painting for a long stretch in his career because he was fearful of influencing his students in any particular direction. Keeping open-minded to various possibilities in painting was problematic to his career when he did paint, critics have argued, as his work bounced around in a variety of techniques and styles. To be a more decisive, fully realized artist, it was necessary for him to finally give up teaching.

"The experience of teaching can be very detrimental to some artists," said Leonard Baskin, the sculptor and graphic artist who taught at Smith College in Massachusetts between 1953 and 1974. "The overwhelming phenomenon is that these people quit being artists and only teach, but that's the overwhelming phenomenon anyway. Most artists quit sooner or later for something else. You have to make peace with being an artist in a larger society."

Artists make peace with teaching in a variety of ways. Baskin noted that teaching had no real negative effect on his art — it "didn't impinge on my work. It didn't affect it or relate to it. It merely existed coincidentally" — and did provide a few positive benefits. "You have to rearticulate what you've long taken for granted," he said, "and you stay young being around people who are always questioning things."

A number of artists note that teaching helps clarify their own ideas simply by forcing them to put feelings into words. Some who began to feel a sense of teaching burn-out have chosen to leave the academy altogether in order to pursue their own work while others bunch up their classes on two full days so as to free up the remainder of the week. Still others have developed strategies for not letting their classroom work take over their lives.

Painter Alex Katz, for instance, who taught at Yale in the early 1960s and at New York University in the mid-1980s, noted that he tried not to think about his teaching when he was out of the class — "out of sight, out of mind," he said.

Others found their teaching had so little to do with the kind of work they did that forgetting the classroom was easy. Painter Philip Pearlstein, who has taught at both Pratt Institute and Brooklyn College, stated that his secret was to keep a distance from his students.

"I never wanted to be someone's guru," he said. "I never wanted to have any psychological or spiritual involvement with my students, getting all tangled up in a student's personality or helping anyone launch a career. I call that using teaching as therapy and, when you get into that, you're in trouble."

Teaching, however, is not all negatives or full of potential pitfalls for these or other artists, and many claim that the experience has been positive overall and, indirectly, beneficial to their work. "Sure, I get exhausted by teaching," photographer Emmet Gowin, who teaches at Princeton University in New Jersey, said. "I come home some nights not wanting to talk for a month, just curl up on a couch and see no one. But, if it's physically wearing, it's mentally stimulating. Teaching and creating are the same thing to me because you are bringing to your class or to your work what's

important to you at the moment. You're always exploring whether or not things go together. And when it works, whether it's a class or a work of art, it's magic. That's vivifying."

With other artists, the very need to do away with some sleep or vacations or social outings in order to make time for creating art has, in a number of instances, instilled a discipline that makes their use of time all the more effective.

"I think that having a job has led to an intensification of my work," Pearlstein stated. "I had to use the little time I had to paint, and it made me work all that much harder. Something had to give, so I cut down on my social life. I decided it was more important to stay home and paint."

Another benefit of teaching is seeing students stimulated and gaining emotional freedom to use what they know. Verrocchio may not have been the equal of Leonardo, but he taught his student a standard of craftsmanship. In the same way, photographer Harry Callahan, who headed the department of photography at the Rhode Island School of Design from 1961 to 1977, was able to encourage Emmet Gowin to a high level of professionalism. Similarly, conceptual artist Joseph Beuys developed in his student Anselm Kiefer a feeling for certain materials and a desire to reflect on Germany's recent past. In this way, thousands of artists have inspired tens of thousands of others as teachers. That certainly does more for both artist and pupil than either giving up one's art or one's students.

Evaluating Schools with BA, BFA and MFA Programs

Art dealers, publishing houses, advertising agencies and others who would represent, hire or commission an artist appear to have little interest in whether or not the artist has a BA, BFA or MFA (or, in some cases, any degree at all), since they judge the artist's work on the basis of a portfolio. Within colleges and universities, however, the issue of which degree is most useful for one's career is hotly debated.

The reasons for a student to select a fine arts curriculum in a BFA or an MFA program or an arts major in a liberal arts curriculum are different. The Bachelor of Arts degree is a more well-rounded program, with distribution requirements and courses in areas quite unrelated to the visual arts; some art majors do go on for MFAs.

According to the heads of many art schools and university studio art departments, however, the main problem for the BA (art major) student is that he or she has less time in the studio than does the BFA student. More time in the studio permits a longer period to work out artistic ideas and a greater opportunity for critical attention by members of the faculty.

The BA program offers less opportunity than the BFA to put together a portfolio and, for either MFA programs or the commercial art world, a good portfolio is a must.

Various art department faculty members also frequently take the position that the BA is not quite as serious as the BFA, claiming that the serious, talented students are often tracked into art programs early on.

This kind of thinking is not shared by every art school and department head. Some feel that the denigration of the BA degree may exist more within an institution than outside of it, as MFA candidates are most often examined by "blind" juries who look at the applicants' slides and otherwise are not told anything about them.

With either the fine arts or liberal arts programs, a key consideration for students is the connection to the art (or design) world of the fine arts faculty, which is important because contacts frequently matter. Prospective students should evaluate a fine arts school or the studio department in a college or university, in fact, by examining the school catalogue, where biographies of the instructors may be found. The frequency (once every year or so) and importance (major galleries or museums) of exhibitions by faculty members indicate their professional standing. Instructors whose artwork has received recognition in the art world lend prestige to the school (or to the art department) as well as open up potential doors for the art student after graduation.

"Even if the teacher doesn't personally help the student with his or her career," Judith Brodsky, director of printmaking at Rutgers University, said, "it helps the student to study with a name-brand faculty member."

The college catalogue will also indicate the number of people teaching various disciplines — students would not want to study painting for four years with the same person — and the diversity of stylistic approaches, which would enrich a student's understanding of his or her media. Liberal arts institutions are not always as likely to have the same depth in their faculty as art schools, although each college must be judged individually.

The MFA program's benefit to a student is debatable. For some, it does pave the way to a job in the commercial art field or as an instructor (although schools generally do not like to hire someone right out of an arts program who hasn't been seasoned by a few years in the world). For others, it represents another year to work in a nurturing, critical environment. Other than how accomplished the faculty is, art schools are generally evaluated by how successful their alumni have been, and this information is usually made available through the specific department or by the admissions office. The College Art Association (275 Seventh Avenue, New

York, NY 10001, tel. 212-691-1051) publishes *MFA Programs in the Visual Arts: A Directory,* which provides basic information on schools, their curricula and faculty, costs of tuition and types of financial aid available. The directory costs $4.

The payback for the MFA degree is difficult to track, as monetary rewards are few for any artists whatever their level of education. What one gets out of art training depends on the intuition, creativity and understanding that are brought to it, and it is only as valuable as the willingness of the artist to follow it up with his or her own discoveries and hard work.

Chapter 5.

The Artist's "Second Career"

The market for art and literature is a model of Darwinian forces at play. Thousands of optimistic people each year leave art schools, creative writing programs and dance workshops with the dream of "making it" as artists. The bloom soon fades from the cheek as few earn anything at all and the need to find a job of some sort enters in.

William Faulkner, for instance, had dozens of jobs from Hollywood scriptwriter to mailman; Paul Gauguin and T.S. Eliot both worked in banks; Charles Ives and Wallace Stevens had jobs in the insurance industry; painter Henri Rousseau was called "le douanier" by his contemporaries because he worked as a customs official, the same job that Herman Melville had.

Seventeenth century Dutch artists were the first to paint without pre-arranged commissions, needing to leave their studios to look for buyers, and they were also the first to learn about second careers. Meindert Hobbema earned money as a tax collector, Jan van Goyen as a realtor; Jan Steen was an innkeeper and Jacob van Ruisdael made a living as a barber. Both Johannes Vermeer and Rembrandt set up as dealers.

Of course, we know these artists for their creations, and most of them were able to leave their paid jobs for what history has viewed as more memorable work. Many others — most artists, actually — are not so lucky.

There are two major career decisions an artist may have to make: The first is, what kind of pay-the-bills job to get — should it be related or not to the individual's abilities in the arts (for instance, a painter doing book illustrations or a novelist writing advertising copy)? Secondly, whether or not the job is related to the one's art training, should the artist just keep the job as extra money or look to move up in the company or in the field. The second question is the hardest, and it makes Sunday painters of a lot of talented artists.

Relatively few people know Robert Kulicke as a painter, although he studied to be one for eight years. The French artist, Fernand Leger, was his teacher for a year-and-a-half, and he also attended various art schools as well as befriended many of the leaders of the abstract expressionist school. But making a name for himself and a living as a painter was not in the cards for him. Rather, many people will think of him as the creator of handsome modular metal frames. The Kulicke frames are known and copied around the world for their simplicity, elegance and modern design. What began for him as a way to make some money in order to support himself and his art became a full-time profession, eclipsing his art while making him a wealthy man.

He started making frames in the early 1950s after a prolonged period of self-doubt and frustration led him to consider a second career.

"My career as a painter has suffered tremendously from the renown of the frames," he stated. "I never really stopped painting, but all anyone would say is, 'Oh, Kulicke the framemaker is trying to be a painter, now.'"

Robert Kulicke's situation is unique in a way but also very common for people who started out trying to succeed as artists but found themselves moving on quite different paths.

The word "artist" is an extremely value-laden one in this century. It means a creator of something significant, something of beauty, power and reflection, and it represents the highest level of achievement to a society conscious of its free time and its homogeneity. It is a psychologically traumatic event for someone to conclude that he or she is not an artist but, considering how little money most visual artists earn from their creative work, finding a paying occupation is an absolute economic necessity for almost all.

Frame-making is but one related career possibility — there are many others. Painter Alexander Liberman has worked as art director at Conde Nast publications for years while sculptor Donald Judd wrote art reviews in the early part of his career. Barbara Kruger, James Rosenquist and Andy Warhol began their respective careers in magazine design, billboard painting and advertising layout.

Some artists are led to become entrepreneurs. Virginia Gardner spent a number of years counseling artists on how to manage the business aspects of their careers, putting to use the knowledge and experience she gained from working in business jobs after receiving her art degree. Art Guerra, on the other hand, put his increasing interest in creating his own paints to work, starting up Guerra Paints and pigments in the mid-1980s in order to "make paint chemistry and technology available to artists."

It is also not uncommon for artists to become art dealers. Many art-

ists have established art galleries that include their own work. Robert Angeloch, a landscape painter in Woodstock, New York, set up a gallery in that town "as a way to show my own work. I had been in some New York City galleries, but they always folded or the owners died."

Entrepreneurism has its own price, especially during the first few years when someone may find him- or herself working seemingly around the clock on everything from bookkeeping to sweeping the floor. The financial risks may also be considerable. The freedom to do one's artwork regularly becomes, for many artists, a question of discipline, a tortuous effort to beat the sunrise to get in a few hours a day in front of the easel or an activity for the part of the day when the kids have been put to bed.

Few American artists have had the opportunity to lead any different kind of life. It is an enormous gamble for anyone to take — picking up odd jobs and part-time work in order to support one's art — in the hope of some day being able to live off one's work. Discipline and stick-to-itiveness are key ingredients, but no one is rewarded just for hanging in there. The art world is full of unknown soldiers.

Some Related Art Careers

Many artists are reluctant to apply their art skills and ideas to money-making activities, fearing that they will compromise their studio creations or that it is a betrayal of their ambitions to have to work on deadline, make corrections or be given themes and subjects. These artists tend to wait tables, work as carpenters or at any number of jobs that do not impinge on their artmaking, other than possibly physically tiring them out.

There are, however, quite a few lucrative areas that artists can pursue that utilize their art skills directly or in a related field. A few are noted here in terms of the potential benefits and drawbacks. This is certainly not an exhaustive listing — there is no discussion of art restoration, book jacket illustration or many of the other money-making applied and fine arts activities to which artists are often able to turn their skills — but a few of the possibilities. Some are full-time endeavors for certain artists while others simply support their artmaking.

Portraiture: The lowdown on the life of a portrait painter is this: There's money to be made — spouses and parents want pictures of family members, universities, corporations and associations seek likenesses of their leaders — but there is little fame for artists in this line of work. Add to this the fact that the most famous portrait painters of the last 50 years gained recognition only for works that were rejected by the patron.

For instance, Peter Hurd, Andrew Wyeth's brother-in-law, painted President Lyndon Johnson's portrait ("the ugliest thing I ever saw" was the sitter's response) and Graham Sutherland did one of Winston Churchill (destroyed by the Prime Minister's wife who was just barely more incensed with it than was her husband). Perhaps, these rejections are signs of the artists' talents and insight, but they largely redefine fame as infamy.

Of course, certain artists who have also done portraits are famous. Edgar Degas, better known for his impressionistic ballet dancers, and John Singer Sargent, who also did watercolor landscapes, both used portraiture as a way to earn some badly needed money (with Sargent, it also brought him notoriety and admission into the fashionable society he coveted). The sculptor Isamu Noguchi is another who made bronze busts and heads in the image of paying clients, although he is best known for his large abstract pieces. Of contemporary artists, Will Barnet, David Hockney, Alex Katz, Alfred Leslie and Philip Pearlstein are among the many who have been induced to do a portrait when the money and sitter are right.

For a number of artists, the issue seems to be whether one is known as a portrait painter or as an artist who also happens to do portraits. Aaron Schickler, for instance, who is best known for his portraits of former President Ronald Reagan and former First Lady Jacqueline Kennedy, eschewed the portrait painter label, noting that "I don't conceive of portrait painting as a separate identity. I am an artist." E. Raymond Kinstler, who did President Gerald Ford's official portrait as well as those of many other political leaders, also skirted the issue by claiming that "I'm in easel painting."

For most artists who do likenesses, portraiture is a sideline that pays the bills until other work starts selling. "It's a marvelous opportunity to sharpen one's drawing skills," Will Barnet said, "and it's a real challenge to capture someone on canvas."

For others, it is a full-time occupation that may involve not only people but houses or pets as subjects, with final works created in a variety of drawing, painting, photographic or sculpting media. Many of these artists work through one of the many specialty galleries catering to those seeking to have a portrait done, such as Portraits, Inc. (New York City), Portrait Brokers (Birmingham, Alabama), Portraits Chicago, Portrait Representatives (Baltimore, Maryland), Portraits South (Raleigh, North Carolina) and The Portrait Group (Alexandria, Virginia), all of which take a 40 percent deposit that is kept in the event that the finished work is rejected.

That 40 percent is also the customary amount of their commission, so the deposit ensures that the galleries lose nothing. Other, regular art

galleries handling the work of figurative artists also arrange portrait commissions. Prices in most cases are set by the artist.

Artists working independently generally require a 15-25 percent deposit that will be kept if their work is rejected. There are a number of other costs that should be negotiated with the patron separately, such as travel for the purpose of sketching a subject, which may include accommodations, food and the cost of renting a studio in another city. Another area of expense is framing and shipping. The expenses associated with a particular medium (bronze, pastels and oil paint are the most common) need also to be considered.

In addition, prices are set on the basis of whether or not there is more than one figure in the picture (a mother and daughter, for instance, or several animals), the type of pet in the painting (a horse may cost one amount, a parakeet another), the type of background (Portraits, Inc. charges an extra 30 percent for backgrounds that are not simply dark but include furniture or a landscape, for example) and the amount of the subject depicted (head and shoulders, half figure with or without hands, three-quarters or full-length).

Daniel Greene, a pastel portrait artist who has been doing likenesses for the past 35 years, stated that some artists charge less for painting children than adults as "portraits of children are usually paid for by an individual, such as a parent, whereas an adult may be the head of a corporation that is commissioning the painting. Corporations have more money than private individuals, and an artist may charge accordingly."

Greene, who holds portraiture workshops around the country, added that prices artists charge for human portraits range from $2,500 to $75,000, with the average being between $4,000 and $7,500 (although portraits done in charcoal or pencil may run only in the hundreds of dollars). Many artists find that word-of-mouth brings them most of their customers and, as their reputations grow, so do their prices and the prestige of the commissions coming to them.

A simple animal portrait may run as low as $2,400, Greene pointed out, with $600 for each additional pet. For a child or an elaborate background, the charge may extend to $8,500. A portrait of a single child starts at $4,500 (extras may bring it up to $6,800) while portraits of an adult range from $5,500 to $7,500.

Constance Coleman of Carmel, California does 30-40 portraits a year of children, generally retaining the reproduction rights to these pictures, which she uses for note cards. These cards are sold around the country through a San Francisco-based publisher (the pet owners themselves get complimentary cards from the publisher when it is their animal).

"People like pictures of animals," she stated. "I get a lot of my commissions from people who have bought the note cards and decide that they want a portrait of their pet. That's great; there's no commission to pay in that, but where am I going to find the time?"

The fees for painting a likeness of someone's house are often less than for pictures of individuals or animals, largely because of the way these house portraits are conceived or used. Interior decorators, landscapers or architects, for example, may commission an artist to paint a customer's house as a memento of their own work, and they are unlikely to pay thousands of dollars for this. Homeowners sometimes also seek a painting of their property, and they may pay somewhat more.

There are various ways of pursuing this market. Geoffrey Stiles of Baltimore, Maryland goes door-to-door, in the more affluent neighborhoods of the city, to some of the more architecturally interesting houses asking whether or not the owners would like a pen-and-ink drawing made of where they live.

"People with nice houses like to talk about them, even if they're not willing to commission me," he said. "It's very flattering to them that I come to their door, and many of these people generally like to talk about art. It's not at all like insurance, which scares people off." Previously, Stiles sold life insurance.

Many of his clients shrink the pictures he creates to put on their stationery or cards, and some place the pictures on their walls as pieces of art. They sell for between $350 (for a 5"X7" postcard size) and $650 (for a 9"X12" picture).

Each rendering takes him approximately two or three days, bunched up when the demand is great, spread out when customers are fewer. Christmas has proven to be a busy season, with demand slowing down for a time shortly thereafter, but his market is largely wealthy people for whom seasonal vicissitudes in spending are not severe.

To balance out his work load, and ease some of the need for door-to-door selling, Stiles has advertised in various national magazines — a pricey way to get work, costing $600 for a two-month ad in *Historic Preservation* magazine, for instance — and has received some responses. Customers send him photographs of their houses that he, in his studio, renders in a pen-and-ink drawing. Even when the house is in Baltimore itself, Stiles still takes photographs and works from them in his studio.

Pictures of adults usually cost more than those of pets, children or houses because they are intended as lasting memorials to be shown in prominent spaces.

Word-of-mouth and arrangements through dealers tend to be the

most common ways of finding work, although there is an association of portrait artists — The American Society of Portrait Artists (Dept. AA, P.O. Box 230216, Montgomery, AL 36123-0216, tel. 800-235-6273, 800-345-0538 for Alabama residents) — as well as one for caricaturists (National Caricaturist Network, c/o Buddy Rose, Dept. AA, P.O. Box 181147, Dallas, TX 75218-1146, tel. 800-955-1820) that may help lead to assignments.

Prices for portraits — either of humans, pets or houses — should be the same regardless of whether a buyer contracts directly with an individual artist or through the artist's dealer. Artists should never undercut their galleries and, besides, they can keep what would be the dealer commission for themselves. However, artists should not have to pay a percentage of their payment to a dealer or gallery when they arrange the portrait commission themselves.

Every artist works differently on portraits, some staying in their studios and relying on photographs that a patron sends them while others insist on site visits to sketch (and possibly to photograph) the posing subject. Ariane Beigneux of Norwalk, Connecticut, who specializes in children, noted that she does a "careful color sketch from life — the child has to sit for a few hours — and then I take maybe 60 photographs from different angles to capture expressions and poses. That gives me a lot of different attitudes and choices." Ellida Sutton Freyer of Chicago, who frequently does pets, on the other hand, takes a booth at an art fair or dog show to make quick sketches and occasionally travels to someone's house to make a sketch, "but it's hard to get animals to sit still and pose. It can be difficult following a cat all over the house."

As with everything else, portrait painting goes through various phases of taste, sometimes leaning more toward photographic realism and other times preferring a looser style. Patrons generally have a sense of what they are going to get, as either the artist or the gallery will have a brochure of previously painted portraits that indicates what the artist does and how. Sometimes, of course, the final work comes as a bit of a shock.

"I've had problems with paintings that, eventually, I had to redo," Raymond Kinstler said. "I did one of then United Nations Secretary General Kurt Waldheim that he just didn't like. He didn't like my interpretation of him, and he made some recommendations. I saw his point in a few areas but I could not, in my artistic sensibility, accept what he recommended that I do, but I agreed to do the painting over again. He posed again and ended up liking the next one."

Daniel Greene suggested that artists show the work in progress to the sitter as "customers like to see the work develop from white canvas to full

color painting" and in order to keep the final work from coming as a "shock" when they finally see.

"It may be a good shock or a bad shock, but it is always startling," he said. "Many artists drape the work when the subject isn't posing or turn it to the wall, and all the sitter gets to see before the final viewing is the back of the canvas. When a subject gets to see the work in progress, that person is generally less prone to reject it at the end."

Rejection is a problem that doesn't exist in the same way in the fine arts realm of gallery exhibitions. "The reason I never wanted to do portraits as my full-time occupation," Will Barnet stated, "is that I don't want to work under anyone's judgement. I wouldn't want someone to tell me to make the nose a little different."

By the way, it is noses and ears that many portrait painters claim are the largest area of dispute.

Trompe l'oeil Painting: _Trompe l'oeil_ (French for "fool the eye") is one of the oldest forms of two-dimensional art, dating back to the 4th century B.C. Greek artist Apelles whose painting of grapes was so lifelike that birds pecked at them. During the Renaissance, the Florentine banking family Medici had their entire counting room painted with _trompe l'oeil_ book-shelves and doors in order to confuse anyone who thought to steal some money.

In the years since the Renaissance, _trompe l'oeil_ has remained a subspecialty in the arts, created in large part to show an artist's virtuosity rather than expressing any larger view of the world. It remains a real money-maker, however, for artists with the requisite skills at highly de-tailed painting who are interested in creating murals for hotels, restaurants and private homes or apartments.

Marble effects for plaster or drywalls and clouds-in-the-sky scenes for ceilings are among the most sought-after images, but what is new is a willingness on the part of patrons to allow artists to be artists, that is, to create expressive and imaginative pictures. According to many artists and gallery owners who set up commissions for the painters they represent, customers look for people who are first and foremost artists and also happen to do mural work. These customers want painters who have their own ideas and are willing to take some chances.

"In general, I am brought in by an interior decorator to solve a prob-lem, such as the way an apartment is laid out," said Ted Jacobs, a New York City painter who has done _trompe l'oeil_ murals for 30 years. "There was one apartment I worked in where, when you opened the front door, the first thing you saw was a kitchen sink. The decorator wanted some

way to make it look different, and I was given a lot of latitude."

Jacobs used that latitude for a project at the Copley Plaza Hotel in Boston for which he painted portraits of prominent past and present Bostonians on a mirror at the hotel's bar, as though to suggest that all these great men were fun-loving drinkers.

Back in the early 1950s, Jacobs had tried to solicit this kind of work from decorators and architects, submitting slides and his resume to a number of people, but without much luck. It was only when a decorator saw his easel paintings on display in a gallery that he was asked to take on a mural in someone's apartment. Some artists who do interior murals get started after being discovered by home or apartment dwellers (or decorators) while others are successful in seeking out architects or decorators.

There is no trade association for artists in this field, nor job listings in any art or home decorating publications for those wishing to pursue *trompe l'oeil* as a full-time career or as a sideline activity. Art dealers sometimes arrange commissions and, in fact, customers appear to like the idea that the painter working in their home or apartment may someday have his or her work displayed in a museum.

Nature scenes tend to predominate in this field. Marianne von Zestrow of New York City, for instance, did an African landscape with animals on a Manhattan living room wall, and Everett Molinari, president of the National Society of Mural Painters, has done a variety of birds in trees over the years in the houses of his customers.

Architectural motifs are also quite common, with Greek columns marblized door casings and statuary, "tile" floors or even fake fireplace found in many private homes. Brooklyn painter John Kelley, whose easel pictures frequently contain ancient Greek mythological scenes, uses many of those same images for his *trompe l'oeil* murals in houses and apartments.

"One of my favorite works was a dining room wall that I painted to look like the Aegean Sea, with doric columns on both sides," Kelley said. He added that the move from easel painting to *trompe l'oeil* murals is not such a large leap for realist artists as "all representational painting has a *trompe l'oeil* element to it in that you are giving the illusion of three dimensions."

Of course, not all wall murals need to be *trompe l'oeil* — Stewart and Dena Stewart of Miami Beach, Florida, for example, collaborate on folk art images that recall a rustic colonial living room while not fooling anyone entering the room — but that style tends to be most in demand.

Fees for interior murals vary widely, with most artists charging by the square foot (between $10 and $100, depending on the level of complexity or if any changes are requested), although some painters ask a per diem

fee of, on the average, $250. Prices tend to be higher for office buildings and hotels, which generally have more money to spend on decorations, than for private homeowners or for restaurants and bars. Restaurants and bars often go in and out of business rather quickly and are loath to spend large sums of money at the outset. Fees may also be higher when the painter has to hire assistants, for whom the artist must pay insurance, workmen's compensation and a salary that may reach $150 per day per person, or pay for special equipment. Rates may also vary, depending upon whether the artist paints directly on the wall or onto canvas that is affixed to the wall afterwards.

Travel, meals and accommodations are often billed to the customer separately. Hotels and some homeowners solve the latter problem by putting the artist up.

Art Copies: In 1913, the *Mona Lisa* was recovered, having been stolen for the third and last time two years earlier. Along with the famous painting, however, eight copies were found that had been made to be sold to collectors as the real thing.

Why someone would choose to buy a work of art that could never be sold or even shown to friends is a question for criminologists and psychologists, but the desire to own a notable and much-esteemed picture is well within most people's understanding.

Many collectors who would ordinarily buy original works have been pushed out of the art market because of the very high prices. They can afford more than a poster of a major artist's work but not the work itself, and some of these collectors have chosen to purchase an exact copy, painted by a contemporary artist brushstroke for brushstroke from the original. These copies generally cost between $100 and $15,000, depending upon the size of the picture, the Old Master artist and the work in question and whether or not the picture is "antiqued" and "crackled" to give it a more ancient look.

The art copying field has become a growth area of the art world, with individual artists and companies (representing a stable of artists who do reproductions) offering their services.

"We're currently selling 1,000 paintings per month," Rusty White, president of The Bianco Collection in Atlanta, Georgia, said. "We've sold to Burt Reynolds; we've sold to auction companies; we sell to people who want a beautiful painting but don't want to have to pay $9 million for it."

The Bianco Collection (404-933-0330), which was founded in 1988, works with approximately 100 artists all over the country, most of whom specialize in a particular artist or style, such as Rembrandt or French

Impressionism. To lessen any chance of confusion, each work comes with a certificate indicating that it is a copy and, unless the buyer specifically asks that the work be created to the same size specifications as the original, the copy is done a little smaller.

According to the company's director of marketing, each artist has studied particular Old Masters and will use the same oil paints and canvas as the original artists. The artists making the copies earn half of the retail price which, at Bianco, ranges from $600 to $15,000. She added that the company also has a separate group of artists who make period frames for the reproduction paintings.

It is perfectly legal, as copyright law only protects an artist's image until the time of death plus 50 years. The majority of the most sought-after artists have been dead much longer than that. Because these are copies of well-documented famous paintings, there is little chance that a buyer would successfully attempt to pass them off as originals. They are made as copies and bought with that understanding. "The French Impressionists I would say are our biggest sellers — Monet, Degas, Renoir," White stated. "But there is also a lot of interest in the Western artists — [Frederic] Remington and [Charles M.] Russell."

For most of the artists who do copies, this is not a full-time activity but rather a sideline that supports their more original work. For Man Kim, a South Korean-born painter living in Dallas, Texas, copies of French Impressionist and 17th century Dutch paintings take up about one-tenth of his creative time. Dennis Asayag of Atlanta, who also makes copies of French Impressionist paintings, spends three-quarters of his time on, and makes two-thirds of his income from, his own original paintings. Both artists also sell both their copies and original work through The Bianco Collection as well as privately to collectors.

There are a number of other companies who also call upon a network of artists skilled in copying the work of various renowned artists. Joy's Classic Copies in Long Island, New York (516-288-0729), for instance, offers copies of works by Chagall, Degas, Gauguin, Matisse, Modigliani, Monet, O'Keeffe, Picasso, Renoir and van Gogh. Heritage House in Ft. Lauderdale, Florida (1-800-448-4583) also relies on its stable of artists to create copies of famous paintings by most of these same artists. Retail prices at both companies range from a few hundred to a few thousand dollars per work.

As with portraiture and *trompe l'oeil,* word-of-mouth is a common way of finding assignments, or one can contact the galleries listed above that market works specifically in this vein.

Joe Klimeak of New Milford, New Jersey, on the other hand, is a

painter in no company's stable, making his own creations as well as copies of French Impressionist and other artists' work for people who hear of him through word-of-mouth.

"I sold some [copies] to friends at the job I used to have, and they told people who began calling me up, asking me, 'Can you do this Renoir?' 'Can you do this Monet?'" he said. He currently sells 10 or so copies a year, usually at $1,000 apiece, and the money helps tide him over when his own paintings are not selling well. "There's no glory in it, but there's no glory in not eating either."

Courtroom Art: Sometimes, artists make the news and, sometimes, they draw it. Winslow Homer, George Luks, John Sloan, Everett Shinn and William Glackens all worked for newspapers as illustrators — a profession that was replaced by the photographer — before going on to fine art fame. Some of today's hopeful painters do courtroom drawings for television stations.

Courtroom art is a second career that can pay first career money, between $200 and $400 per assignment (which may be just a one-hour arraignment) and more for cases that run into days or for artists under contract to local TV stations.

It can also be a hectic existence, with long periods off and then rush calls to get down to a court, that may disrupt an artist's concentration. The style of art required, too, may be difficult to reconcile with one's normal studio patterns as courtroom sketches need to be very realistic yet often spatially out of proportion, done quickly without planning or much detail or a sense of "finish."

"There's no warm-up time; it's do or die," said Joan Thompson of South Glastonbury, Connecticut who works for CBS affiliates in Hartford and New Haven. A painter of barroom scenes who has exhibited her work in Hartford and South Glastonbury, she added that "you have to be ready on five minutes notice, and it's best if you don't have kids."

Ruth Pollack, a painter in New York City who began doing courtroom sketches in the mid-1980s, said that "you can't invest a lot of time in any one picture; you never know when something dramatic is going to happen that is far more important than what you were working on."

Because of this, she noted, a courtroom artist must develop a method of working quickly, using whatever medium feels most comfortable (pastels, magic markers and watercolors are the most favored tools) and learn how to compose a picture economically. "Not being a perfectionist is probably the best skill to have," she added.

"You generally have to shrink the space," Pollack stated. "In a real

courtroom, the witness and attorney are quite far away from each other, but you have to put a lot of things close together in the sketch you make. You can't be totally accurate, even while you are describing as truthfully as you can what's going on."

An artist who has "always liked to draw people," she got into this field by knowing "someone who knew someone" — that someone being Christine Cornell, another painter in New York City who has done courtroom work since the late 1970s. This is generally a small field, as local television stations are the main buyers, and they may only call upon one or two artists at any given time and only when there is a newsworthy case in federal court.

A connoisseur of courtroom dramas and people, Cornell noted that she loves courtroom art because she learns "something new every time. You hear things that you never hear anywhere else. Some of that admittedly is very grim stuff, about torture and the real seedy side of life."

Her favorite subjects to draw (she uses pastels) are jurors "who sit patiently listening to testimony, giving me plenty of time to do portraits. It's great, because I like to stare at people."

Most artists who get into courtroom sketching do realist work anyway, often portraiture or something involving the human figure, but the style of work in one's studio and in a court of law are often at a variance. Joan Thompson does her serious painting in watercolor, but uses charcoal and pastels in the courtroom "because I'm afraid I'll spill water and they'll ask me to leave and never come back again. You're supposed to be unobtrusive."

The choice of medium is not the only aesthetic issue for artists working in the courts. While Sharon Falk, a Brooklyn, New York painter currently under contract to a CBS affiliate in Manhattan, noted that "it's good for artists to have to draw every day. A lot of artists lose the ability to draw because they forget to do it every day," Christine Cornell pointed out that her studio work involves oil paint that is applied in "thin, progressive stages. You can't go right in and work on the emotion, as you can in a courtroom setting using pastels, because you have to wait for the paint to dry. I'm often fearful of losing the spontaneity that I need for the courtroom pastels."

As is the case with many other "second careers," courtroom art can interfere with one's studio work to the point of obliterating it.

"When I first started doing courtroom sketches, I was working four or five days a week," Ruth Pollack said. "The pressure was so great that I couldn't even think of doing other work. It's very hard to do serious work in the studio when you never know if the beeper is going to go off. It's

hard to make a committment to painting. It took a lot of years, but now I can think of doing other work."

Another way that courtroom art may impinge on one's career is by making one's off-time so precious that an artist is unlikely to get out of the studio to show work to dealers or potential buyers. "I have no time to market myself," Christine Cornell stated, "and no inclination. Whenever I have a free moment, I tend to go back to the studio." Sharon Falk, who at one time had gallery representation in Arizona and Louisiana, also noted that she is "not selling any work at the present. It's hard to hustle my work on my schedule, and the time that is free I prefer to spend in the studio than in trying to sell my work."

Courtroom sketching is also not a career with a certain future. Television cameras have moved into many lower courts, leaving only federal courts and arraignments available for the artist, depending on the discretion of the judge. Some courtroom artists have already taken on "third careers," as it were, in such fields as book illustration and portraiture. Another generation of Winslow Homers and John Sloans may have to arise from a field that technology has limited and may one day eliminate.

Theater Design: "I think it was around 1962. Rauschenberg was designing a set for the Paul Taylor Dance Company, but Taylor didn't really like it and asked Rauschenberg to make some changes. Rauschenberg said he wouldn't do it, and Taylor was ready to scrap the whole thing but then asked me if I would do the design...."

So began painter Alex Katz's involvement with the performing arts. Actually, it was a little more complicated than this. Paul Taylor had only heard of Katz through Edwin Denby, the poet and dance critic, who had met Katz through a mutual friend, photographer Rudy Burkhardt. Word-of-mouth and personal friendships, however, seem to be key factors in how most artists become involved in theatrical productions in the first place.

Pablo Picasso, it is said, was adversely affected by his contact and collaboration with theatrical productions as his stage sets and costumes for the ballets of Serge Diaghilev and others were a decided retreat from his Cubist tenets. For most other artists, however, the experience has proven favorable in terms of their development and receiving recognition from a new and wider audience.

One needn't belong to a theater union in order to do this sort of work; personal relationships and an involvement with more avant-garde performance groups are more likely to lead to these free-flowing relationships than any specific association.

The relationship of artists and the performing arts has been strong for most of this century, with artists making a range of forays into the theater, from painting backdrops to being the performers themselves. The futurists, dadaists and Surrealists of the first three decades of the 20th century all looked at performance as a way of breaking down categories in art and society, as a way of shaking things up and leading people to question — if nothing else — why artists were making a spectacle of themselves. "Throw an idea instead of potatoes, idiots!" Italian futurist Carlo Carra yelled out to a theater audience that had been deliberately provoked with verbal and physical assaults from the artists/performers on stage.

Their aim was to make the art audience less passive — a basic Modernist principle — and more ripe for action which, for these artists, was the essential element of art itself. Performance art in general looks to provoke first and get people to ask questions later. One surmises that the measure of good and not-so-good performance pieces is the degree to which they inspire both reactions.

Many other artists are happy to be less visible personally while allowing their stage designs to speak for them. Painter Jane Freilicher's set for John Ashbery's 1981 production "The Heroes" included three connecting panel paintings of a landscape with a painted wooded divan and miniature Trojan Horse, suggesting the downfall of proud men. Frequently, artists work interpretively with dramatic material in this way.

Other times, their work is intended to fit within the play's structure. Sculptor Judith Shea's costumes for Edwin Denby's "Four Plays," a play that is difficult to follow as the dialogue is jumbled from one character to another, are quite distinct for each performer. One may not be able to understand what is being said on stage, but at least the costumes help one see who's saying it — clearly, nothing more could be asked of a visual artist than that.

Visual artists have historically befriended, or have collaborated, with artists of other types. Novelist Emile Zola first made his mark as an art critic and defender of Edouard Manet, an appreciation probably based on his long friendship with Paul Cezanne with whom he had grown up. Playwright George Bernard Shaw began his career as a music critic, and Henri de Toulouse-Lautrec haunted nightclubs and theaters — some of his best work was lithographs used as advertising posters for these cabarets. Back in the 17th and 18th centuries in Japan, artists had done much the same thing in creating colored woodprints of renowned actors in their favorite roles as well as scenes from dramatic productions.

Nightlife and dissipation may have hastened Toulouse-Lautrec's death but, artistically, the theater has seldom hurt an artist. Jasper Johns, for

instance, was never any less a painter for his occasional stints as artistic director for the Merce Cunningham Dance Company. Larry Rivers, on the other hand, seems to have bridged two worlds, starting out as a jazz musician before switching to painting.

Knowing someone tends to be most artists' entry into the theater. "A friend of mine, who was actually a neighbor, managed a number of rock groups, and I made clothes for some of the band members," Judith Shea said, adding that other friends of that neighbor who wrote for the theater began asking her to create costumes for their theater productions. After a time, her name began to get around. "More recently, I've been getting calls from people I've never met who just know my costumes. They've never seen my sculpture and are often surprised when I mention that's what I ordinarily do."

Robert Kushner, a painter, also became involved in designing for theater through personal contacts, in this case his wife, Ellen Saltonstall, who has danced in various companies. He made designs for these companies' productions as well as for other choreographers whom he met "through the same circle of people."

Working with theater groups, he noted, "gives an artist the chance to work on a large canvas whose painterly components are characters."

For some artists such as Kushner and Shea, whose artwork tends to resemble fabric design and wearable art, respectively, their involvement with the theater is closely aligned with their artistic aspirations. With others, the theater is more a vacation from art. "It's enjoyable and it's different and it's fun and it's occasional," Larry Rivers said. "It makes you feel refreshed when you go back to painting."

Certainly, not every artist has the temperament or interest in creating designs, costumes or backdrops for performances, and some are plainly bad at it.

"I've been fortunate with the painters I have worked with," Paul Taylor stated. "None of them have used the stage as just a gallery for their works, but that sometimes happens. I was in Paris some years ago and saw a play that Salvador Dali had designed the set for. All it was, though, was a Dali painting with various performers doing things in front of it but having no relation to it. Dali simply used the stage as a way to sign his name to a painting the public would not otherwise pay to see."

Every artist is different to work with, Taylor claimed. Whereas Rauschenberg will come in to look at a finished dance piece and then design a set around it, Alex Katz "often has given me the set first, before I've choreographed the piece. It's a challenge to work around what he has designed."

One example of this was a painting Katz made of soldiers several years ago. "I made this painting just for myself," Katz noted, "and then thought, 'Gee, this would be great for a stage set,' and so I used it in 'Sunset'" — a dance that the Taylor Company premiered.

"Alex brought in this big painting of soldiers, and it effectively chopped off a third of the stage," Taylor said. "I had to choreograph the piece around it, and it worked very well. It's a very painterly idea to limit space and angles. It's one of the reasons I prefer working with artists than with set or costume designers. They try things that the professionals wouldn't normally think of."

In the best collaborations of artists and theater people, the artist's vision is there on stage, not competing for attention but expanding it. Recognition has grown over the years of this unique partnership, and some artists' designs have been saved to be placed in museum collections. These are the sort of things that tend to be lost —the precious object art world and the make-do theater world divide at this point — since it is the habit of the theater to discard or recycle backdrops and costumes.

Chapter 6.

The Materials That Artists Use

As important as it is for artists to know how to create art, their understanding of the physical properties of the materials they use and the durability of the works they make is also important. Collectors, viewers and other artists assume that art should last a long time; pieces that fall apart or lose their color within a few years can greatly damage an artist's reputation.

But beyond consideration of the durability of a work of art, there is another imperative: Artists should have a clear understanding of the materials they are using for quite personal reasons — their own health.

Safe Art Practices in the Studio

Lots of people — the U.S. Government says 63 million in this country — like to work on arts and crafts projects as hobbies. Just close your eyes and imagine a person in every other dwelling in America busy with painting, pottery, weaving and who knows what else.

Unfortunately, part of that vision is also some of these same people poisoning themselves through using inappropriate materials, unaware that many of these products contain extremely toxic substances. Working on arts and crafts projects at home can be a source of both fun and chronic ailments for professional artists, amateurs and, especially, children.

Knowing what's in these products is the first step. The new federal and state "right-to-know" laws have made this much easier for those artists who have art-related jobs, such as in publishing or teaching. Employers of these artists are bound by law to provide ingredient information about the materials they use on the job in the form of special data sheets. These sheets are called Material Safety Data Sheets, and they include the products' manufacturers and distributors.

Self-employed artists may also write to manufacturers for these Material Safety Data Sheets, although in many states the manufacturers and distributors are not required to provide them. Most responsible companies, however, will supply this information.

The data sheets are necessary because art materials labels do not list ingredients. And, until recently, only acute (immediate) hazards had to be listed, such as severe eye damage from splashes in the eyes or poisoning due to the ingestion of small amounts of a product.

In 1988, the federal government enacted a labeling law requiring art supply manufacturers to list chronic (long-term) hazards associated with the product on the label. This enables buyers to make safer choices and, if artists understand the hazards of particular chemicals, they can use the warnings to identify the contents. For example, a yellow material labeled with warnings about cancer and kidney damage is likely to contain a cadmium pigment. A material labeled with warnings about reproductive damage, birth defects, nerve, brain or kidney damage may contain lead. (Unlike ordinary consumer paints, artists' paints are still permitted to contain lead.)

The federal law was clearly needed. Several studies have shown that professional artists have high rates of cancer and other occupational illnesses associated with the products they use.

Among the hazardous substances found in many art materials are arsenic, antimony and chromium (which, when repeatedly inhaled or ingested over many years, cause skin ulcers), cadmium (causes kidney damage), cobalt (affects the lungs), lead (damages the gastrointestinal and neuromuscular systems), manganese (affects the nervous system), mercury and uranium as well as a barrage of toxic solvents. There are also many instances of injury from toxic substance exposure among artists and children resulting from the use of art supplies. Some artists and children are especially at risk because they work at home where exposure is intimate and prolonged.

Michael McCann, an industrial hygienist and director of the nonprofit Center for Safety in the Arts and Crafts in New York City, found in a survey he conducted that a high proportion of professional artists did their work in rooms in their homes where their families lived and ate.

Half of the artists surveyed said that they worked at home, and half of those working at home in living areas. Even more disturbing than that, however, was finding that 40 percent of women artists with children did their work in living areas, presumably because when they had children they lost their art studios.

One finds that there is a strong correlation between parents making

art in living areas and the numerous calls that various local and regional poison control centers receive concerning children swallowing turpentine, pottery glazes or other toxic substances. It is not unusual for an artist-parent to put turpentine or a similar material in a milk container or other food container. Children, believing that there is just milk or something else they like in the container, will start drinking from it.

These data are reinforced by findings from other polls and surveys. There are also individual cases of children who accidentally swallowed turpentine and other toxic art materials. The Centers for Disease Control, in their 1985 report, "Preventing Lead Poisoning in Young Children — United States," specifically mentioned home activities involving lead, such as making stained glass or casting lead objects. Working at home with toxic paints, pastels, ceramic glazes and other materials could be equally hazardous.

Exposure of family members to the toxic effects of art materials can occur in many ways. For example, they can breathe in dusts from pastels or clay as well as vapors from turpentine and paints or inks containing solvents. Dusts and vapors can travel all through the house, and dusts may also be ingested when small amounts drift into kitchen areas, contaminating food.

To combat this kind of exposure, parents are generally advised to segregate their art activities in rooms that have a special outside entrance and that are locked to prevent small children from entering. Work tables and floors should be wet mopped regularly. Ordinary household and shop vacuums ought not to be used since their filters will pass the small toxic dust particles back into the air. Sweeping is even more hazardous, for this will cause dust to become airborne.

Running water should be available in the studio. Floors should be sealed to facilitate easy cleaning, and spills must to be wiped up immediately. Separate clothing and shoes should be worn and left in the studio in order to avoid carrying and tracking contaminants into the house.

Dusts and debris should be disposed of in accordance with local, state and federal disposal laws; one can find out what is required by calling the local sanitation, environmental protection or public works department. These laws vary widely, depending on the type of waste treatment in one's community. Pouring solvents down the drain is against environmental laws everywhere as well as being a danger to the artist and his or her family. Solvents in drains and sewers tend to evaporate, producing flammable vapors in the drain that may cause explosions.

Many communities have a toxic chemical disposal service that will accept waste solvents and other toxic waste created by households and

hobbyists (defined for this purpose as people who do not make money from their work). Professional artists may be required to hire hazardous waste disposal companies to pick up their toxic refuse.

Usually, ordinary waste from consumer art paints and materials can be double bagged and placed in the regular trash. Lead metal scraps, on the other hand, can be recycled. Again, one should call local authorities for advice on disposal of art materials, as the fines for violating the laws can be quite high.

Monona Rossol, an industrial hygienist and president of the nonprofit organization, Arts, Crafts and Theater Safety in New York City, recommends that studios be properly ventilated. The ventilation should be tailored to fit the type of work done in the studio. For example, all kilns need to be vented, and there are several commercial systems that can be purchased for them. More complex equipment may require an engineer to design a proper system.

One simple system she recommends for many individual studios requires windows at opposite ends of the room. The window at one end is filled with an exhaust fan, and at the other it is opened to provide air to replace that which is exhausted by the fan. This system should not be used in studios where dusts are created, although it is acceptable for painting and other arts activities that produce small amounts of solvent vapors.

The hazards associated with certain arts and crafts materials have been a growing area of concern for toxicologists and others. In a number of instances, the connection between the ailment and the materials is discovered posthumously. Doctors have suggested, for instance, that both van Gogh's insanity and Goya's mysterious illness resulted from ingesting lead paints they used, perhaps by "pointing" their paint brushes with their lips or just by both artists' poor hygiene. Dr. Bertram Carnow of the University of Illinois School of Public Health has speculated that the blurry stars and halos around lights in van Gogh's later works may have been caused by a swelling of the artist's optic nerve, which can be attributed to lead poisoning. Eyewitnesses reported that paint and turpentine covered the clothes he wore and the food he eventually ate. The theory about Goya, stemming from the knowledge that he used large amounts of white lead in his paint and occasionally fixed himself a "cocktail" of absinthe and turpentine, goes against the longstanding view of him as either schizophrenic or syphillitic.

Children are considered to be at a much greater risk than adults when using hazardous art materials because they have a higher metabolic rate and are more likely to absorb toxic elements into their bodies. Younger children have incompletely developed body defenses, making them more

susceptible to disease. One victim, 13 year-old Jon Glowacki who died in February, 1985, spent a lot of his free time at home working on arts projects that involved rubber cement. Rubber cement contains a form of hexane that has been known to cause nerve damage and irregular heart-beat, and Glowacki (according to the coroner who performed an autopsy on him) died from inhaling it.

Adult supervision of children's use of art materials is one way to lessen the risks but, according to Monona Rossol, the underlying rule is that "adult art materials are for adults. Children should simply not be using products that haven't been specifically tested to be safe for them. I've seen very young children using airbrushes and spray-painting, which creates a lot of toxic mists. I've seen kids using solvents that give off vapors that are really neuro-toxins — that is, they are narcotic, because they'll do just the same sort of damage."

For instance, adult permanent felt-tip marking pens as well as many oil paint solvents and varnishes contain these kinds of solvents. Most adult acrylic paints contain ammonia (irritates the skin, eyes and lungs) and formaldehyde (irritates the skin, eyes and lungs, causes allergies and is a suspected of being a cancer agent). Dusts from ceramic and sculpture clays contain lung-scarring silica and talc.

Children should use only water-based markers, water-based paints and clays that are low in silica and talc-free. Clays and paints should always be purchased and used premixed to avoid children's exposure to the powder or dust. In addition, all art materials for children should be known to be safe, such as dustless chalks, oil pastels and dyes using vegetable or food coloring.

The Arts and Crafts Materials Institute (715 Boylston Street, Boston, MA 02116, tel. 617-266-6800) has a list of products they have approved for children that includes all these kinds of materials. For additional information, one may contact Arts, Crafts and Theater Safety (181 Thompson Street, #23, New York, NY 10012, tel. 212-777-0062) or the Center for Safety in the Arts (5 Beekman Street, New York, NY 10038, tel. 212-227-6220).

Substitute Ingredients In Artists' Paints

As noted above, federal law has been enacted to require art supply manufacturers to label the potential health risks from ingredients in their paints and other products. That's an answer to the questions — What is in the materials I use? Which known health risks do I face? — but, sometimes, answers don't resolve problems as much as lead to more questions.

What many have discovered in examining the new, more inclusive labels is that some of these supplies contain synthetic and substitute ingredients instead of what they believed they were buying. What painters thought was cadmium in a tube of paint actually, in many cases, was napthol or thioindigold red; similarly, "cobalt blue" didn't contain any cobalt at all but ultramarine (itself now a synthetically produced pigment), phthalocyanine blue or something called Pigment Blue 60. Lemon Yellow is another pigment which, traditionally composed of barium yellow, was found to now be nickel titanate, and alizarine crimson turned out to be an unpronounceable dihydrozyanthroquinone.

What happened to the real stuff?

The fact is, industry officials state, until labeling became a common practice, artists were not aware that the colors they were using might be synthetic. In the past, art supply makers took the position that substitutions were implicit. They said, in effect: "Look what we're charging. No one would think it's real cadmium at that price." Now, there is a different system.

That system, established by the Philadelphia-based American Society of Testing and Materials, is to call pigments "hues" when they contain substitute ingredients but still use the generic designation of, for instance, cadmium red or cobalt blue. Some laboratory-created colors, of course, have long been known as substitute ingredients, among which are pigments marketed under proprietary names, such as Windsor & Newton Red, and a pigment such as Naples Yellow — traditionally formed from lead antimoniate — had to be reformulated when lead was removed from this paint for reasons of safety. The "hues" are a newer phenomenon.

To a significant degree, synthetically produced pigments are a result of permanency and price. Certain colors, such as alizarine crimson or Hooker's Green, are terribly fugitive and tend to fade quickly. The color ingredients used to replace the traditional pigments are said to make these colors much more permanent. The cost of other pigments, such as cadmium and cobalt, for example, has become so high that artists just wouldn't be able to afford them.

High prices for certain materials are due to either scarcity or huge demand (or both). Cadmium, for instance, is used in batteries and for processing diamonds, while cobalt has a role in tempering blades in jet engines as well as in nuclear devices and cobalt therapy. The major sources for cobalt also happen to be the Soviet Union and Zaire, where export is not an inexpensive or simple matter.

Prices for the synthetically produced "hues" are between two-thirds and one-half the cost of the real thing. In one art supply store, the retail price for a small tube of Winsor & Newton Cadmium Red Medium was twice the cost of its Cadmium Red Hue, and Liquitex's Cerulean Blue cost 30 percent more than the Cerulean Blue Hue. The permanency rating for the "hues" is largely the same as the traditional colors they might substitute for — Wendell Upchurch did point out that "ultramarine is not as permanent as cobalt in the 'hue' form" — and the colors will not be identical.

The cadmium red hue and the cobalt blue hue, for instance, shift a bit to the violet, while phthalocyanine sometimes shifts to green. If they choose paints with synthetic ingredients, artists will pay less, but they'll have to be more observant, correcting the color shifts by adding yellow to the cadmium hue and green to the cobalt hue. The hues are not the same, and artists find themselves having to work harder to preserve what they thought they had.

Perhaps, between 20 and 30 percent of all professional artist paints contain synthetic pigments, increasing to perhaps 40 percent for supplies just under artist grade, with almost all student grade paints being substitute ingredients.

The synthetic pigments clearly have benefits and some drawbacks — or, at least, give rise to new battles among art supply manufacturers. The more expensive iron oxides, such as burnt siena, Indian red or yellow and raw umber, are literally dug out of the ground and tend, because of their source, to have impurities. The lab-created pigments, on the other hand, have few impurities and also a higher tinting strength, requiring the addition of inert pigments — such as aluminum hydrate, barium sulphite and calcium carbonate — to tone down the color. The result is that the new generation of paints tend to have less cadmium in cadmium, less cobalt in cobalt, with other ingredients added — such as enhancers or toners — for opacity, body, consistency, brightness, value and to eliminate excess oil. All this requires artists to assume less about the paints they use and to learn more about what goes into their supplies.

This becomes a problem because not all manufacturers of artists' materials label their products in the same way. Part of the system established for labeling by the American Society of Testing and Materials requires manufacturers to list on the product label the enhancers used when they comprise more than two or three percent (by volume) of the material. Not all American companies, however, subscribe to the ASTM standard, and few European suppliers do. The result is that artists may find themselves purchasing what is labeled as pure cadmium but that actually

contains a considerable amount of toner (dye color). It is a concern for which few artists or hobbyists these days are prepared.

"In the old days, artists learned chapter and verse what you can and cannot do with materials," George Stegmeyer, artist consultant to Grumbacher, the paint manufacturer, said. "That aspect of art training has been largely eliminated from our culture, replaced by the intellectual and theoretical aspects of becoming an artist."

As of 1991, only a handful of schools — the school of the Art Institute of Chicago, Boston University, University of Delaware, University of North Carolina at Greensboro, the Pennsylvania Academy of Art and Yale University School of Art among them — offer courses on art materials, instructing students in the composition of the products they use and their durability. Artists, who are accustomed to simply purchasing materials at a store and assuming that everything is basically the same as it always was, find that they have more information (through the product labels) but not necessarily the ability to understand it.

Permanence and price are not the only factors that have led to the use of synthetic pigments, according to various people concerned with art materials. "I think the health concerns about some of the heavy metals have definitely resulted in, or at least accelerated, the use of substitutions," Michael McCann stated. "You have cadmium and the cancer question, and then there's cobalt and manganese. Companies now have to put warning labels with them. It's better to try to find a substitute, and they get to save money at the same time."

There's probably no return to 19th century paints, and few artists would want it even if it were possible. Today's materials are purer, more affordable and permanent, more buttery in texture, less damaging to one's health and available in a far wider range of colors. Still, synthetic substitutes are not the same as the original pigments, and artists can be a traditional bunch. Barium, for instance, is often used with cadmium, screening out ultraviolet light and thereby making the color more permanent but also reducing the tinting strength. The victory for permanence is potentially pyrrhic. New concerns about what they are using are the price artists must pay for progress.

Experimenting with Materials

Knowing what is in the materials artists use is half the battle; the other half is knowing how to use these materials properly so they hold up over time. Aubrey Beardsley commented somewhere that "a painting starts to disintegrate as soon as the artist puts his brush down," but some works

last far longer than others. The work of an unknown and forgotten artist often languishes in the attic, subject to extremes of heat and cold, and neglect is the major scourge of art collections. Paintings of greater esteem and value are accorded more and better care but, still, some works are born trouble.

Early in his career, Spanish artist Antonio Tapies loaded up his oil paints with sand and other gritty material to give his paintings a sculptural quality on the canvas. A nice idea, except the canvas couldn't support all the weight, and the medium simply fell off time and again. As one of Tapies' former dealers noted, "it would just fall on the floor. You would sweep it up with a broom and send it back to Tapies who would put it back together again."

The maintenance problems of most contemporary artworks are not as extreme, but there is cause for some alarm. Much of the most important art created since the end of the World War II involves extensive experimentation, not only with style but with media. The whole concept of "action painting" (as abstract expressionism was labeled by critic Harold Rosenberg) was to get something down quickly, without undue concern for a finished job. In contrast, Picasso and Kandinsky both broke artistic ground by moving away from identifiable imagery, but their techniques were basically traditional.

The artists of the New York School of the 1940s and '50s, on the other hand, eliminated all recognizable images from their works and heightened the emotional effect by mixing in various materials with their paints — dirt, metals, sand, wax and more. If that was not enough, artists such as Mexican muralist David Alfaro Siqueiros and French cubist Fernand Leger both did paintings on burlap. Chagall made designs on bed sheets and Franz Kline, perennially short on cash, used house paints and occasionally worked on celatex board — a low-grade paper pulp. Their intention was to achieve different textures and effects without regard, it seems safe to say, for future conservation. With these artists and their followers, the surface of a painting became an integral part of the overall aesthetic statement, and there the problems began.

The introduction of new materials, the admixture of materials and a fair amount of experimentation by artists have made many new movements in the arts possible, but the works of art have been frequently enfeebled as a result. Many works have what art conservators call an "inherent vice" — something that will make them come apart.

Acrylic paints were first introduced in Mexico in the 1940s, finding their way into the United States in 1953. The durability of acrylics has been widely debated since then.

Acrylics are actually pigments suspended in an emulsion of water and acrylic polymer (or plastic). The drying process is considerably faster than with oils, permitting artists to work more quickly and with a lighter material. Joy Turner Luke, a technical committee member of the American Society of Testing Materials, noted that "acrylics may not deteriorate as much as oils. There are chemical changes that go on for some time with oils but, with acrylics, these changes are over right away. Oils embrittle as they get older and often darken or get yellow. The canvas itself absorbs moisture and, as it dries, it moves a little. That movement can create cracking in an oil painting. Acrylics, on the other hand, keep their color and are able to 'breathe' much better and remain flexible longer."

The chemical changes that take place with oils are a process of oxidation, which may last 60 or 70 years. Over time, oil paints become stronger, less soluble, and possibly darker as the linseed oil (which is their base) may cause the picture's colors to darken to a degree.

It is probably impossible to determine how much longer than oils acrylics could remain flexible, since oils have been around for centuries and acrylics have only been with us 40 or 50 years. Luke's faith in acrylics is based on industry-held accelerated aging tests in which paints are exposed to high heat in coordination with high humidity and high ultraviolet light for periods of time. It's almost the definition of an educated guess.

Others in the conservation field are not as convinced about the long-term durability of acrylics, claiming that they don't dry as hard as oils and, thereby, are more difficult to clean. They can also freeze in sub-zero temperatures and shatter like glass. In addition, acrylics are sometimes found to powder on the surface of the picture.

The cleaning problem is a serious one for conservators. Lucy Belolli, a conservator at the Metropolitan Museum of Art in New York City, stated that acrylics "naturally draw in more dirt than oils" and are harder to clean since "they are soluble in certain cleaning solvents, which can affect the paint. It's true even with synthetic solvents."

Belolli added that applying varnish, which protects the outermost portion of a painting, becomes an ethical question with acrylics since, unlike oils, it is almost impossible to remove varnish from many acrylics. "It's a life decision you are making," she said.

Another potential problem with acrylics is their sensitivity to heat and cold. However, for most conservators, the issue is not so much oils versus acrylics; rather, it is the admixtures of media and materials that were improperly used. A large number of Andrew Wyeth's paintings developed considerable flaking, for instance, because the artist made mistakes mix-

ing gesso and egg tempera. There have also been many problems with paintings by Willem de Kooning because of the artist's mixing of safflower oil and other materials with his paints. De Kooning wanted to make his medium buttery and sensuous — a perfectly acceptable intention — but that does make it difficult for the paint layer to dry.

Other problematic admixtures involve oil and acrylic paints, which generally don't bond well, and even successive coats of acrylic paints if too much time elapses between one and the other. There are different rates of drying — or contracting movement between successive coatings — and this inhibits bonding as does any dirt that may attach itself to an under-coat. When a canvas is not (or is improperly) primed, the result can also be troublesome. When this chemical bonding is not adequately taking place, flaking may result and, later, surface cracking.

Artists, of course, are not chemists and they often are not knowledge-able about the chemical properties of the materials with which they are experimenting. (In addition, many artists do not see themselves as creat-ing works for posterity — this was certainly part of the aesthetic of graf-fiti art — as posterity is more a concern of the marketplace than the stu-dio.) They should, however, make their own tests as well as consult with a museum conservator about the kinds of experiments that they are per-forming. Artists need to balance their desires to experiment with their medium with the interests of their collectors who expect to have the art-ists' works in good condition for a long period of time. As the issue of artists' "moral rights" becomes an increasingly understood legal principle around the country — protecting an artist's work from alteration and mutilation — the potential for long, drawn-out court battles between artists and conservators (who are attempting to put their works back to-gether again) looms large.

A Case in Point—Watercolors: You can blame the artist who creates it, or the collector who puts it on display, but the real culprit is the wa-tercolor painting itself. Watercolors just don't have long life spans in com-parison with oil paintings or sculpture. The colors fade, the paper rots or gets eaten by insects.

Over the long run, the collector — the person with the responsibil-ity to properly mat, frame, store and display the work — is usually the one at fault. Still, artists can do a great deal to create pieces that are not likely to deteriorate soon after leaving the studio.

First, they can purchase and use the most durable, high-quality ma-terials available. For instance, their paints should optimally be made of

mineral pigments, which hold their color longer (as they are chemically inactive) than those created from vegetable dyes. However, mineral paints are not available in every color — they tend to be darker earth tones — and artists will likely have to use vegetable dyes.

Certain paint manufacturers, such as Windsor & Newton and Rembrandt, provide permanency ratings for their products, listing them as A (absolutely permanent), B (mostly permanent), C (utilitarian) and D (absolutely evanescent). An artist can also test the paints' durability by applying paint to paper, cutting the paper in half and putting one part in a window with a southern exposure for a few weeks or months and the other part in dark drawer. At the end of the test period, the degree of fading should be evident. Another aid to permanence is using the same brand of watercolors for any given piece, since manufacturers create their own chemical balances which vary from one company to another.

No less important than the paint is the paper, which is made from wood pulp, cotton, linen or some combination of these. Just as with paints, paper should be tested, using the window-and-drawer method or even baking it in an oven to age it artifically.

Another simple test is to run a wet brush over a piece of paper to see how much it buckles. A very heavy paper won't react as much as lighter paper to changes in the environment. One may also look to a heavy paper — 140 pounds and up — when using a very thick watercolor, which tends to crack with the movement of the paper. Heavy paper is also a good choice when the work is moved a lot.

The main signs of trouble with an artist's paper are discoloration or overall darkening as well as embrittlement, which are often the result of acids in the paper breaking down the cellulose polymers that hold the paper fibers together and make them flexible.

There are various ways in which acidity becomes a part, or can attack, paper. Unrefined wood pulp is high in acidity and will cause yellowing in a short period of time (most newspapers are 80 percent unrefined wood pulp). Other internal problems that may damage the paper are chlorine from the bleach that wasn't completely rinsed out of the paper when it was washed. Sizing agents, which are used to give paper its absorbency and surface character, can leave behind metallic (that rust) or organic (that form fungus) particles and brighteners (that make the paper look very white) that may also leave chemical compounds behind.

Air pollution (acidic gases) is another cause of paper deterioration, as is contact with poor quality framing and matting materials (acids in these discolor the paper where they come into contact). Of course, spills of coffee, oil, tea or water may also lead to deterioraton and staining. It is

advisable for artists to maintain a clean workplace and for collectors to protect pieces from young children or their own clumsiness.

Leslie Paisley, paper conservator at the Williamstown Regional Conservation Laboratory in Massachusetts, recommended that artists "store their paper in a dark, acid-free environment; they should never leave their paper outdoors. I've seen instances of artists buying very good paper but, by the time they're ready to use it, the paper is all discolored from having absorbed too many acids from the environment."

She added that another way artists inadvertently damage their own paper is soaking it in tap water — a traditional technique that makes the paper more flexible so that it can be taped down on a drawing board. Distilled water should be used and the water ought to be changed daily. Water from a household tap may contain acidic minerals that will stain the paper or cause fungus. The same is true for water used to moisten the colors on the artist's palette or for a sponge that is used to keep the paper or the brush wet.

Other dangers for all works on paper are insects and rodents which like to eat them. As insecticides may damage the paper, conservators generally advise collectors to store works on paper away from places to which these pests can gain access.

The remaining problems that may affect watercolors — overexposure, poor quality matting and framing, heat, light and humidity — are often controlled by collectors rather than artists, but they still are important concerns for watercolorists who frame and display their own work. In addition, artists may want to advise collectors on proper handling techniques.

"If you want to live with your artwork, there are certain precautions to take," said Margaret Holben Ellis, consulting conservator at the Metropolitan Museum of Art in New York City. "The artwork needs to be placed in a dimly lit room. That means, close the shades or drapes in the morning or when you take a vacation. That means, rotate the work from an outside to an inside room every so often. Ideally, the work should not be on display any more than three months a year — that's what museums do — but, if you don't plan to take the work down periodically, the room shouldn't be flooded with a lot of bright light."

Daylight is the major scourge of art, emitting damaging ultraviolet rays, but fluorescent lights also give off ultraviolet rays. Regular light bulbs, or incandescent light, are the least harmful as they largely emit heat that is easily diffused in a room.

The galleries in museums devoted to works on paper are usually lit to scientific measures of between five and eight "foot candles." To deter-

mine whether one's own rooms are brighter than that, one can use a light meter, which many professional photographers use. Setting the ASA scale to 100 and the f-stop at 5.6, the indicated shutter speed will be equal to the number of foot candles. If that number exceeds eight, the room should be dimmed or the artwork moved elsewhere.

In addition, room temperature should be maintained between 60 and 75 degrees Farenheit and the relative humidity (which can be measured with a hygrometer, a device carried by certain hardware stores and costing as little as $25) between 45 and 55 percent. In that humidity range, mold cannot propagate.

All mats and backing, which provide physical support to the work, should be acid-free. Cotton rag board, buffered rag board and conservation board are all terms for these cardboard supports that are pH neutral or slightly alkaline in order to protect the watercolor from external acidity. A wood pulp mat, on the other hand, would damage the paper.

The backing itself should be thick, to protect against accidental puncture, while the matting (an internal frame, composed of acid-free paper or rag board with a carved-out center) should be deep enough to provide a layer of air between the work itself and the glass on the frame. Condensation on the glass may result in mold growth if the paper and glass touch (and adhere). That touching may take place if the paper buckles due to changes in humidity, even when the work is correctly matted. To prevent this from happening, conservators often suggest double matting the picture to increase the space between the paper and the glass. They also recommend that glass be an acrylic plexiglas, which reduces harmful ultraviolet rays.

Various companies around the country produce archival, or tested acid-free, materials and will supply catalogues of what they offer. Artists should contact a local museum conservator (they don't mind being asked) who can recommend the name and address of companies with which he or she has worked. It is wise for artists to understand how to protect their own works and, when discussing them with current or potential buyers, to note basic points of conservation that will keep the art looking new as long as possible. Art dealers almost never bring up such matters, fearing that the mention of artwork fading or needing special attention will turn off collectors. What is more likely, however, is that collectors whose works on paper turn yellow or fade will be reluctant to purchase more works from the artist again.

Conservators would not have their hands so filled with art requiring extensive repair if artists used archival materials to begin with. Franz Kline, for instance, painted on the Yellow Pages, and Jackson Pollock occasion-

ally used shirt cardboard. They probably did not expect these pictures to last for the ages, but collectors, who spend large amounts of money for works by these artists, do. It behooves both the artist and the collector, therefore, to proceed with greater care.

"There are a lot of masterpieces out there that weren't created archivally," Margaret Ellis said. "Think of Picasso's collages. If Picasso had called up a conservator and said, 'What do you think of sticking some cut-out newsprint on a piece of paper?' the conservator would have died."

Chapter 7.

Getting Ready to Handle the Pressures

The life of a visual artist is frequently one of continual pressure and tension. Like lawyers, doctors and other highly skilled professionals, they must live solely by their wits; yet, unlike these professionals, there are no prescriptions or standard rules on which they may rely — artists must forever chart their own paths, both artistically and career-wise.

The best art tends to be a "catharsis" (to use Aristotle's definition), a spiritual renewal, and it is often a wonder that it can be created at all. Artists are pulled by many conflicting needs. On the one hand, they are creating an intense moment — the art itself — yet their intensity is disrupted by the need to do some kind of work, often unrelated to their skills as artists, in order to survive. They may receive no recognition throughout their entire careers, but they must maintain their personal identity as artists and not let bitterness interfere with their ability to work.

They live always with the knowledge that many are called and few chosen; they suffer the agony of self-reliance as their subject matter, especially for those whose realm is nonobjective art, must come full-blown out of their own imagination. They take chances and risk public ridicule; they often feel guilty about "selling out." Small wonder, then, that so many artists seek psychological counseling.

Learning how to handle the pressures of creating art or of being an artist is something each creator must do for him- or herself. When painter Philip Guston wanted to obliterate all the art history he had filling his mind and forget what other artists were doing in order to ready himself for something new, he would take in a double feature.

"I generally clean the house a few times, go shopping," painter/sculptor Lucas Samaras said about his own method, "all sorts of stuff to wipe my consciousness clean of what everyone else is doing."

Other artists have been more self-destructive when responding to pressures, often with the view that such behavior enhanced their art. Alexander Calder overate; Pablo Picasso vented his anger on women; Jackson Pollock and Franz Kline both got drunk; Jean-Michel Basquiat took drugs. Some artists, such as Mark Rothko and Vincent van Gogh, simply found the pressures on their lives too great to be borne.

Some ways of handling talent and artistic pressures are clearly preferable to others. Unfortunately, stories about self-destructive artists have given the world an image of what an artist is and does, and many younger artists seek to live up to the bohemian image. The likelihood, however, is that this leads to more ruined lives than to more good art.

In *The Thirsty Muse,* literary historian Tom Dardis wrote about "what a number of...great talents have sought in [alcohol and] drugs: an altered state of consciousness that permits the artists a freedom they don't believe they possess in sobriety. The fact that this freedom is illusory is beside the point; many artists have convinced themselves that they obtain it in no other way."

Clearly, it is important for artists to know what some of the potential pressures are in order that they may be prepared.

Changing One's Style

During the winter of 1906 and 1907, Pablo Picasso painted *Les Demoiselles d'Avignon,* a work that was a breakthrough for both figurative and cubist art. Drawing on African influences and defying Western art's tradition of visual perspective, Picasso developed a style that appears to present a clumsy relationship between parts but that actually creates its own more personal order.

For 30 years after its creation, however, the *Demoiselles* was almost more legendary than real as few people had actually seen it, although more had heard of it. Having received some initial criticism and fearing that people would not understand the painting, Picasso turned the canvas to the wall and only the few who came to his Paris studio — artists and dealers, mostly — ever saw it until its first public exhibition at the Petit Palais gallery in Paris in 1937.

Most artists won't wait 30 years before showing their developing art but, if their work is well-known and they change their style, they may easily understand Picasso's reluctance to exhibit the *Demoiselles.*

Style has become all-important to an art market where investments, high prices and the desire by dealers and collectors to "package" an artist in a particular mode or school have been paramount. Up and coming

artists are given major media attention early — Frank Stella was only 34 when the Museum of Modern Art in New York City held its 1970 retrospective of his work — and less time is permitted for an artist to develop and formulate ideas.

How an artist changes his or her style and to what degree are questions as significant to buyers and sellers of art as the specific content or formal qualities of a work.

Most artists see changes in style as part of an evolution and not as a radical departure, with the change reflected in the form works take but not in their basic meaning. Pressures to change or not to change come from a variety of sources, including friends and peers, critics, collectors, dealers and, of course, from within the artists themselves.

One of the most notable examples of an artist leaving a successful style to work in a different manner is painter Philip Guston, who died in 1980 at the age of 66. Originally a social realist, heavily influenced by Mexican revolutionary painters David Siqueiros and Diego Rivera (who himself started out as an orthodox cubist painter in Paris), Guston switched to an abstract expressionist style in the 1950s. Lauded for this abstract work by critics, collectors and peers, he shocked many when in 1970 he returned to the more figurative, social realist style of his youth.

No works sold from his 1970 show at the Marlborough Gallery in New York City and the gallery quickly dropped him from its roster. Some fellow artists were quick to register their disgust with Guston, capped by a *New York Times* review of the exhibit that concluded, "In offering us his new style of cartoon anecdotage, Mr. Guston is appealing to a taste for something funky, clumsy and demotic. We are asked to take seriously his new persona as an urban primitive, and this is asking too much."

Guston himself was "uncertain about his own works and somewhat fearful to show them," according to his dealer, David McKee. "He was worried about what people thought as no one knew what to expect."

McKee noted that Guston needed "more nourishment from his own work than abstraction allowed" and looked to bridge the separation of art from social realities for his own survival as a painter and for the survival of painting as a serious activity.

Guston's two dramatic changes in style were not, however, complete breaks in the entire body of his work. There are clear similarities in the palettes for the various phases of his work, and he was always searching to revitalize painting. The differences, however, were what got pointed out, drawing the sharpest criticism.

Guston was deeply affected by the negative response of many of his peers and was quite grateful that his friend of many years, fellow painter

Willem de Kooning (who himself went back and forth between total abstraction and elements of figuration), liked his work, assuring him in the midst of the storm that "this is all about freedom."

Freedom is an essential ingredient of the best work, but many artists claim that their freedom is limited by outside forces influencing how they change their style and in what direction. Artists tend to point the finger at dealers.

"When you are talking about art as a commodity, dealers are mainly selling a look," stated Sol Lewitt, whose own art has gone from painting to minimalist pieces to "wall drawings." "If you change your look, dealers have to resell the artist all over again. This is all about product recognition."

"Changing a style really means changing an audience," painter Alex Katz said. "If an artist has a small audience, changing a style is no problem. If he has a large audience, then many people become upset. Dealers are in the commodity business and generally are concerned with keeping the same look year after year."

The ways in which dealers may put pressure on an artist are usually quite subtle. Regular exhibitions may not materialize, for instance, or dealers may relay criticism from "potential collectors." The result is that many artists are pushed to do the same work again and again.

Sol Lewitt noted that dealers will say to him about his newer work, " 'I like it, but I really like the work you were doing from 1967 to 1974' or something like that. What I usually tell them is, 'You'll get used to it.' "

For other artists, the greatest pressures come from peers. Artists often feel that the only other people who know anything about art are other artists. Philip Guston was far more hurt by the unfavorable reaction of his peers than by critics or collectors, and he responded with anger and rejection. In general, however, artists criticize each other in the form of silence.

Sculptor George Segal stated that his artist friends are his toughest audience and that they have gotten the most upset over every change he has made in his work over the years.

Renowned for his white plaster cast sculptures of human figures in common outdoor urban settings, Segal said that "when I began introducing color a number of years ago, friends said, 'Don't give up white!' They complained that I was changing their idea of what my sculpture was."

He added that "if you have the nerve to withstand criticism from close friends, you can stand it from anyone."

At times, collectors, dealers and critics may react quite sharply to changes in an artist's work, as though aiming to confine that person to a single style. Guston's work from all his periods now sells quite well, and many or his paintings hang in museums around the country, but the

negative *New York Times* review of the 1970 show greatly affected sales at the time.

Clement Greenberg is often cited by artists and dealers as the archetypal critic-strongman, emphatically promoting a certain style of work and scorning all others. Willem de Kooning claimed that he once threw Greenberg out of his studio after the critic pointed at various canvases, saying "You can't do that. You can't do that."

For his part, Greenberg stated that the influence of dealers and critics has been greatly overplayed in discussions of what artists do. Noting that nobody now worries about what critics said about Matisse or Courbet, he said that the pressures that "make artists do less than their best" come from within. These include being afraid of having their work look different than it has in the past because it will sell less, "or it may just be a fear of their own originality. Artists will change anyhow. I've never known an artist who works dishonestly."

Art collectors are no less a part of the equation, and may also react favorably or unfavorably to changes in an artist's style. Many dealers, aware that collectors frequently lag behind artists in terms of style changes, promote prints in the styles with which these buyers are more familiar, allowing their artists time to evolve.

Most artists have made some significant changes in their art at some time in their careers, although few do so when their careers have reached a pinnacle. Of course, there are some exceptions. Picasso had half a dozen distinct "periods" and de Kooning shocked many when, for a time in the 1950s, he left behind his totally abstract pictures to do his "Women" series. The look of Frank Stella's painting also changed radically in the 1970s, losing its flat linear appearance and becoming more gestural and three-dimensional. However, all three artists were well enough established that their careers did not suffer and, in fact, were enhanced by the changes and evolution in their work.

Unless there is some movement in an artist's career, his or her work will tend to fall into a decorative vein or just be repetitive. Even though art is usually seen as a calling for the very sensitive, it is not a profession for the thin-skinned. Artists whose work suffers because they have succumbed to the demands of market, or who cringe from possible criticism and never experiment, have no one to blame but themselves.

Criticism

"That's part of the game." "It just makes me laugh." "I don't care what they say as long as they spell my name right." Artists, especially those who have achieved some recognition, tend to shrug off negative reviews of their work

and stress the importance of concentrating on one's own art. However, not far below the surface, anger at some art critic or critics in general lies waiting to be tapped.

"One reviewer said about my work, and I'm paraphrasing, Is this art? Why did someone go to the bother to make this thing?" sculptor Donna Dennis said. "Another time, a critic with a Marxist point of view said that the scale of my work suggested the upper classes looking down on poor people. My problem with art critics is that they often have a set point of view to which they want your work to conform, and they refuse to open their minds to see where you're coming from."

Painter Leon Golub noted that negative reviews "irritate and, sometimes, depress me," while Larry Rivers, another painter, stated that he "can be stung by something I've read about my work. I remember what was said, but I try not to let it weigh on me." When she has become angry or depressed by a review that seems "nasty or personal," sculptor Marisol has gone to the lengths of sending the critic "a letter insulting him, in order to get even." Clearly, success doesn't make an artist's anger or insecurities go away when a review is unfavorable.

In fact, success seems to raise the stakes concerning write-ups — favorable or otherwise. Robert Longo, a painter in New York City, stated that negative reviews are "harder to deal with now than in the past" as "the quality of my work demands a certain kind of attention, which is greater than when I first started out." Donna Dennis also noted that "a poor review affects me financially now whereas, when I first started out, it only hurt my feelings."

Coping with criticism, both adverse and positive, is one of the most difficult tasks for any artist. Is there any truth in what someone else is saying? Does a negative review mean that the work is bad? Do misinterpretations by a critic suggest that the work isn't communicating clearly with the public? Should one just write off all art criticism as, in the words of painter Jules Olitski, "the lowest, most scurrilous area for writers to go into"?

To a certain degree, reviews and criticism serve different purposes for the writer (of the review) and for the artist (whose work is being reviewed). Critics generally like to establish their own presence in a review — as judge of art or of the ideas conveyed in the art or even to make sweeping statements about trends in art — while artists first and foremost see the write-up as a public acknowledgement of their presence in the art world. Being reviewed in a newspaper makes one's show an event, something that readers may want to attend regardless of the content of the review, which tends to be forgotten sooner than the fact of the exhibition. A picture of one's

work next to the review has a lot longer staying power in a reader's mind than the words describing the piece, which is why press photographs are deemed so essential. "I don't care what they say about me since people don't usually read it," painter James Rosenquist said, "but they may look at the picture and remember that."

The critic then, at his or her most basic level, is a conduit for information, telling the public that such-and-such artists exist and their artwork may be seen at such-and-such a place. At a more gratifying level to the artist particularly, the mere existence of a review indicates that the artist is being taken seriously as a professional, which may take the edge off the sting of any negative commentary.

In general, art critics have very little influence with collectors over the long run, and most critics have a short and shallow presence in the public's consciousness even during their moment. Any reviewer or critic who has ever knocked an artist's work in an exhibition is reminded that "The critics hated the Impressionists, too!" And it's true. Many of the critics in Paris in the 1860s and '70s failed miserably, labeling as "lunatic" and "imbecile" the work of the best artists of the day. But who were these critics and how important, ultimately, were they? Their names have long been forgotten, their criticism recalled only to point up how wrong they were and, implicitly, how powerless their condemnation really was.

Some critics may gain a certain footnote longevity resulting from a memorable coinage — such as Louis Leroy's "Impressionism," Louis Vauxcelles' "Fauve" and "Cubism," Roger Fry's "Post-Impressionism," Robert Coates' "Abstract Expressionism" or Lawrence Alloway's "Pop Art" — but most critics are forgotten long before they are dead.

There may be a great temptation for artists to respond to misinformation in a review, a problem artists complain of frequently. Environmental artist Christo noted that the titles of his work are frequently misspelled as are his and his wife's names, and facts such as his nationality (Bulgarian) are often incorrect. "Some critics wrote that I am Czechoslavakian," he said. "One person wrote that I was born in Belgium." Donna Dennis pointed out that the scale of her work doesn't reflect class differences (as the Marxist critic had written) but "the scale of my own body, which a feminist critic would have understood." Most artists, however, see reasons to check the impulse to respond.

"I never respond to criticism, even when I thought that facts needed to be corrected," Jules Olitski stated. "It's unseemly, demeaning and gives the critic too much importance. I compose the letter in my mind but never send it."

Beyond the questions of the critic's value in making public mention

of the artist and whether an artist should respond to potential misinterpretations, is the deeper issue of whether or not criticism resonates as true. Larry Rivers suggested that criticism may prove most valuable and constructive when it parallels one's own private doubts and concerns. Criticism, whether favorable or otherwise, is often able to present ideas and provoke discussion.

"Criticism has expanded my vision when the person has tried to make an intelligible and intelligent statement," Leon Golub said. "It's like a goad, a provocation thrown at you, and it energizes me and my work. Sometimes, I respond to criticism through my work."

Not all criticism is unfavorable, of course, and in fact most is quite positive. The artist may be met with considerable praise, which certainly makes the artist feel good but also may involve a pitfall or two. One can start believing in one's own touted "genius" too much, interfering with one's ability to work boldly.

"Artists who have been pushed around a little should know not to let praise go to their heads," Golub stated. "Sure, I'm happy when I get praise, and I get depressed when something negative comes out. If you let it go to your head, you're a schmuck; if you let it stop you from working, you're self-destructive. You can't let either praise or damnation take over."

Artists may be able to hear criticism from critics, from friends, peers, family members or, perhaps, from no one. Some people respond to criticism in certain ways, regardless of whether they are artists or shoemakers, but the real issue is how confident the artist is in his or her own work.

Criticism can come too early and too hard for some artists, and James Rosenquist recommends that artists hold off displaying their work until they feel secure in what they have made — secure enough to make it public and let it go off into the world. Once a work of art leaves the studio, it no longer belongs exclusively to the artist; rather, it belongs to the world. It is liked and understood (or disliked and misunderstood) according to the tastes and knowledge of the people who see it, and the artist becomes just one more person in this chain. Sometimes, criticism opens an artist's eyes to facets of the work that he or she hadn't before realized. The artist must learn to step back, watch the processes of the art world, pick up what good can be gleaned and go on to the next creation.

Choosing an Art Form

"Yes, but is it art?" is a question that can give people who call themselves artists many sleepless nights. It is a question but also a kind of judgement on artwork that veers from the already-seen. It seems to become more

difficult every year to clarify what art is and isn't but, still, most people tend to cling to some concept or other. To a degree, theories of art become a part of the problem for artists because the intent of these theories is to exclude.

Among the pressures fine artists may have to withstand during their careers are finding their work slighted as not being "high" art or not really art at all.

Computer Art, Holography, Xerography: Take, for example, borderline media that people are unsure how to classify. At present, there are at least three. Computer art has "art" as its second name, but it is not clear that many people believe it. Computer art imagery is rarely ever seen in a museum or art gallery but is almost exclusively contained on the pages of computer trade magazines and specialty art journals. Holography has been used by some people to represent three-dimensional moving images of human figures or abstract shapes but, outside of supermarket scanners or the reflecting area of one's credit card, few people ever have any association with it — again, almost no museums or art galleries represent it. Xerography may be another example. It has been deemed a legitimate art process by the Print Council of America, but what is that? and what does that mean?

A growing number of artists are using computers to some extent, the most notable being realist painter Philip Pearlstein who has made life studies on a computer terminal. More and more art schools are also bringing in sophisticated computer equipment and softwear for their students and, in some cases, requiring them to take courses with these machines.

Whether these courses eventually result in widespread use of computers to create works of art or simply help students find work after graduation in the computer field will be decided in time. At present, however, few artists are able to earn any money from the sale of images generated on a computer.

"I tried taking some of my still images to a number of galleries, but most dealers didn't want to touch the stuff," one artist, who works in both the fine and applied arts, said. "It's so easily reproducible, once you've punched in all the data, and art galleries want works that are unique. They saw no real sales value."

There are probably even fewer artists working with holographic technology, and few artists use it as their primary medium although a few have tried it out (Salvador Dali, for instance, made a "hologram" in the early 1970s). Holography is three-dimensional laser photography that records the full volume of an object, as opposed to just one or two sides of it as

with a traditional camera. Because of this, the image never appears flat and, in fact, seems to move and change as the viewer walks around it.

Holography was invented as a theory in 1947 by a Hungarian physicist, Dr. Denis Gabor, who stumbled upon this use of laser photography while attempting to improve the electron microscope. Because laser beams did not become commercially available until 1960, it was not until 1962 that any scientists sought to apply Dr. Gabor's theories to a practical instrument — since then, laser photography has been largely used for scientific and medical research. One may see holograms either in special multi-media exhibitions or at the Museum of Holography in New York. The museum, founded in 1976, publishes a magazine on laser photography and offers lectures on this still somewhat obscure art form as well as selling holographs in a variety of sizes at a wide price range.

Xerography, the use of copying machines in artmaking, has a small group of collectors and practitioners, with prices that reflect more the cost of operating a copying machine than keeping body and soul together for an artist. The medium exists somewhere between printmaking and photography, using copiers to reproduce images in a fast, grainy, frequently distorted way. The novelty of xerography is that it is a reproduction medium being used to create original works of art, blurring the distinction between the two. As with computer art and holography, the number of places where one can see these works are few. Dealers aren't taking chances with them, thereby limiting the possibility of collectors purchasing them, and museums have little incentive to experiment with them if collectors and dealers won't.

Most offbeat media that enter the mainstream art world do so either on the strength of noted artists making them — for instance, Picasso and Braque and collage — or by a sizeable number of artists becoming involved with them, as in the case of fiber art. Photography and graffiti art have become part of museum collections where they had in the past been viewed as, respectively, mere craft and urban blight. Rubber stamp art and mail art, however, for which there was a passing fancy among some artists in the late 1970s, seem to have died out. Like hula hoops, the fad came and went, leaving no monuments.

When it was first installed, many St. Louis residents sneered at the Golden Arch (which has since become that city's symbol) but, these days, locals point to it with pride. It wasn't because a swarm of art critics and architectural historians descended on the city to explain and defend Eero Saarinen's creation that so changed many people's minds. People just got used to it. The clock does a better job of defending art than art critics, as time has a way of opening closed minds. So it may be with experimental

forms of art. New technology often leads to new art media, but their general acceptance as valid art may take a while, providing yet more uncertainty in an artist's life.

Artists Tapestries: There are other hybrids that make potential collectors scratch their heads. One is artists tapestries, which combine an artist's image with a weaver's skill. Just as with computer art, holography and xerography, it looks like art, has an artist's signature on it, but is almost never sold in an art gallery.

Many of the biggest names in the art world over the past 40 years (including Milton Avery, Helen Frankenthaler, David Hockney, Hans Hofmann, Alex Katz, Willem de Kooning, Roy Lichteinstein, Saul Steinberg, Frank Stella and Andy Warhol) have authorized tapestries, selling at prices of between $3,000 and $26,000. The price varies with both the prestige of the artist and that of the weaver. The particular weaver may effect the price most, as artists tapestries created by the renowned Aubusson textile factory in the South of France are generally considered of higher caliber than those made by either Navaho Indians or weavers in Hong Kong. As with art prints, artists tapestries are almost always done in editions, usually between six and 20.

They are certainly not easy to find, however, as the same galleries that represent the paintings of Milton Avery, Helen Frankenthaler, David Hockney, Hans Hofmann, Alex Katz, Willem de Kooning, Roy Lichteinstein, Saul Steinberg, Frank Stella, Andy Warhol and others do not carry the tapestries that bear these artists' imagery. Tapestries, one dealer stated, "really appeal to a different market."

That market is primarily corporations, which use the tapestries as decoration for lobby walls. Many tapestries can be quite large — Roy Lichtenstein's "Amerind Landscape" is nine feet by 12 feet — and few homes can accommodate such expanses. Business art advisors and interior decorators tend to be the major promoters of artists tapestries, and it is generally through them that tapestries can be found in the first place.

Whether or not a larger market will develop in this country for artists tapestries is a matter of some debate. In general, this art form has more of a history and acceptance in Europe where tapestries were designed by such masters as Boucher, Goya, Raphael and Rubens in past centuries, Dufy, Matisse and Picasso in this century. Tapestries had a brief vogue in the United States in the 1920s, when tycoons such as J.P. Morgan, George Cornelius Vanderbilt and others traveled to Europe to buy art, returning with modern artist tapestries along with paintings and sculpture. These tapestries may still hang on the walls of their homes, or have been do-

nated to museums, but one has to look hard for them.

A couple of specialty tapestry galleries exist in New York City (they also are the main "publishers" of these editions), such as Gloria Ross and Modern Masters Tapestries, but artists interested in this art form have few other resources at present.

Watercolors: Most people are happy to say something nice about watercolors — at least, no one says anything bad about them — but why, then, is it so difficult for watercolorists to make any money from their work? The reason may well be the difficulty in finding somewhere to show (hence sell) these works to the public.

"Dealers know that there's more money in oils than watercolors," said Lawrence Fleischman, partner of Kennedy Galleries in New York City which does exhibit this medium, adding that a watercolor will generally sell for half the price of an oil even when both were painted by the same artist.

Some dealers will handle an occasional watercolor if it is done by an artist they already represent who primarily works in another medium. Few galleries have much interest in watercolors by artists whose primary medium is watercolor. Deborah Frizzell of the Connecticut Gallery in Marlborough, Connecticut noted that collectors are "far less interested" in buying watercolors than oils, both because of the sense that works on canvas are physically longer-lasting and need less care than works on paper and due to the lingering view of watercolors as preliminary sketches for more major works. Yet other dealers speak of nervous collectors who have sunny homes and are fearful of buying a watercolor that may deteriorate in the light. The result is watercolors that are harder to sell and which bring in fewer dollars. The same degree of talent, effort and professionalism by a watercolor artist tends to mean less money in galleries, and the same amount of salesmanship by a dealer nets more of a profit with an oil painting than with a watercolor.

The debate over what to do about watercolors is both old and new, as it largely concerns the attitudes of those who buy or take care of these works. Adolph Gottlieb, the New York School painter, recalled that "a dealer, when I was young, was considering giving me a show of my watercolors, and she turned me down. She said, 'Well, you know, the history of art was never made with watercolors, anyway.'"

Museums don't help the situation, as many of them have significant collections of watercolors but rarely exhibit them. Part of the reason is that they are legitimately concerned about the ability of these works to withstand long-term exposure; another reason is that few institutions have

galleries set aside for works on paper of any sort (the Art Institute of Chicago, Cleveland Museum of Art and Museum of Modern Art in New York City are rare exceptions). Curators in these departments occasionally do battle — and usually lose — to find temporary or permanent space for exhibits of watercolors, depriving the public of ever seeing many watercolors at any one time. This reinforces their invisibility.

Because of this, watercolorists have had to find other avenues for selling their work, the most common being the juried art competition. Regional juried shows do not tend to attract as much of the country's small body of watercolor collectors as those competitions sponsored by the national watercolor associations, and prices for works reflect the differences in these shows' stature. Relatively few artists can earn a living from these shows, especially at the regional level.

Commercial vs. Fine Artists: The distinction between "fine" and "commercial" art may be more strongly held by artists themselves than by collectors, as there is no lack of painters who feel that doing illustration is selling out. Art schools, where the ratio of commercial-to-fine art students is still in the four- or five-to-one range, often imbue a certain snobbery about the lesser importance of the applied arts. Elsewhere, it is tantamount to an epithet to compare someone to Norman Rockwell.

This feeling of second-class citizenry in the art world has a long history. N.C. Wyeth, for all his acclaim as an illustrator, forcibly steered his son, Andrew, into serious painting and away from his youthful excursions into commercial work. Many American artists at the turn of the 19th century — including William Glackens, Winslow Homer, Edward Hopper, John Sloan and James MacNeil Whistler — started out as illustrators (Glackens did pictures for books, Hopper worked in an advertising agency and Homer, Sloan and Whistler were all newspaper artists) but quickly moved into fine art with a sigh of relief as soon as they could.

That second-class feeling has not been limited to American illustrators. Gustave Dore, for instance, the noted French book illustrator whose dreamy, romantic style and interest in the grotesque influenced van Gogh as well as the painters of the Symbolist and Surrealist movements, opened an art gallery in London (where Sotheby's is now), the Dore Gallery, in order to display his fine art oil paintings and sculpture. Like Dore, George Cruikshank, an English illustrator and caricaturist, also turned to easel painting later in life as a way of obtaining more mainstream appreciation as an artist; but, like that of Dore, his fine artwork was generally viewed as of a lesser quality and interest than the commercial work and did not find many buyers. John Tenniell, a British artist who became renowned

in the 19th century for his illustrations for *Alice in Wonderland,* craved respectability but was snubbed by the Royal Academy when he sought to become a member. In fact, the Royal Academy refused to accept any artist who also did, or had ever done, illustration.

One of the reasons that some illustrators have not been accepted into the fine art world is that their skills are limited. Neither Cruikshank nor Kate Greenaway, who achieved enormous attention for her illustrated book of verses, *Under the Window* in 1879, was skilled in the use of oil paint. Art critics and historians find Cruikshank's oil paintings, for example, to be crowded and confused, as the technique and style that worked in his line drawings failed in the paintings.

Clearly, there are also tangible and psychological differences between pursuing fine and commercial art, the main one being the freedom to do as one chooses. "The talent of an artist may put a lot into an art piece," said James Rosenquist, a billboard painter before entering the fine art world in the 1960s, "but the advertiser or art director may restrict it. Painting is someone's ability to set in layers and layers of skill and thought into a canvas. Slowly, it all seeps back to the viewer, but it takes time. Commercial art tends to have an immediate impact, and there is usually not that much behind it."

Still, all art reflects a way of looking at the world, artistic for its use of metaphor, expression and style, and art created for a specific patron (whether a portrait, a book illustration or product advertisement) may have all those same qualities. Some collectors and dealers have come to see that logic, and a number of art galleries representing the work of commercial artists have sprung up in New York City and elsewhere around the country. The fact that certain artists, such as Rockwell or Frederic Remington, have sold well at auction indicates to collectors that these works have real investment potential.

Certain illustrators have been able to overcome the inherent obstacles to art world stature. Aubrey Beardsley, best known for his illustrations of Malory's *Morte d'Arthur* and Oscar Wilde's *Salome,* entered the art world through his great popularity with the public and by his influence on fine artists, such as Gustave Klimt in Vienna and the Pre-Raphaelites in England. William Blake, who had been trained as an engraver, gained a sort of cult following for his romantic, symbolist poetry that carried over into his painting. Honore Daumier was simultaneously successful as both an oil painter and as a caricaturist. His paintings were much admired by Delacroix (who copied some of his works), critics, collectors and artists of the Barbizon School, and his newspaper caricatures (for which he himself made the lithographic plates) were known throughout France.

Daumier had, in effect, two markets that only occasionally overlapped, but one never cancelled out the other.

Unfortunately, few artists who have worked in commercial illustration have found anywhere near the same sort of success.

Smaller, regional institutions have periodically taken a chance on traveling displays of the work of illustrators, but, again, it is major museums that have lagged in their appreciation of changes in the market and in the definitional categories that have maintained hierarchies of high and low art. The ability of the larger museums to enforce the general invisibility of these works continues to hurt the marketing prospects of many artists.

Chapter 8.

Handling Art World Publicity

In 1949, *Life* magazine published an article whose title asked the question, "Is Jackson Pollock the Greatest Living Painter in the United States?" Although the article's tone seemed to ask readers to answer in the negative — which, based on the letters to the editor that were published, they did — it heralded a new attitude by the media toward art. Despite a portrayal of Pollock as an oddity whose work and mode of artmaking defied comprehension, the art was described in terms of his success in selling his works. If he sells, it is assumed, the rest is OK.

Money talks, and in the art world it publicizes. Exhibitions of the work of van Gogh in Paris, Chicago and New York City have not done as much for the widespread acknowledgement of the artist's greatness as the sales within the past 10 years of several of his paintings for $20 million, $40 million, $53 million and $82 million.

Publicity has become a staple of the art world, affecting how artists see themselves and how dealers work. On its good side, this publicity has attracted increasing numbers of people to museums and galleries to see what all the hullaballoo is about and, consequently, expanded the market for works of art. More artists are able to live off their work and be socially accepted for what they are and do.

On the other hand, it has made the appreciation of art a bit shallower by seeming to equate financial success with artistic importance. At times, publicity becomes the art itself, with the public knowing that it should appreciate some work because "it's famous" rather than because it's good, distorting the entire experience of art. Seeing the touted works of art may be anti-climatic, especially when — as in the case of Georgia O'Keeffe — the poster images of an artist's paintings are occasionally larger than the actual pieces themselves.

The focus of publicity in the art world has changed in the years since the *Life* magazine article. Back then, the radical look of the artwork was highlighted; later, in the 1960s, the spotlight shifted to the artist's lifestyle and, after that, the buyers of art. Clearly, money has made itself known with art taken along as a passenger.

The artists who were most affected by the media interest in the arts were the abstract expressionists in the 1950s. Although their works and goals were almost too diverse to truly label them as a group, these artists who had grown up during the same period and shared many similar experiences were united by a mood that all shared — alienation. That shared isolation was broken up by the new attention their work began to receive, as some artists who were less successful felt bitter about others who were more so. They all felt a degree of anger at the loss of their seclusion and how their lives had suddenly gone public as well as guilty that they had become commercial — they were all committed leftists, after all, whose decision to abandon politically conscious art for total abstraction had been difficult.

Feuds, alcoholism and bitterness poisoned these artists' lives. Franz Kline, William Baziotes, Bradley Walker Tomlin and Ad Reinhardt all died relatively young. Arshile Gorky and Mark Rothko committed suicide — Jackson Pollock's car crash (the last of many) can be called an "accident" only with quotations — and the male survivors (Willem de Kooning, Conrad Marca-Relli, Philip Pavia and Jack Tworkov) complained of feeling passed over by the media for the next generation of artists.

"The art world, by which I mean critics, dealers, everyone except the artist, is interested in the new and forgets everything else," Jack Tworkov noted not long before he died. "Some artists got put on the back burner after a while. It is inevitable."

Whereas in the 1950s the art attracted the most attention — treated with curiosity, disdain and bewilderment by a public that was unused to such stuff — the focus shifted in the 1960s to the artist's life. To many, it represented an alternative lifestyle for those disenchanted with middle-class society; to others, it became chic for the socially ambitious to rub elbows with artists and become a museum trustee. Within relatively few years, in fact, the boards of trustees at the nation's major art institutions changed from old money and old families to new wealthy businesspeople who brought a whole new set of values to the operation of museums.

Openings at museums and galleries also became major social events during this time, and artists were courted by politicians and tycoons.

Pop artist Andy Warhol was probably the most notable figure, for whom creating a public or media image was as important as creating art,

but many others — some of whom flitted in and out of notoriety — found that their lives had become a matter of public concern, limiting their freedom.

Many aspects of the artist's lifestyle — with the exception, of course, of the general poverty of most artists — were appropriated by members of the middle class, the most obvious example being loft-living. Artists found themselves priced out of the abandoned warehouse buildings into which they had settled as the glamor of living in a spacious loft (as opposed to the suburbs) gained popularity in Boston, Chicago, Los Angeles, New York City, Philadelphia and elsewhere.

The spotlight in the 1970s shifted from the art and the artist to the buyers of art, largely because of the record-setting prices paid for works, and the focus of publicity has remained there since. To a degree, the reason for this is the lack of any consensus about aesthetics or standards of taste. Without a clear conception of inherent quality, the only certainty about art becomes the amount of money paid for it. A new definition of art is the result: Art is whatever someone puts down money for and says, "This is art." The corollary of this is that quality is identifiable only in terms of the sums spent. A $200 piece is not worth talking about; a $2,000 piece is OK, a $20,000 work is significant; a $200,000 piece is excellent; and, at $2 million, the artwork starts to be called "priceless." There had traditionally been in the art world a distinction between commercial success and what is called *success d'estime*, the prestige and influence of a work. More and more, the distinction has been blurred as critical and monetary values have become intertwined.

This may not necessarily be bad; rather, it is a recognition that the history of art and the history of art patronage are the same history — it is a 20th century concept that art should belong to artists. In a market sense, it is the purchase of works, or a recognition of their saleability, that is the primary factor in raising nonfunctional, possibly decorative objects into the realm of art. An artist's say-so is no guarantee of value and, because of this, collectors of art are not mere dispensers of money but proponents of entirely new concepts of art.

Whether art was purchased as a hedge against inflation, as a tax shelter, as a form of self-flattery or for more personal reasons, the buyers of art found themselves the celebrities over the past 20 years. The artist's success became their success in being wise or wealthy enough to acquire a work. Armand Hammer, Walter Annenberg, J. Paul Getty, Robert Lehman, Norton Simon, David Rockefeller, Alfred Sackler, Joseph Hirshhorn, Victor Kiam, Robert and Ethel Scull, Count Panza di Biumo, Daniel Terra — these were among the most notable buyers of art, and they received considerable attention for the prices they paid for works, the

collections they amassed and what they did with those collections. Various art magazines now annually devote whole sections or issues to who the top buyers are in any given year, and a number of home and architecture magazines regularly feature the houses and collections of wealthy art buyers.

In some cases, they erected monuments to their art interests. Conglomerateur Norton Simon purchased the Pasadena Museum of Modern Art in 1974, renaming it the Norton Simon Museum of Art at Pasadena, and reserved 75 percent of the museum's space for his own works. He began selling off many pieces in the museum's original collection that were not his personally. Others have set up whole museums, or had other art institutions add wings, that bore their names, and often some strings are attached to ensure that their persons are not forgotten amidst the art. Robert Lehman, for instance, whose collection went to the Metropolitan Museum of Art in New York City which built a wing (the Lehman wing) for it, stipulated that the display be set up to exactly resemble the donor's home, with works (and furniture) placed just as Lehman liked them.

Capturing publicity becomes a means of nabbing dollars, and artists have become in many instances as infected with the excitement as dealers, auction houses and collectors. Small wonder, then, that so much art of the present day goes in for theatrics, exaggeration and rhetorical stances, as the getting and keeping of public attention has become a central part of contemporary artmaking. Artists are reacting to their times.

Out of the Spotlight

Most people tend to limit their memories to either what is personally important to them or what is currently being talked about. It is always with a sense of astonishment that anyone thumbs through a 10 or 20 year-old art magazine and remembers the artists who were being lauded right and left. The obvious question is, "Whatever happened to...?"

The language used to describe these artists' then-current work is learned, partisan and enthusiastic. This artist's work is a "significant contribution," that artist is having a "major show" while another is the "leading spokesman for his generation."

So many of them never seemed to get written up again and, years later, one wonders, what happened to them. Did they die? Did they stop working? Was their subsequent work so bad that everyone thought it best just not to mention it ever again?

They largely continued to live and do work of the same quality, but they all learned how uneven attention can be in the art world. They also learned what it is to go out of fashion.

"America is a consumption society," Marisol, a folk-Pop art sculptor who was the toast of the art world during the mid-1960s, said. "They take you and they use you and then they throw you away."

Marisol was in all the art and fashion magazines and her opinions on fashion, culture and cuisine were meticulously noted. People hungering for her pronouncements have had little sustenance since the late 1960s when she seemed to disappear — at least from the periodicals. Exhibitions of her work became fewer, and her name fell into that area of consciousness that includes the name of President Eisenhower's Secretary of Agriculture and the first movie one ever saw.

"The people who count don't forget," she stated, "but you do wonder, when all the noise dies down, what all the attention was about. Was all that excitement really about your work or just excitement about being in fashion." She added that she never stopped working — "but now I just do it more privately."

All art is created privately, anyway. An artist goes into his or her studio to commune with the Muse, not with the art magazines, in order to produce a work of art. But creating art is not just a form of self-therapy, and artists need some way of gauging their audience. Most artists want to project themselves and get more than an echo.

The feedback they receive is often short-lived and not without some drawbacks. Historically, since Impressionism, no single art movement has dominated the art world for as long as 10 years. By the time one group of artists begins to receive recognition, a new generation has grown up and starts to express itself. The old group recedes, having made its mark on history, but no one wants to be historical in one's lifetime — one might as well be dead.

One example of this phenomenon took place midway through this century. Abstract Expressionism hit the art world like an earthquake in the late 1940s and early '50s and, like an earthquake, it left a number of institutions in shambles. Among the ruins were American realist painters, who had dominated the galleries and museums that displayed work by contemporary artists and who found interest in their work tumbling.

The most severely hit artists, perhaps, were the Social Realist painters who saw all of their most cherished beliefs about art upended. To them, art had to address itself to the concerns of the masses, depicting in recognizable (although often exaggerated) imagery aspects of the lives of the poor and working classes, exhorting them to some sort of political action.

The art of the new abstract school that swept these older artists of the 1930s and early '40s away suggested just the opposite. The new art was

concerned with color and formal problems of art, implicitly rejecting mass political efforts for personal solace and expression.

Arguments over artists' intentions aside, the new art did pose a very practical problem for those Social Realists who still believed in their art but sought to make a living. "The big change in the art world damn near buried me," painter Jack Levine stated, adding that the market for his works shrank considerably for a number of years. Some artists — the most notable being Philip Guston — jumped ship and became abstractionists. Others slogged on and hoped for a change in the winds of the art world.

"I felt more and more that I was not painting in the popular mode," Lee Jackson, who first gained prominence in the 1930s with his Social Realist images of life in the city, said. "It felt like the air you breathed, the ground you stood on was suddenly pulled out from under you and left you dangling. I felt deflated as people all around me who had been doing Social Realism suddenly began doing abstraction. For a lot of us, it was a period of self-searching and disappointment."

Some Social Realists attempted to combine their social concerns with the new emphasis on color as an expressive entity in itself and on the more formal concerns (flatness, the painting surface, lack of illusionism) of the abstractionists. In the 1950s, for instance, Isabel Bishop showed new interest with movement in a painting as well as spatial relations between figures in a composition, and Ethel Magafan's pictures became considerably more abstract.

"An artist has to change," Magafan, a former Works Progress Administration muralist, said. "If you don't move forward, you fall back, and you can't really be an artist of your time if all you do is disapprove of everything around you."

Ben Shahn was another painter who refused to omit politics from his work, yet, by the 1950s, he too began to focus less on specific instances of social or political injustice and more on broader allegorical themes of humanity. Some scholars have also noted a greater interest in more formal, compositional problems in Shahn's art.

Certainly, most of the Social Realist artists — such as Philip Evergood, William Gropper, Robert Gwathmey and Stefan Hirsch — continued in the same vein of painting, refusing to allow changes in fashion to dictate their style or subject matter, but the price of that decision was relative or total obscurity. "I wouldn't sink so low," Jack Levine remarked when asked if he had ever tried an abstract painting. A number of the Social Realists refused to believe that the interest in abstraction was not a spoof, a scam that would soon pass, allowing their work to be appreciated once again. Devoted dealers continued to display the ongoing work of the Social Re-

alists into the 1950s, '60s, '70s and '80s but, for most art enthusiasts, it was as though an entire school of artists had mysteriously died. Books on 20th century American art reinforce that impression by highlighting these painters' work of the 1930s and never what they did afterwards.

The phenomenon was repeated a dozen years later. A number of artists of the New York School of Abstract Expressionism, most notably Mark Rothko and Franz Kline, felt bitter when they seemed to be passed over for the Pop artists. They continued to sell well, but they were wholly unprepared for the fickleness of the art world, and bitterness was added to their sense of alienation and, in some cases, depression.

Another painter of that period, Ray Parker, claimed that he has been through the popularity-neglect mill several times now: "Taste changes very rapidly," he stated. "One day, everyone loves you, the next day no one remembers you. But the changes are fast enough and cyclical enough that, at least in my case, people come back. Then, they go away again. You learn to get used to it."

Other artists handle the seeming fall from grace in their own way. Painter Robert de Niro, father of the actor, was highly respected and touted in the 1950s but, when his works seemed to be ignored during the 1960s and '70s, he retreated into a scornful silence. The career of Adja Yunkers, who died in the mid-1980s, went through a period of prolonged submergence in the 1970s and the artist himself grew increasingly cantankerous as a result. "I was all over the place in the '60s," Yunkers said shortly before he died. "You couldn't open an art magazine without finding my name in it."

By now, most artists in the public eye know that some day they will be replaced, and they must prepare themselves for that eventuality, investing their money now, producing as much as possible while they're hot and attempting to change their style with the turns of the market. One of the unwritten credos of today's art world is that a young artist (just as a young rock star) may well be considered through by the time he or she is 40, and one should rush to strike while the iron is hot. Isn't that what hype is all about? Commitment by an artist means persevering even when recognition is not there.

For all those artists in the old magazines about whom one hasn't heard anything since, the real issues may be whether or not they deserved the attention in the first place — were they just hot starlets of only passing interest? — and if the attention they received had less to do with their work's qualities than with then-current fads.

Love and Marriage

There are a number of reasons that people marry or divorce and, sometimes, it is because they are both artists. Another artist will understand the art one is attempting to create, will accept the lifestyle and serve as an in-house supporter as well as an experienced eye. Another artist may also be in-house competition and one's fiercest critic, resentful of one's success and scornful in his or her own.

It is not infrequent that artists marry each other, as the people they tend to meet in their art studies, at gallery openings or through their professional associations often are involved in the art world. Leon Golub and Jack Beal, for instance, met their wives (Nancy Spero and Sondra Freckelton, respectively) while attending the school of the Art Institute of Chicago.

Despite the real benefits for an artist of marrying (or living with) another artist, the identical careers — regardless of how dissimilar their respective artwork may be — create tensions for the two of them. Being an artist requires an ego of considerable size; two such people may find themselves clashing frequently, even if their disputes have nothing to do with their art or careers. Strong, unbending wills have destroyed more marriages than anything else.

Some artists approach these issues in advance by talking out a list of potential concerns. Jack Beal proposed to Sondra Freckelton three times before she finally accepted. "At first, he had the idea that I might be Madame Matisse, but I said 'no' to that. I didn't study art in order not to have a career on my own," she said. The back of their 1953 marriage certificate includes a written "agreement of partnership" establishing that they are equal partners.

"Artists have to outline what the dangers are, could be, might have been," said Miriam Schapiro, a painter who has been married to another painter, Paul Brach, for over 40 years. "You have to discuss whether or not to have the same or separate friends, whether you want to be treated as a couple or as individuals, whether your careers allow you to have a family, where you want to live, whether you want to be in the same gallery or not. They're all difficult subjects, but married couples — especially those with the same career — have to be able to communicate."

Other artists attempt to resolve the tensions of both spouses being artists through establishing separate studios (sometimes never even visiting each other's studios), using different dealers and generally staying out of each other's careers. One example of this was the house that Mexican muralist Diego Rivera had built for himself and his painter wife Frida Kahlo. There were two separate buildings, containing two separate living

units and art studios, connected by a bridge on the second floor level.

Having two distinct studios, one for her in the garage and one for him away from the house, is "a physical manifestation of what is already going on," said Scott Prior who is married to Nanette Vonnegut, both of whom are painters. "If we are too close, we sort of step on each other's toes. We do talk about each other's work, but there are times when Nanny would just as soon that I not say anything about her work because I can be disruptive."

It is relatively seldom that both artists in a marriage receive the same degree of attention and success in selling their work. At times, one artist's career is clearly on the rise while the other's has peaked, a scenario played out in the Judy Garland-James Mason film (later remade a couple of times), "A Star Is Born." Collectors, critics and dealers may come visit one artist's studio and not the other's, which can be especially painful when the two artists share the same space. Competition and anger may enter a relationship.

"When my wife's career is doing better than mine," Leon Golub stated, "I don't feel as good about myself and may develop resentment."

Golub added, however, that he directs that resentment elsewhere — at limited thinking in the art world, for instance — and not at his wife.

The tension and sense of competition may be too great for some marriages. The wives of Edward Hopper and Philip Pearlstein gave up their art careers, for instance, believing that there could only be one "genius" in the family. Sally Avery said that her "career has flourished over the past 20 years" after her husband, Milton Avery, died. While he was alive, "I wasn't trying to promote my own work. I tried to promote his work, because I thought he was a better artist than me."

Problems are not necessarily lessened when an artist marries a nonartist. Janet Fish, a painter who first married and divorced an artist, then married and divorced a nonartist and currently lives with another artist, noted that "problems about being an artist are really symptomatic of other problems in the relationship. Men simply have more problems than women with competition. There is something in their upbringing that requires them to be the breadwinner. The bad relationships I've had have been when the man's ego has been too tender."

She added that "I know some women artists who say their husbands never come to their openings or to see their shows, as though they are trying to deny these careers exist."

While artists marrying artists has a certain logic, the history of art reveals many examples of artists preferring a caretaker. Almost the entire Abstract Expressionist movement of the 1940s and '50s, for instance, was

supported by the wives of the major artists. Barnett Newman's wife, Anna Lee, for example, was a typing instructor; Mark Rothko's wife worked as a model, and Adolph Gottlieb's wife, Esther, taught school. In Europe, it was a tradition for artists to marry "working girls." Goethe married his housekeeper, as did Pierre Bonnard and Marc Chagall — when his first wife left him, Chagall married his next housekeeper. This kind of marriage (and this kind of support for male artists in general) has largely disappeared with the advent of the women's liberation movement.

Marriage, of course, isn't a professional decision but a personal one. The success rate of marriages is not necessarily improved when artists marry critics or dealers and, in many respects, the marriages of artists are no different than those of everyone else. Some artists get along well enough both personally and professionally that they, like Claes Oldenburg and Coosjie van Bruggen or Edward and Nancy Reddin Kienholz, are able to collaborate on art projects. Others, whose artistic ideas are not easily compatible, keep their marriage out of their careers as best they can.

"I think it's hard to be an artist married to an artist. I think it's generally hard to be married and be an artist," painter Lois Dodd, who was once married to sculptor William King, said. "When you're married, you have to think of another person, and art is a very selfish activity."

The Children of Artists

Many children of artists grow up to be artists themselves. For some, it seems the obvious thing to do, but the hardest part are the comparisons and the internal need to live up to the success. "Big American stardom doesn't have a lot to do with being an artist," noted Abbie Shahn, one of Ben Shahn's three artist children, "but you sometimes feel like you have to prove something to people, make as big a statement."

Few children born to the famous can equal — or better — their parent's renown which, for some of them, gives them an ongoing sense that they didn't live up to something chromosomal. Their sense of identity is somehow misplaced and the results can be tragic. Certainly, this is not by any means limited to artists. Daughters of Karl Marx and Winston Churchill, for instance, took their own lives as did the eldest sons of Josef Stalin, Theodor Herzl and Bishop Pike. With these great temporal and spiritual leaders, their lives took the form of a missionary single-mindedness in the service of a tangible cause. Their children felt connected to the causes but not equal to them. With artists, however, their goal is more personal and internal. One cannot really carry on an artist parent's work the way, for instance, that Anna Freud could follow through on her father's. The children of artists may understand what their parents are

doing and share in aspects of it, but no one can truly participate in another's creative act. That they must discover within themselves. They see how an artist lives and works — the accouterments of the artistic life — and may attach themselves to it, waiting for creative impulses.

For these children, the choice of being an artist is rarely easy. There is a certain amount of guilt about not having to work as hard for name recognition as others. It can be extremely difficult to contact dealers, especially those with family connections, and ask them to come to one's studio.

Kurt Vonnegut's daughter, Edith, who is a painter, spent five years wondering whether she should change her last name. She never could make up her mind and finally decided that she needn't run away from the fact of her father's literary fame.

Jack Tworkov's daughter felt that her name problem was a "double whammy" since both her father and her husband, Robert Moskowitz, are well-known painters, the one of the Abstract Expressionist school and the latter of a Minimalist orientation. She chose an in-between road, using her middle name and calling herself Hermine Ford.

No such luck for Maxfield Parrish, Jr. but, unlike Edith Vonnegut and Hermine Ford, he sought to escape his father's renown by staying away from art. He took other, industrial sorts of jobs but finally drifted back to painting and an acceptance of his name and its implications.

Some find themselves wondering whether or not there is such a thing as a "creative streak" and if it exists within them or ended with their parents. Failure can seem doubly harsh — failing both oneself and one's artistic inheritance — and it raises the stakes in the decision to be an artist.

One of the saddest examples of this is Klaus Mann, son of the Nobel Prize winning author Thomas Mann. Klaus wrote three novels concerned with existential rootlessness before committing suicide in 1949 at the age of 45. He chose fiction writing, although it was never easy for him, and one wonders if he ever felt he could do otherwise. He stated in a letter to his sister that literary pursuits were "a curse with us" and, in an interview towards the end of his life, he said that he felt "under an especially great obligation. When the son of a great writer writes books on his own, many people shrug their shoulders. The mixture of condescending patronage and hypercriticism with which people usually approach the son of a great writer rather hinders than helps him."

For most children of artists, their lives forever revolve around their decision whether or not to enter the "approved career."

Hermine Ford stated that she "grew up painting" but felt terrified of making the decision to be an artist when she became an adult: "It wasn't

such a struggle for me to make art as it was for everyone else. I thought I must be doing something wrong."

She put off the decision for a time and even debated going for a teaching degree, but finally resolved at age 30 to try to make a go of being an artist.

Children of artists often appear to take a different attitude toward the artistic lifestyle than their parents but, of course, they grew up in it — it was not a matter of choice for them — and it seems quite natural. Milton and Sally Avery's daughter, March, was born in the middle of the Depression when her parents (her mother, Sally Avery, is also a painter) were making very little money. Being an artist then meant no security but, to March, drawing and painting were a form of security in itself.

"My parents didn't have a separate studio and worked in the house," said March. "Artwork was all over the place. All their friends were artists. When I was young, I thought that everyone grew up to be artists. Sometimes, I think it was only because of lack of imagination that I became an artist."

In these families, the introduction to art starts quite early. They are given the best tools and materials to work with almost as soon as they show the first signs of artistic interest. Eric von Schmidt, son of Harold von Schmidt, the painter of life in the Wild West, remembers drawing his first nude (from a live model!) at age four.

Noting that "painting is taken quite seriously in my family — you could never just dabble," Jamie Wyeth said that he "literally grew up in my father's studio" and was always encouraged to paint. His brother, Nicholas, on the other hand, never showed any artistic inclination but, not to be left out, he was made the family dealer and has handled Andrew and N.C. Wyeth's (the grandfather) paintings since he was 16 years old.

Not every family of artists is as lucky. One of the sadder footnotes to greatness was the Cornish Colony — a community of commercial and fine artists living in Cornish, New Hampshire during the first half of this century. There were painters, sculptors and writers there, including Maxfield Parrish and Abbott Anderson Thayer as well as sculptor Gaston Lachaise. The legacy of this colony was over 45 divorces and a dozen suicides among the children of these artists.

This was first generation greatness and second generation decline. "These artists were not used to all the attention, accolades and wealth," Maxfield Parrish, Jr. said. "The Rockefellers had several generations of wealth and knew how to handle it and raise their children with discipline. The kids of Cornish weren't so lucky. They were handed everything and taught nothing."

His older brother, Dillyn, was one of the victims of Cornish. Dillyn

Parrish began drawing animals at age eight and was considered to be the sure successor to the father, but something went wrong. Dillyn had talent but measured it in terms of the amount one could earn. When he didn't quickly make money, he gave up painting and drifted from job to job, at one point selling cars. He resented his father's success and his own lack of it, finally drinking himself to an early death. Some of his childhood friends from Cornish followed similar paths.

It should not be particularly surprising that a child of an artist grows up with a desire to make art and, historically, this has frequently been the case. The Renaissance had numerous father-and-son pairings of artists, although rarely were they of equal renown. Being the son of an artist was a tremendous advantage then as it led to instant recognition and commissions. Pieter Bruegel the Elder (1525-69) was undoubtedly the finest Netherlandish artist of the 16th century, and his sons Jan (1568-1625) and Pieter the Younger (1564-1638) were also talented painters although they largely pursued their father's style and themes. A similar sort of progression existed with the German painter Lucas Cranach the Elder (1472-1553) and his capable if less original son, Lucas the Younger (1515-86) as well as the Florentine sculptor Luca della Robbia (1400-82) and his son Giovanni (1469-1529) and his nephew Andrea (1435-1525) who largely carried on, mostly working from Luca's designs.

A certain progression of increasing renown through the generations can, however, seen with Pisan sculptors Nicola Pisano (1239-84?) and his son Giovanni (1258-1325?). While the father was a highly expressive artist, the son was far more revolutionary in outlook and is considered a precursor of the advanced Renaissance style soon to predominate Italian sculpture. Also with Hans Holbein the Elder (1465-1524) and Younger (1497-1553), the son was by far the more forward-looking, employing a painstaking realism and psychological nuance that gave his paintings real forcefulness. Similar conclusions may be drawn about the sons of Jacopo Bellini, Giovanni and Gentile, although probably not about Filippino Lippi, son of Filippo Lippi — all of whom were 15th century Italian painters. Antonio da Sangallo the Elder and his nephew, known as the Younger, were both architects and sculptors, and historians generally take no stand on their relative merit.

Sculptors, always as much craftspeople as artists, tended to need assistants, and they brought their sons and relatives into the business. Family, as well as artistic, traditions were carried on this way.

As time passed and tastes changed, it was no longer considered adequate for an artist to continue doing the same kind of art as had been done by one's parent (or in one's parent's day) but important, rather, to

strike out on one's own. In some cases, children have worked in different media than their artist parents as, for instance, did Jean Renoir, filmmaker and son of Impressionist painter Pierre Auguste Renoir. Norman Rockwell had three children, of whom two became artists — Thomas a writer and Jarvis a sculptor. Painters Roy Lichtenstein and Robert de Niro, Sr. both have sons who became actors, and two of Kurt Vonnegut's daughters paint.

"I wouldn't touch writing," Edith Vonnegut said. "I would feel like I'm in competition. The females of my family have always been better in the visual arts than the males, and I thought I had something over my father because I could paint and he couldn't."

The differences in media have allowed her to acknowledge her father's influence and to find peace with it. "I do bizarre things in paint the way he writes," she noted. "I guess you could say I carry on a family tradition."

For those who work in the same medium as their parents, the problem of "influence" has been the largest stumbling block in establishing their own identity as artists — and possibly as individuals. The strength of their names opens some doors and closes others. Art dealers and collectors may be more willing to look at the work of the child of a noted artist than that of an unknown, but their responses can be, as Klaus Mann discovered, either patronizing or hypercritical.

"A name inflames peoples' ideas and expectations. It's a cultural defect," said Jonathan Shahn, sculptor son of Ben Shahn. "People lose objectivity, looking at things either too kindly or hostilely. It's rarely just looking at the work and, sometimes, I think that they aren't looking at all but just thinking about the name."

Both of his sisters, Judith and Abbie, have experienced similar treatment. But, even more, they have privately worried when their own work begins to resemble paintings or themes their father did. Three times in her career, Judith Shahn has stepped back to look at a canvas and said, "Oh, my God, that looks like something Dad painted," and all three times she decided never to display the work publicly. Abbie has had similar situations. In 1980, she was painting a somewhat allegorical work about El Salvador and, when she stepped back, she was struck by how similar it was to "The Passion of Sacco and Vanzetti" — one of her father's most famous paintings.

At first, Abbie was somewhat alarmed: "I felt that it came from the inside of me but, when it was right out there to see, it was obvious that there was a lot of Ben Shahn in it. I began to feel that I was carrying on a tradition, and there's nothing really wrong with that. Others try all the time to be original, but I don't think that's what art is about."

Chapter 9.

How Artists Perceive Themselves, And How Others See Them

Age doesn't appear to be such an important factor with people who paint or sculpt. No one asks a gallery director how old the person is who painted a picture on the wall. The artist could be 20 or 80 — it really doesn't matter if you like it, or even if you don't.

Most visual artists (as well as writers) tend to reach their stride somewhere in the middle of their careers, and the inspiration that drives them to keep going lasts well into their later years. One looks back with a mixture of pity and admiration at Matisse who, unable to get out of a sickbed at age 80, began to make wall-sized collages of cut paper and other materials he could handle working supine. Impressionist painter Renoir, crippled by arthritis, strapped a brush to his arm in order to keep painting. Even when he was completely unable to work, he dictated instructions to an assistant for the creation of some simple sculptures. There was no quit.

Such stores are heroic yet appear to be common for most artists who try to accommodate their creative impulses to the limitations caused by age. Doctors told Alice Neel, for instance, who had a pacemaker implanted in her chest, to limit her painting to no more than two hours at a time, but she never worked less than those two hours.

It may be that they go on creating out of fear of dying, sustained by creative feelings. but some of the most productive artists have led remarkably long lives. For example, Titian lived to be 99, as did Georgia O'Keeffe; both Louis Nevelson and Michelangelo lived to be 89; Picasso, Matisse and Monet lasted until they were 92, 85 and 86, respectively.

Art itself is immortal, and its creators seem to try to keep up with it, for immortality confers perfection. The Japanese artist, Hokusai, felt this sort of ongoing self-realization through art, writing to a friend that "by

the age of 50, I had produced countless designs; yet, in all I drew prior to the age of 70, there is truly nothing of great note. At the age 73, I have at last begun to understand the true aspect of birds, animals, insects — the vital nature of grasses and trees. Therefore, at 80, I shall have penetrated still further, and at 90 I shall have penetrated the deeper meaning of things. At 100, I shall have become truly marvelous, and at 110 each dot, each line will surely possess a life of its own." Unfortunately, he was unable to reach his hoped-for plateau, as he died at age 89 in 1849, and was troubled by intermittent bouts of partial paralysis for the last 20 years of his life.

Maintaining one's creativity into old age means overcoming obstacles — some of them emotional and others physical. On the emotional side, there is the ever-present possibility of simply running out of gas or just losing the drive to keep producing. If they have never been able to receive the recognition or favor their peers did, some artists may become disappointed and move further and further from art into something else.

Other artists still have the interest to keep going but find themselves less physically able to do so. During the last years of Norman Rockwell's life, his work deteriorated dramatically. His technical facility diminished, with the realistic sharpness that was his trademark becoming increasingly dull, and the subjects he chose were also not as poignant. In addition, he became increasingly senile during these years and was unable to see the decline.

Many artists somehow try to adapt to their age and physical limitations, the way a veteran major league pitcher will vary speeds and pitches and stop trying to strike out every batter with fastballs. Adolph Gottlieb discontinued his large-scale works and began painting watercolors from his wheelchair. Milton Avery was slowed by a heart attack but used the time he spent recuperating to experiment with monotypes of which he did 200.

In many cases, as they get older, artists become more what they are, becoming more fully released as artists. They often cast off what is unimportant, such as social activities and looking at what other artists are doing and, instead, concentrate on their artwork.

It is often said that, as artists get older, they become more conventional and reactionary. In fact, it appears that the opposite is true and that they become more revolutionary. J.M.W. Turner, for example, moved further and further away from strictly identifiable forms in his later years, concentrating on atmospheric conditions and changes. This was the Turner to whom John Ruskin and many of the French Impressionists felt most drawn. Goya's style became darker in his old age with, as some historians have postulated, a sense of mortality providing a nightmarish in-

tensity to his later works. Titian is another whose style became looser, the pallette decidedly bolder, and Monet, bedeviled by cataracts and a resulting depression, devoted 10 years to painting images of waterlilies that experimented with color and light.

Adja Yunkers was practically blind in his last years, bending over to look at his colors close up. His late paintings, often composed of one or two simple colors, have been highly praised. The artist frequently said during that time that "one has be blind in order to sell color."

Age, of course, has nothing to do with aesthetics, although it does give an artist more time to make his or her artwork closer to the perceptions that inspire it.

Becoming an Artist After Another Career

All kinds of people get involved in some form of artwork — often, the dabbling "Sunday painter" sort of activity — as a way to pass the time or simply because it's fun.

For some, the art turns into more than a hobby. It becomes their passion. Sundays aren't long enough to say all that they have to say. Canvases accumulate, stacked neatly in the room designated "the studio," and the creator's consciousness of him- or herself as an "artist" begins to grow. Some people quit their jobs and take the plunge; others, possibly retirees, just work at it harder, taking classes, trying to get their work shown, and hope to make some money from it.

Mary Anne Robertson "Grandma" Moses is probably the best known example of the late-blooming artist. A housewife, she began taking painting seriously in the late 1920s after the death of her husband, in part to overcome her sorrow, and her first one-person show took place when she was 80. A Pittsburgh housepainter, John Kane, also painted on the side — interestingly, he used housepaints on his canvases, well before Jackson Pollock startled the art world by this practice — but was not publicly shown until age 67.

Another, James Stewart of Rock Creek, West Virginia, took up sculpture after retiring from the coal mines with black lung disease in 1974, chiselling busts of current and historical figures from the pieces of coal that brought about his retirement. The executives of coal companies found out about his skill and began commissioning him to do their portraits at $3,000 and up.

"I wish I had gotten into this a bit sooner, but I never thought I could make a living at it," he said. "The fellows I used to work with find it hard to connect me with the person they see getting written up in art publica-

tions. I never thought of myself as a sculptor but as a coal miner. The people I've known all my life aren't sure if they should look at me differently. It's hard to know how to take all this.

Herbert Ferber, a well-recognized painter and sculptor born in 1906, exhibited his work for decades — during the 1960s, his room-sized environmental sculptures influenced countless artists — but he did not give up his dentistry practice until the late 1970s.

"I knew that painting and sculpture couldn't support me, so I became a dentist," he said. "I quit being a dentist when I realized that I could make more money from art." Those intervening years were quite busy for him, as he maintained a private practice, taught at Columbia University's dental school and researched and published numerous articles in a variety of dentistry journals, all the while making art and keeping his hopes alive that, someday, he might not have to do anything else. When it finally came true, he noted, "it was like a holiday."

Another well-known dentist-turned-sculptor, Seymour Lipton, seemed almost embarrassed about his previous career. "You know, there's a book out about my work, just my work," he said shortly before his death. "In the whole book, there is only one paragraph about my having been a dentist. The fact that I was a dentist has nothing to do with my artwork. Dentistry was just an oddity I did for a number of years in order to make a buck. No one talks about Wallace Stevens because of his work as an investment banker in the insurance industry. The important thing is the poetry he wrote."

To a degree, he is right. No one would think to look for images of molars or gum disease in Lipton's work. However, the need to create art and the necessity of earning a living are twin concerns in every artist's life. In a society where the work ethic is central, one is what one makes a living at, and dentists and lawyers (Chekhov and Kandinsky both studied law) and bankers (T.S. Eliot and Gauguin) and others have to keep their own faith. For many women, artistic pursuits may have to take a back seat to family obligations, such as childrearing. Both Louise Nevelson and Louise Bourgeois, two of the most important sculptors of the post-war era, took time off from their work to raise children, but they came back. "You have children for 15 years, not for 80 years," said Louise Bourgeois. "It's just one episode in your life. There's a lot more to life than that."

The desire to create art gives one's life a shape and meaning. For a number of years, Grandma Moses submitted both homemade jellies and paintings to competitions at country fairs: The jellies won prizes but never the art. She was undaunted. Her work had moved from escapism and hobby to obsession, and it was her patience and talent that won out.

One person who understood that victory was Sidney Janis, a former ballroom dancer and shirt manufacturer who became a professional art dealer in 1948 at the age of 52. One of the first people to show abstract expressionism and Pop Art, he had been a collector of art since 1926 and wrote books and articles about artists in his off hours. Janis is credited with, among other things, having discovered Morris Hirschfield, another clothing manufacturer who turned to painting at age 65.

"A large number of artists, Hirschfield included, retire or become ill and turn to painting," Janis said. "They've often worked in very different professions and took up art, painting in a very untutored, instinctual way. The world has always had them; the art world has not been quite so aware."

The world still has such artists. Publishers are backed up with piles of manuscripts sent in by people who believe that they have a story to tell. Art galleries are jammed with prospective artists trying to show portfolios and slides of their work in the hope of an exhibition. Meanwhile, the dentist fills a cavity, the clothier stitches a seam, the house painter scrapes off one layer of paint before applying another, and a massive reservoir of art interest and talent awaits discovery a little below the surface.

Must Artists Move to New York City?

Once a year, Mideast Moslems make a pilgrimage to Mecca in Saudi Arabia, the spiritual center of their religion. Many Christians make an Easter trip to Calvary and, for the Jews, the Passover seder ends "Next year in Jerusalem."

For artists in the United States, too, there is a central point where they may feel whole again, where their troubles are understood and their good works appreciated. That place is New York City, the capital of the world's art market and home of most of the country's major art critics and magazines.

Most of the nation's artists, however, do not live in New York City, although many have gallery or dealer representation there. If they don't have Manhattan representation, they spend a lot of time trying to get it.

For the majority of this country's artists, New York City is more than just a place. It is where works of art are seen by people from all over the world, and where that art is taken seriously and understood by a sophisticated market. The pressure to decide whether or not to move to New York City may be the most intense that any artist will have to face. To many artists, it is synonymous with the question of whether or not they think of themselves as serious professionals or just Sunday painters.

"Anyone who goes to art school — and I got a graduate degree — constantly hears, 'New York! New York! You'll never be on the big board if you're not in New York,'" said Robin Rose, a painter who has lived in a number of different cities and is represented by a New York City gallery.

"New York is always at the back of my mind," Ida Kohlmeyer, a Baton Rouge, Louisiana painter, stated. "I thought about moving to New York back in 1963, after I had won a Ford fellowship. But I had a family, and it might have broken up my family, and so I stayed."

Pluralism has been one of the dominant features of the art market over the past two decades, and more attention is being given to "regional" arts activity. No longer is the rest of the country referred to as "the provinces." But, is it possible for an artist to establish a major reputation outside of New York City?

Yes, says Dickie Pfaelzer, assistant director of the Elaine Horwitch Galleries in Santa Fe, New Mexico, but it just takes a lot longer.

"You don't find that many 28 year-old artists here with national reputations," she said. "Generally, the gallery has to show some national names to get the serious collectors to come in. They can then see the local artists."

No, says Ivan Karp, director of the O.K. Harris Gallery in New York City, but they can support themselves and make a fair living without being in New York.

"If they have a rampant ego and a driving ambition, which is what a real artist must have, they will want to make it in New York," he stated. "Some artists will be satisfied with local fame. They have a coterie of disciples where they are and do quite well. They may redefine what it is to establish oneself as a major artist, but history won't afford them recognition in the wider culture."

Ivan Karp pointed out that he sees 150 artists a week, many of them from out of town, who are looking to be represented in his gallery. It would mean a major sacrifice for many artists to try to "make it" in New York — a sacrifice of time away from their work or of money as New York City is an expensive place to live and work.

It is also difficult for artists who are not familiar with New York City to know which galleries and dealers are right for their particular work. There are hundreds of galleries, some in for the long term while others have short lifespans, and each has its own particular level of artistic quality and pricing. The wide variety does not necessarily ensure a good fit for an artist.

Still, "New York" tends to rest heavily on the minds of many artists not living there.

David Freed, a painter in Sedalia, Missouri who is represented by a SoHo gallery in New York City, noted that although he has been able to sell well in the Midwest, "the art world just doesn't come to the Midwest. Artists, dealers and collectors here have a big inferiority complex: They live in a never-never land, hoping that fame can happen to them without having to go to New York."

A regional reputation, he feels, is "meaningless in terms of the national market. You enter regional competitive shows in order to build your confidence, and you try to establish a following for your own happiness. If you are serious, though, you recognize that you will have to do the New York thing."

Some artists don't just think about New York but, in fact, move there.

"You can charge twice the price for your works in New York than in Cleveland," Vivian Abrams, a painter who left Ohio for the Big Apple in the late 1970s, said. "I had a show in my Cleveland gallery in 1977 where I sold two-thirds of my work and still didn't make a profit. I was charging as much as a local artist could."

"There's more critical attention in New York to your work, and it makes New York more exciting than any other place," said Taro Ichikashi, a Japanese-born painter who moved to New York City from Washington, D.C.

It was not easy for either of these two artists to obtain gallery representation — that was something they left behind — although the move brought more optimism about their careers. If something is going to happen for them, they believed, it will happen in New York City. "What does it really mean," Abrams asked, "to 'make it' in Cleveland?"

Many artists in other parts of the country feel a bitterness toward New York City and a "New York Arts Establishment," which they believe ignores them. They claim that it is difficult to be reviewed in the major art magazines and by the major critics who are based in New York City.

"I like to think that it's possible to be a good artist anywhere," said Tony DeLap, a painter and sculptor in Corona del Mar, California. "It's important for artists everywhere to be seen and receive critical comment. However, it gets distorted when a well-known West Coast artist like myself is ignored and less talented artists in New York are hyped by the media."

Others take their bitterness a step further. Betty Moody, owner of the Moody Gallery in Houston, Texas, stated that she speaks for "most if not all" Houston dealers when she noted that "the coverage in the New York-based arts magazines has been inadequate. The reason for this, I believe, is due to advertising. I think that, if there were more advertising coming out of Houston, you would see more coverage of the arts in Houston. None

of the arts magazines will admit to this, but I believe it's true."

The media situation is changing, if slowly. Some of the major art magazines have featured special sections of the country, such as Taos, New Mexico or California, and their writers now include correspondents from a variety of cities.

Certainly, there are more artists living in New York City than in any other single location, and the reasons are not solely the easy access to galleries where they can attempt to show their work. Many of them enjoy the atmosphere and the kind of intellectual stimulation that comes from being in the center of the art world. That stimulation, which can dramatically affect the way artists there make art, is less available for artists outside of New York or any major urban art center. Without at least visiting Manhattan from time to time, artists can glean only those developments that the art magazines report.

The question of whether or not to move to New York City is often more burning with younger artists than with those who are older and have settled in a particular region. The "need" to go to New York City must be weighed against other personal concerns. Sculptor Joan Grant, who lives in New Orleans and is "still married," noted that career decisions are based on "what you want to do and how you're going to make it work. For me, making art is more important than hustling to sell it. It's all dependent on your individual needs for achievement; otherwise, you lose touch with yourself and with your art."

Although Ida Kohlmeyer didn't choose to come to New York City in 1963, her years of work in establishing a regional reputation were not wasted. By the early 1970s, New York art dealer David Findlay asked to represent her work in his gallery, and her first show there was a sell-out. By 1980, she was one of five women to receive an award for her work from the Women's Caucus on Art.

"I've received many accolades, and I've thought many times to myself that I had really made it on a national scale," she said. "But when I was honored by that award along with such women as Alice Neel and Louise Bourgeois — that tasted so good."

The (Unflattering) Portrait of the Artist

Artists may think well of themselves, cope admirably with the vicissitudes of stylistic changes and critical praise or damnation, stay out of trouble with the Internal Revenue Service, make peace with their decision about where to live and maintain their desire to create to the last minutes of their lives. Still, the perception of artists in the wider society tends to be nega-

tive. One finds that to be the case in novels and movies (where artists are forever unkempt, frequently alcoholic or hooked on drugs, full of neurotic — or worse — problems, childlike creatures who need others to keep their lives in order, amoral or immoral bohemians who take no responsibility for their conduct) as well as in a number of psychological studies of artists and creativity in general (usually finding manic-depression and other mood disorders as essential ingredients of artmaking).

Unfortunately, this negative stereotyping of artists is not a new phenomenon and, in fact, has a long history. What is more unfortunate is when young artists, insecure as to their place in the art world, attempt to look or act the part of the artist as defined by these images. It is more surprising that age-old attitudes continue to the present day, obscuring more meaningful discussions of art and the creative process. Having two strikes against you in the public's mind is one of the most severe pressures faced by artists.

What makes artists do what they do? This is a question that has bothered essayists, philosophers and psychologists for centuries, with new epochs providing fresh theories. Scorning the apparent irrationality of the artistic process, Plato described the poet as "not in [his] right mind," possessed by the muse with "reason...no longer in him" and, many centuries later, Friedrich Nietzsche wrote that "it does not seem possible to be an artist and not be sick." Certainly, others have assigned loftier attributes to artists than mental or physical disorders, but artists have tended to be seen as somehow "off," removed from real-world concerns (except poverty), and the process of making art has remained a mystery.

Sigmund Freud, for instance, was a keen observer and enjoyer of art. However, he also believed that all emotions were chemically based and that their chemistry would someday be discovered. Freud saw art as a neurotic symptom of an individual who could not face reality and was convinced that art was something of which people could be cured.

Freud's followers have sought to be more precise in their work on the subject. We now can speak of which side of one's brain controls the creative impulses, for instance. In the early 1970s, University of Iowa College of Medicine psychiatrist Nancy C. Andreasen found that 80 percent of the participants in the university's Writers' Workshop suffered from mood disorders, including manic-depression in some cases. Dr. Andreasen went on to publish findings on the relationship of creativity and mental illness. Not long after, in 1983, a psychologist at the University of California in Los Angeles, Kay R. Jamison, surveyed 47 British artists and writers, again finding a high percentage of mood disorders and even psychiatric ward hospitalizations among creative types.

Ernest Hartmann, a sleep researcher and professor of psychiatry at Tufts University School of Medicine, discovered a connection between nightmares and creative activity in 1984. Writing in The American Journal of Psychiatry that the subjects in his study "have a biological vulnerability to schizophrenia," he noted that "nearly all the subjects had occupations or career plans relating to arts or crafts." More recently, Karl U. Smith, a psychologist at the University of Wisconsin, discovered that people who are more expressive on the left side of their faces are more likely to be creators than others who are "right-faced."

All of these studies (and there are others) are based on a small number of carefully chosen subjects, and are unanimously associative in their method — finding certain personality qualities in the subjects that are attributed to these peoples' professions. Anecdotes of suicides and mental disorders among artists are liberally sprinkled about. There is no attempt to compare these artists with doctors or lawyers, for instance, who are also highly trained and reliant upon their wits to understand and solve problems. The aim is not to understand general human psychological issues; rather, the endeavor is consistently to segregate artists as a special category and diagnose them as flawed individuals whose flaws give rise to their art. Ultimately, what we are presented with is an ad hominem attack on art, for how can one trust the creation of a nut?

With the work of novelists and filmmakers, the same negative stereotypes are established through their characters, but it becomes more of a danger since their work is more widely disseminated.

Somewhere in the latter half of Gail Godwin's Violet Clay, the artist-protagonist sits down with a book that she hopes will give her the courage to stop doing commercial illustration and start painting seriously: "I set aside Hemingway's Islands in the Stream. The jacket copy said it was about an artist. What I really wanted was a book about an artist and how that artist went to his work every day and wrestled with his demons. I longed for a blow-by-blow account of what really happened when he was by himself, without any romanticizing, or skimming over or faking."

It's unlikely that the Ernest Hemingway story gave her much insight. Its central figure, painter Thomas Hudson, wrestles with young women and bottles of gin. He is a successful artist but only, it seems, because such a person may be the only kind Hemingway could think of who didn't have to work regularly and had money to drink and go boating all the time.

In its own way, Violet Clay also conveys rather little of what it is to be a visual artist, but to do so was probably not Godwin's intention. What one sees in her 1978 novel is a woman striving to become the best woman she can, and the artist bit is a metaphor for something else. This is a femi-

nist novel — call it *Fear of Painting* — with a thin coat of art world terminology.

Let's not fault Godwin or Hemingway too severely; rather few writers who try to portray artists are able to do so with any real degree of credibility. Novelists tend to employ artist characters — whose benefit to them is that they don't have fixed schedules and can be sent around easily where the writer needs them for the story — in order to make a point about something else, and that something else is what really is important to them. Along the way, however, these writers convey a vision of artists that reflects society's worst stereotypes of them. As soon as someone in a book is labeled a painter, these characteristics are inevitably brought up.

Jeremy Pauling, the sculptor in Anne Tyler's *Celestial Navigation,* is a parody of the romantic concept of the artist who must isolate himself from the world in order to create — this artist is plainly agoraphobic and cannot bring himself to go beyond his front door. The grand old man of painting, Henry Breasley, of John Fowles' novella, *The Ebony Tower,* is a drunken dirty old man who delivers diatribes against all of modern art — a point of view largely accepted by the author. Still, that denunciation of art hardly compares with the invective Alberto Moravia presents in *The Empty Canvas* in which, as the book's title indicates, no painting takes place while the ineffectual, dried-up, lecherous "artist" pursues opportunities for self-destruction.

In films, too, artists are almost always depicted as cautionary figures, and the impression of a pouty, self-absorbed individual lingers long after one leaves the theater. One thinks of the artists in *An Unmarried Woman* (a paint pourer), *Hannah and Her Sisters* (a pedantic snob), *Gauguin* (a lecher), *Amadeus* (a skirt-chasing, belching and farting brat), *Round Midnight* and *Bird* (heroin-addicted musicians), *Barfly* (a slovenly, brawling drunk), *Vincent and Theo* (an inarticulate slob) or *The Good Mother* (a sexually boundless sort). If the filmmakers were asked directly whether or not they believe artists generally are the negative things they describe in their works, probably they would strongly disagree, claiming that these are merely individual characters with no symbolic reference. However, when one puts all these images together (as they must fit together in the minds of those who see these movies), what is clearly presented is a view of artists as people who are unprofessional, unsavory and unworthy.

Here and there, a writer or novelist will portray an artist in a positive light, indicating something about how art is made or conceived (Virginia Woolf's *To the Lighthouse* is one of the best), but these are rare occurrences. Artists will continue to be portrayed as fools, louses, abusers and trivial — and the governmental arts agencies that support them will continue

to be subject to periodic attack by religious groups — until we decide that this vision of an artist is not our vision and work to change it.

Chapter 10.

Grants and Commissions

The first and last thing artists need to keep in mind about applying for a grant is that they may not get it. Rejection leads some artists to bitterness and dejection, an I-won't-get-burned-twice attitude that cuts off future options and attempts. The failure of a grant application to be approved may be taken personally as a negative judgement about the artist and his or her work or talent. Meanings are read into form letters and the psyches of those who approve or disapprove applications — many of whom serve as jurors on selection panels for only one grant cycle — are examined to discern prejudices and favoritism. Hell hath no fury like an artist scorned.

It is wiser to realize that *all* funding sources these days are beseiged by applicants — that's the reason for the form rejection letters — and that grantgivers need to look for reasons *not* to allocate money. Applicants who don't fill out the grant form completely or neatly, who are not residents of the right area (for instance, a German applying for a National Endowment for the Arts fellowship or a Maine resident seeking project funding from the Oregon Arts Commission), or who are not professional artists but art students, who are applying for money from the wrong organization (such as seeking a fellowship from the New York State Council for the Arts, which makes no individual grants), whose projects are not described succinctly or whose budget sounds inflated (or too low) — these are the easiest to dismiss and are eliminated eagerly as the decision-makers look to whittle down the stack.

There are lots of sources of support for individual artists and their projects, including governments on the municipal, state, regional and federal levels, foundations, churches, corporations, private individuals, colleges and universities. These kinds of support range from commissioning or collecting individual works of art to fellowships or artist-in-resi-

dence positions, in-kind services (Polaroid and Eastman-Kodak, for instance, provide equipment and materials to photographers) and exhibitions. Money, of course, is not free and often comes with some built-in strings that may or may not be onerous to certain artists. Government, especially on the local and state levels, prefers to support art projects that have a community benefit, while educational institutions look for artists who will patiently explain to students what they are doing. Corporate collectors rarely choose artists whose works express anti-business sentiments and churches aim for the decorative in what they purchase.

Government Support

Finding the right source of money for oneself or one's project is imperative, and the reference room of a public or art (museum or university) library is a good place to start. For grants from the federal government, one should look into the *Cultural Directory* (Smithsonian Institution Press, 1980), which lists various arts programs and the addresses of the granting agencies. The National Endowments for the Arts and Humanities are prime sources for artists, but so is the Defense Department (which commissions and collects works as well as sponsoring artist-in-residence positions), Housing and Urban Development, Commerce (technical assistance rather than money to individuals and groups), Small Business Administration, General Services Administration and Veterans Administration (both agencies commission works for new buildings), Labor Department, State Department and the United States Information Agency (which sponsor exhibits at embassies as well as cultural exchanges) and a number of others. Artists should write for applications from specific agencies for these arts programs, and they will receive information on how the forms should be filled out as well as deadlines for their submission.

Equally important is obtaining addresses and telephone numbers for state and municipal governmental arts agencies. For who and where to write for applications and program descriptions, one may request information from the National Association of State Arts Agencies (1010 Vermont Avenue, N.W., Washington, D.C. 20005, tel. 202-347-6352) and the National Assembly of Local Arts Agencies (1420 K Street, N.W., Washington, D.C. 20005, tel. 202-371-2830).

There are approximately 4,000 local arts agencies in the United States. An artist wishing to know what local agencies are near where he or she works and lives may get this information from NALAA, costing $20 plus 60 cents per page, or from the state arts agency itself which usually has a local arts development person on staff.

All state arts agencies and most municipal ones also hold free seminars from time to time on how and when to apply for grants as well as what the agencies may be looking for. Call or write for where and when the next seminar of this kind may be offered in your area.

Existing somewhere between the governmental and the private arts agency are regional arts support organizations that get most of their funding from state governments. There are seven of these:

Arts Midwest
Hennepin Center for the Arts
528 Hennepin Avenue, Suite 310
Minneapolis, MN 55403
(612) 341-0755
Serving Illinois, Indiana, Iowa, Michigan, Minnesota,
North Dakota, Ohio, South Dakota and Wisconsin

Consortium for Pacific Arts and Culture
2141c Atherton Road
Honolulu, HI 96822
(808) 946-7381
Serving American Samoa, Guam and Northern Marianas

Mid-America Arts Alliance
20 West 9th Street, Suite 550
Kansas City, MO 64105
(816) 421-1388
Serving Arkansas, Kansas, Missouri, Nebraska, Oklahoma and Texas

Mid-Atlantic Arts Foundation
11 East Chase Street, Suite 1-A
Baltimore, MD 21202
(301) 539-6656
Serving Delaware, District of Columbia, Maryland, New Jersey,
New York, Pennsylvania, Virginia and West Virginia

New England Foundation for the Arts
678 Massachusetts Avenue
Cambridge, MA 02139
(617) 492-2914
Serving Connecticut, Maine, Massachusetts, New Hampshire,
Rhode Island and Vermont

Southern Arts Foundation
1401 Peachtree Street, N.E., Suite 122
Atlanta, GA 30309
(404) 874-7244
Serving Alabama, Florida, Georgia, Kentucky, Louisiana,
Mississippi, North Carolina, South Carolina and Tennessee

Western States Arts Foundation
207 Shelby Street, Suite 200
Santa Fe, NM 87501
(505) 988-1166
Serving Alaska, Arizona, California, Colorado, Hawaii, Idaho,
Montana, Nevada, New Mexico, Oregon, Utah,
Washington and Wyoming

These groups have their own publications on what they look for in grant applications as well as where in their regions artists and arts organizations may apply for funds.

On the whole, the manner by which state, regional and federal agencies decide which artists should receive a grant is the same. Experts in the field (the particular medium or discipline, such as artists, curators, dancers, writers, theatrical directors) are brought in from outside the agency to form a panel that evaluates applications for need and artistic merit. The visual arts panel of the National Endowment for the Arts, for instance, includes five artists working in various media and one major museum curator. Those artists and curators are from various parts of the country, usually several from New York and California (which account for a little more than half of all the applications) and the others from somewhere between the two coasts. There is also usually a mix in artistic styles on each panel, such as a painter working in an abstract style and another who is an academic realist. Panelists are involved in only one year's group of applications, with a completely fresh batch of artists and curators brought in for the next funding cycle.

On the state and regional levels, the same criteria for applications hold true, and the panelists are frequently sought from out of the state or region in order to avoid (to the best anyone is able) the possibility of favoritism. On the municipal level, special panelists may or may not be brought in, depending upon the size of the city and the budget of the arts agency and they are likely to be local. (Panelists usually are paid, in the area of $1,000 on the state and federal levels.) In addition, "benefit to the community" is more frequently a criterion for applications. It is rare to find a fellowship on the municipal level, and projects need to involve people in

the area. In addition, the kind of art funded on the local level often must meet community standards of taste and appreciation. This is in contrast to the state and federal agencies, which have a greater likelihood of providing money to artists working in more avant-garde styles. Artists should try to match their kind of art to the agencies most likely to fund it.

Commissions for Percent-for-Art Projects

Governments don't need reasons to support the work of artists, but they frequently enact laws to make that support easier to justify. The statute that the federal government, some states and a few municipalities have created is known as the Percent-for-Art law. This requires the appropriate federal, state or city agency to spend between one-half of one percent and one percent of the construction or renovation costs of a government building on one or more works of art for that building.

The federal government's General Services Administration has been, since 1962, the largest sponsor of commissioned artwork by contemporary American artists, installing during that time more than 250 sculptures, murals, stained glass, graphic pieces, environmental works and other permanent works at the sites of newly constructed federal buildings all over the country. On occasion, the GSA buys a finished work but, mostly, the agency prefers to commission new pieces for which the artist may evaluate the site with the building architect, creating something that forms a visually aesthetic whole.

Between 15 and 25 commissions are made each year, ranging in value from $14,000 to several hundred thousand dollars, annually amounting to a little over $2 million. The GSA is always looking for new artists to commission, and the list of artists who have been hired over the past three decades includes both the well-known and largely-unknown. Those who wish to be considered should submit a resume and representative 35-millimeter slides (in a plastic slide sheet) of their work to the Art-in-Architecture Program, Public Buildings Service, General Services Administration, Washington, D.C. 20450. The slides are placed in the agency's permanent registry and continually reviewed. When deemed appropriate for a particular project, these slides are submitted to the artist nomination panelists for their consideration. It is advisable for artists to update their slides and resumes every five years as the agency is unlikely to track down those who have died or moved.

As one might expect, the sculptural works commissioned are the most expensive. As one might also expect, most of the pieces commissioned for the lobbies or courtyards of these federal buildings, 85 percent in fact, are

abstract art. That often is the cause of public criticism of these pieces; however, other, more figurative styles and other media are represented somewhere.

There is a multi-step process to selecting an artist for a commission. It starts with the project architect who works with the National Endowment for the Arts, members of the GSA's Art-in-Architecture program and selected members of the local community working together to develop a proposal for where the art should go and what type it should be.

The arts endowment then appoints a panel of art experts to meet with the architect in order to review visual material from the GSA's slide registry. The panelists may have some specific artists in mind, or they may simply try to pick certain artists whose work fits a look — for instance, abstract and minimalist sculptures or colorful, figurative murals. The final selection is made by the GSA's administrator who then negotiates a fixed-price contract with the artist. The contract award amount covers all costs associated with the design, execution and installation of the piece. Efforts have been made over the years to increase the percentage of local artists doing local projects and, with smaller commissions, the chances that lesser-known artists may be considered are improving.

In the midst of all this and while the chosen artist is preparing the work, the GSA attempts to involve the local community in seeing the proposed site and the design of the work as well as meeting the artist to discuss the ideas behind the piece. In one case of a GSA-commissioned piece by Alexander Calder in Grand Rapids, Michigan, the agency conducted an adult education class to acquaint the public with the artist and his works so that what came out would not be a total shock. This isn't the norm, but it was considered helpful as many people are quite dumbfounded by contemporary art. Some of those people react negatively.

Sculptor Guy Dill was commissioned by the GSA to create a large steel work in Huron, South Dakota where, according to Dill, "they had never heard of art and all of a sudden were getting a sophisticated piece of art. They didn't want it."

A plumber in Huron headed up a campaign to have the work removed. He was able to get several thousand signatures on a petition for this, although many of the names were found to be invalid.

Sam Gilliam, a Washington, D.C. painter, found himself blasted in the local press while he was working on a GSA project in Atlanta for which he was paid $50,000.

"I heard people complain about how people were being laid off, how they wanted government help, and here was someone getting $50,000 for a work of art," he said.

Among the largest to-do's over GSA-commissioned work occurred in Baltimore in 1977 and in New York City in 1985. In Baltimore, nine federal judges decided that they wanted nothing to do with a steel sculpture by George Sugarman outside a newly-built federal courthouse. The judges claimed that muggers could hide behind the work and rape secretaries who work late, or someone might place a bomb under it and people could be hurt by the flying shrapnel, or children might play on the work and get hurt. The claims by the judges were lambasted by newspapers and arts leaders around the country who said that the charges covered up the fact that the judges simply didn't like the work.

Richard Serra's "Tilted Arc," a 75 foot-long Cor-ten steel sculpture placed outside a federal building in New York City, raised a major art world ruckus, peaking in 1985 — when the GSA, reacting to widespread criticism over the piece, decided to move the work elsewhere — and continuing for a number of years through a legal battle over the terms of the original contract and the meaning of "site specific."

Those with thin skins clearly should not look for GSA commissions, although the projects do raise an artist's national profile.

Besides the GSA, The Veterans Administration's Art-in-Architecture Program (Washington, D.C. 20420) and the National Endowment for the Arts' Art in Public Places program (c/o Visual Arts Program, 1100 Pennsylvania Avenue, N.W., Washington, D.C. 20506) provide federal dollars for commissioned art projects around the country.

A number of states also have Percent-for-Art ordinances — Alaska, Arkansas, Colorado, Connecticut, Florida, Hawaii, Illinois, Iowa, Maine, Massachusetts, Michigan, Minnesota, Montana, Nebraska, New Hampshire, New Jersey, New Mexico, North Carolina, Ohio, Oregon, Rhode Island, South Carolina, South Dakota, Texas, Utah, Vermont, Washington and Wisconsin (as well as American Samoa, the District of Columbia and Guam) — and commissions are decided in roughly the same manner as the GSA (see Appendix). Some of the Percent-for-Art laws (such as in Florida, Hawaii, Michigan, New Jersey, Ohio, South Carolina and Texas) are not mandatory but permit the state to spend either one or one-half of one percent of construction costs on purchasing works of art. Some states (California, New York, Tennessee and West Virginia) have no specific Percent-for-Art legislation but do commission public works through special line-item appropriations. Some state Percent-for-Art laws require special administrative appropriations. Some states permit out-of-state artists to compete for projects. Most of these programs are administered by the state arts agency, while others are run by a department of capital planning or other state agencies, but the arts agency is the best place to

look for information on how and where to apply.

The state arts agencies will be able to indicate which cities or counties within the state that have their own Percent-for-Art laws as well as private groups sponsoring public art projects. Pennsylvania, for instance, does not have a Percent-for-Art statute, yet the cities of Philadelphia and Pittsburgh both commission artists for public works, and 23 cities or counties in California have their own Percent-for-Art or other public art programs.

To find out where to get in touch with either a state or municipal arts agency, contact the National Association of State Arts Agencies or the National Assembly of Local Arts Agencies (addresses listed above).

Damage and Neglect of Public Art: Other than a concern about potential criticism of work they create for a public commission, artists might also want to ensure that their work is looked after in a responsible manner. The GSA has money set aside for the care of the pieces it has purchased ($700,000 in 1990), but the same sort of budgeting does not exist on the state or local level where things are run on a catch-as-catch-can basis. The people assigned to take care of outdoor, public art are the same maintenance workers who keep the elevators running, the floors mopped, and are rarely given special training in preventing the kinds of damage that may ruin a mural, tapestry or sculpture.

The New Haven (Connecticut) Department of Cultural Affairs is one of the few places that has sought to take substantive steps to care for the more than $1 million in art it has purchased under a Percent-for-Art program since 1981, but its own actions revealed the extent of the problem for artists and the works they create. In 1989, the Department of Cultural Affairs established a special fund to refurbish or restore public sculpture and murals throughout the city, some of which dated back to the WPA of the 1930s, or even before. The first action of the city, however, was to find out just how much art the city owned, where it was located and in what condition it was in.

"It was confusing to know what to do," said Linda Stabler-Talty, visual arts coordinator at the Department of Cultural Affairs. "If you saw some public work that needed attention, who would you call — Parks and Recreation?"

The Department of Cultural Affairs is the first city agency in the country to take on this responsibility, although its budgetary commitment is still small. Other agencies on the regional, state and municipal levels have reason to do the same but simply don't.

Various private groups around the country have attempted to fill the void by caring for public works of art. For instance, in Philadelphia, a private foundation called the Fairmont Park Art Association has begun tending to the artworks in that city's parks and, in Seattle, a private non-profit group of artists called Artech has been hired by the city to take care of public sculpture there. New York City's Municipal Art Society and Chicago's Friends of Lincoln Park have also enlisted the support of the public through an Adopt-a-Monument campaign, using the money raised to provide regular care.

The agencies that commission the art should be compelled to care for it appropriately. Maintenance workers need to be shown that a work of art must be treated differently from a file cabinet and that there are special techniques involved in this care. It may well behoove the artists commissioned to create these pieces to discuss methods of care and the frequency of this care with the agencies involved, perhaps even writing these points into any contract. These works of art may be the most visible expression of the artist that the public will see and, if it is left to deteriorate through neglect (stained, later rusted because of pigeon droppings, automotive pollution or acid rain) or in the face of vandalism (such as graffiti), it can only injure the artist's reputation.

The Cost of Liability Insurance: It's ugly. It's a waste of taxpayers' money. Who are these con artists anyway? The debate over public works of art has generally centered on whether the public likes the way they look, but the rising cost of liability insurance, which artists or the agencies commissioning them must obtain while the work is being installed, is proving far more decisive in determining what (if anything) will be built. The insurance problem becomes even more critical as both the artists and the agencies may also have to maintain a high level of liability coverage for as long as the work remains in a public setting.

The cost of liability insurance and the not-infrequent difficulties that artists and their sponsors have in obtaining it may well undermine the future of the public art movement more than any public outrage over a particular work. This strong financial disincentive for both artists and agencies falls most heavily on lesser-known artists and smaller arts agencies, which are less able to afford the hefty insurance premiums.

The liability crisis is not peculiar to the arts; rather, the art world is affected just because everyone else is. Indeed, certain critical areas of insurance coverage, such as medical malpractice and liability policies for day care centers and manufacturers of potentially hazardous products, have

experienced much higher rate increases than others. Claims in these areas have reached the millions of dollars, resulting in demands by insurance companies for changes in the tort system — the legal process of obtaining financial remuneration for injury or damages. Enormous claims, according to insurance companies, force them either to raise their rates or drop policies.

Artists and arts agencies have been seriously hindered in their work by this situation, finding insurance premiums increasing between two and 10 times from one year to the next, if they can get insurance at all. With both performing and visual arts activities, high premiums are based on what insurors call their "high exposure" — the number of people who may see the object or event and become injured in an accident. The likelihood of suits grows with the number of public works of art and arts events.

There have been infrequent occasions of someone being hurt by an artist's work. A couple of injuries have resulted from children playing on Mark di Suvero sculptures, and lawsuits followed when workmen hired to assemble a Richard Serra sculpture in Minneapolis in 1971 and a Harold Kimmelman sculpture in Philadelphia in 1977 were killed in connection with installing the pieces. However, the current liability situation appears to have more to do with the insurance industry's complaints about the willingness of people to bring suit and receive large jury awards.

Many artists who are regularly commissioned to build public artworks — such as Alice Aycock, Claes Oldenburg, Richard Serra, Mark di Suvero and George Sugarman — maintain ongoing million-dollar liability policies, and others take out short-term insurance coverage when they are asked to create a piece. Most Percent-for-Art programs around the country require the artists to have a liability policy (valued at up to $1 million in some cases), at least during the work's installation.

Premiums for these policies may come to more than $5,000 a year, sometimes eating up much of the value of the commission for the artist. Many artists find that they are either unable to afford this insurance or simply cannot obtain it, due to the reluctance of companies to open up areas of potential risk.

In some instances, the contract between the artist and the agency commissioning the work may require the artist to have liability insurance from beginning to end of a project. The requirement may also extend to a year after transfer of title, usually in order to ensure that the materials and workmanship are of sufficiently high quality.

"I always write into my contracts with whoever is commissioning a piece that, once the work becomes the property of whoever is commissioning it, the piece becomes their responsibility and not mine," said sculp-

tor George Segal. "It would be unfair for an artist to have to carry a liability policy in perpetuity."

This is, however, a subject of some debate. Transfer of title, even transfer of title plus one year, may not free the artist from responsibility if someone is hurt in connection with the work, many lawyers believe. "An artist remains forever liable and cannot transfer that liability," one attorney stated, and others point out that, if someone gets hurt, the blame can always be with the artist for a poor design. Questions of which parties are actually liable in the event of an accident must be determined in court on a case-by-case basis.

Even more potentially frightening for artists is the fact that some insurance companies demand a say in which pieces they will insure. In the mid-1980s, an insurer told the Lower Manhattan Cultural Council to remove a nine foot-high plywood sculpture, which the arts group had recently commissioned, because it looked too risky. Cityarts Workshop, also in New York City, which sponsored the creation of murals, found that a basic element in its projects — community participation — had to be dramatically altered when its insurer stopped scaffold coverage in the early 1980s. Other insurers ask for a series of detailed drawings and models of the commissioned work in order for the piece to receive and maintain a liability policy up until its installation. The difference between telling an artist what to do and not permitting him or her to create it may prove negligible, and the result could be public art that is more conservative both in form and content.

Artists who do public works, and people who commission them, face enormous obstacles — from people who hate what they do, from others who vandalize or destroy their work, and from still others who may sue after getting hurt while climbing on their work. Donna Dennis, a sculptor who has had one public work in South Dakota used as target practice by gun enthusiasts and had another in Dayton, Ohio pipe-bombed, was asked some years ago to create a piece for the New York City Board of Education and based part of her decision on whether or not she could afford the liability insurance bill. She took the risk but, when one considers the costs involved and the fear that years later an artist may be named in a liability suit, blowing up public works may turn out to be the kindest thing to do for the artists.

Foundation Support

There are over 30,000 private foundations in the United States (spending $63 billion annually) and a portion of them make contributions to the

arts. The Foundation Center offices in San Francisco (312 Sutter Street, Room 312, tel. 415-397-0902), the District of Columbia (1001 Connecticut Avenue, N.W., tel. 202-331-1400), New York City (79 Fifth Avenue, tel. 212-620-4230) and Cleveland (Kent H. Smith Library, 1442 Hanna Building, tel. 216-861-1933) have libraries of information on who gives money for what, and a section of that library is devoted to the arts. For those who cannot make the trip to any of these four cities, however, many of the same publications can be found at more than 180 cooperating libraries or branch offices (call or write for the nearest locations), and the Foundation Center also publishes two books that many libraries around the country purchase, *Foundation Directory* and *Grants to Individuals.* These books can be purchased by individuals from the Foundation Center, but they are expensive, costing $125 and $26, respectively.

The *Foundation Directory* includes information on 6,000 of the country's largest foundations (defined as having assets of $1 million or more or making grants of $100,000 or more), while *Grants to Individuals* notes 1,200 foundations with all sizes of endowments and grants. Both books are at best modestly useful to individual artists. Only a small portion of the foundations listed in the *Directory* provide any money for the arts, and most of this is for organizations (largely performing arts groups). To have a chance at this money, individual artists might look for an arts organization (known in the field as an "umbrella organization") to sponsor the artist for a particular project as a way to become acceptable to the prospective foundation(s).

That, of course, eliminates individual fellowships from consideration, putting project grants in their place, and these are clearly different kinds of arts support. Individual fellowships are much more no-strings-attached affairs, with artists provided year-long money as a reward for good quality work in the past and the hope for even greater success in the future, as the fellowships are intended to ease economic burdens that presumably get in the way of creativity. Project grants involve contractual obligations to do a specific thing during a certain period of time. Whole plans must be thought-out, approved by community or civic groups that the project would serve; permits need to be obtained (if necessary) from any governmental agency and a budget should be prepared in detail.

When an umbrella organization is involved, the process of putting together an entire project may be lengthened considerably as an artist must convince yet another group of people, some of whom may want to have changes made in the design, concept or something else as well as getting a cut of the funding — usually, 10 percent.

An umbrella organization can be any nonprofit group (in or out of

the arts) that is eligible to apply for a governmental grant. However, the umbrella organizations most likely to receive grants are ones with a track record of successfully accomplishing arts projects of that sort. Artists should also question whether or not the possible arts project fits into the plans and image of the umbrella organization and if that group will be able to get the grant. An organization in turmoil or whose history includes antagonism with governmental officials or community leaders might be a poor choice as an umbrella. It is for that reason that artists should contact the relevant state arts agency or the National Endowment for the Arts for the name and address of an appropriate organization that might serve as an umbrella.

It is also true that the significant amount of paperwork involved in applying for a grant, coupled with the small cut of the grant money received, may lead an organization to decline to act as an umbrella for a project.

The grant payments for projects themselves are frequently different from those for individual fellowships. With a project, an artist may have to submit invoices for actual expenditures to the funding source for reimbursement (up to the amount provided in the grant), and the reimbursement process may take time. The fellowship, on the other hand, is paid by one or more checks provided promptly. Everyone prefers a fellowship, but fellowships, like general operating support for a museum or arts organization, are relatively rare and project grants tend to be the main source of financial assistance in the arts. Better find an umbrella.

Moneygivers are often averse to giving a grant for a project that would absolutely not take place without that grant. They like to see that other sources of support have been obtained, such as from a company, foundation, religious or cultural institution, governmental agency or private donations, that make this project look like a steam roller that they should get on board. Nothing succeeds like success in the world of grant applications, and artists who appear prosperous are more likely to do well.

Grants to Individuals is perhaps more helpful to artists than the *Directory*. Most of the 1,200 foundation sources offer aid to educators — researchers and scholars — and only 45 or 50 provide money for individual artist fellowships. That is, however, a start and may be worth the time slogging through the book.

A bit more helpful than the Foundation Center's library is the Arts Resource Consortium Library at the American Council for the Arts (1285 Avenue of the Americas, New York City, tel. 212-245-4510 or 800-232-2789) where the arts and individual artists particularly are a central concern. That library has annual reports and grant applications for both the

National Endowment for the Arts and the New York State Council on the Arts as well as a variety of career manuals for artists and books on where to find money. Besides money concerns, the Resource Consortium Library also offers information on legal, insurance, housing and other matters of great interest to artists.

An additional source of information and potential money is The Funding Exchange (666 Broadway, New York, NY 10012, tel. 212-529-5300), a group of 15 politically active, left-of-center private foundations around the country that occasionally provide funds for art projects related to community organizing or current social issues.

In general, four main points need to be made in an application, certainly for foundations and often for government and corporate sponsors: The first is to clearly define the nature of the art project and its importance as well as indicate that it is do-able. The second is noting the experience and qualifications of the person, team or organization planning to accomplish the project. Third, it is important to note that other factors (such as facilities in which to site the art project, support of colleagues, an institution or town body, availability of materials and other sources of financial support) that ensure the project will be successfully realized are in place. Finally, the project should be of the sort that the foundation to which one is applying has shown a decided preference. That final point needs to be discovered through research in the various publications. Potential sponsors who have clearly indicated an interest in projects that assist the educational process in public schools, for instance, may be more interested in an arts-in-the-schools idea than a community poetry reading.

Church Support

"There has been a general feeling that we in the church have neglected the relationship of the arts and religion, and there has been a movement towards church support of arts activities," said David Read, Minister at the Madison Avenue Presbyterian Church in New York City and one of the founders in the early 1960s of the Society for the Arts, Religion and Contemporary Culture.

Churches of all denominations have reemerged as patrons of artists, although their role has changed greatly since the Middle Ages and Renaissance. It is less a commissioner of art (although that does sometimes take place) than a promoter of the arts, frequently inviting art exhibitions, concerts and theatrical performances to be held on church premises. The Episcopal Cathedral of St. John the Divine in New York City, for instance, has its own in-house composer, avant-gardist Paul Winter, as well as an

apprenticeship program for sculptors and artists in stained glass and other media. Also in New York City, at the base of the Citicorp Building in midtown, is St. Peter's Lutheran Church whose chapel was designed by sculptor Louise Nevelson and which holds 23 short-term (one to three months) and long-term (three to six months) exhibits of both well-known and lesser-known artists.

Equally novel is the Boston Jazz Ministry, led by Mark Harvey, a Methodist Minister and jazz trumpeter, at Boston's Emmanuel Church — an Episcopal church. The jazz ministry presents jazz liturgies in regular concerts and also provides counseling (career and psychological) and community organizing for artists.

In Miami, Temple Beth Sholom opened a "selling" gallery, highlighting the work of Jewish artists — such as Ben Shahn, Chaim Gross, Jack Levine and a number of contemporary Israelis — with profits going toward the purchase of other works of art in order to establish a permanent collection of art and Judaica for the synagogue.

The Pacific School of Religion in Berkeley, California and the Wesley Theological Seminary of American University in Washington, D.C. both have artist-in-residence programs, and the Metropolitan Memorial Methodist Church in Washington, D.C. has a ministry of the arts that integrates all of the arts into the worship setting. There are other artist-in-residence programs at churches around the country, and the Ford Foundation's Affiliate Artist Program (run from its New York City headquarters) pays a full year's salary to be part of an artist-in-residence program, which can take place in a church as well as at a public school.

Commissioning artists to create new works for a church still goes on, with opportunities becoming available all the time. Most church national headquarters have art and architecture committees, in charge of selecting artists for churches that are being built or renovated. Among these are the Union of American Hebrew Congregations (Department of Synagogue Management, 838 Fifth Avenue, New York, NY 10021), Evangelical Lutheran Church of America (Division of Church Music and the Arts, 8765 West Higgins Road, Chicago, IL 60631), United Church of Christ (United Church Board for Homeland Ministries, 132 West 31 Street, New York, NY 10001, attention: Secretary for Church Building), Presbyterian Church (100 Witherspoon Street, Louisville, KY 40202, attention: the Art Committee), Episcopal Church (815 Second Avenue, New York, NY 10017, attention: Director of the Building Fund) and the United Methodist Church (Fellowship of United Methodists in Worship, Music and Other Arts, 159 Ralph McGill Boulevard, N.E., Suite 501-C, Atlanta, GA 30365).

All of these churches accept slides and biographical information from

artists and will pass on recommendations to member churches in need of someone to create some object for a church. Artists may have just as much luck applying to churches in their areas as well, regardless of whether or not art has ever been purchased, commissioned or displayed in the past. It also doesn't hurt to ask the clergyman; even if that church is unable or uninterested in having anything to do with art, there may be other churches looking for more of an art presence in the local community.

Churches vary greatly in terms of whether they seek works that are religious in orientation or simply that reflect a favored artist or style. The Union of American Hebrew Congregations looks for Judiaca, such as Torah curtains and mantles, while St. Peter's Lutheran Church in New York City was free-wheeling enough to commission Willem de Kooning to create a $1 million three-panel altarpiece.

In addition, the Interfaith Forum on Religion, Faith and Architecture (1777 Church Street, N.W., Washington, D.C. 20036) keeps a registry of artists' slides and biographies, both for its annual juried show — which awards certificates of merit to 13 winners and puts these works on display at the group's annual Spring conference — and for referral, as church officials from all over the country frequently call to find appropriate artists and architects.

Other denominations have less central governance, and individual churches tend to be self-governing. With Baptists, Catholics and Christian Scientists, churches need to be addressed individually. As opposed to the Catholic church of Renaissance times, churches today have far less money to spend on major works of art. A few here and there, however, develop collections.

Part of the reason for the changing attitude toward the arts by many churches has to do with the kind of seminary student increasingly embarking on this vocation. Often, they are no longer just philosophy or religion majors right out of college but, rather, older second career people who have had some experience with the arts and want to integrate culture with church teaching.

In addition, the change reflects the influence of Paul Tillich (1886-1965), the German-born American theologian and philosopher who wrote that the arts posed questions that theology ought to answer. According to Doug Adams, a professor at the Pacific School of Religion in Berkeley, California, Tillich saw the arts as "an early warning system for theologians about questions that society and the general culture were raising."

Who Decides Artistic Merit?

Not everyone fits well into the grant awards process. Albert Einstein, who stated that "I am a horse for single harness, not cut out for tandem or team work," devised the theory of relativity while employed in a patent office, and Sinclair Lewis' bittersweet novel *Arrowsmith* was based in part on the experience of Paul de Kruif at the Rockefeller Foundation.

Coming up empty when applying for a grant or commission is an ever present possibility, but hope should never be lost. Successful grant recipients, like most recent contenders for the United States presidency, tend to try again and again until finally getting approval. Funding priorities and the people who make the final decisions change from year to year (as do application forms and deadlines for their submission at foundations and governmental arts agencies), and rejection may result only from this year's crop of deciders.

Every year, thousands of artists are selected to be in exhibitions, to receive awards and stipends. The quality of their work is judged (largely) sight-unseen, based only on slides, and an industry of artwork photographers has come into being in order to help artists present their creations in the best possible light.

But who are the judges determining an artist's career based on one-inch by one-inch transparent slides? With more than 22,000 juried arts and crafts shows taking place annually and fellowships offered by municipal, state and federal government arts agencies as well as private foundations, there is no one type.

There is also no single number of jurors that is generally recognized as best for making these decisions. Many private, nonprofit organizations make do with just one person — deciding which of the applicants for a juried art show are to be included — while most governmental agencies, which provide fellowships to resident artists in a variety of disciplines, use between three and five.

However, every organization or agency has its own rules and ways of doing things. For instance, the Pollock-Krasner Foundation in New York City, which makes grants to emerging artists, involves 10 people in the process (three program staff members, the four people on the Committee of Selection, the foundation's chief operating officer and the two members of the Board of Directors), and some other organizations — such as those run by artists — will go as high as a 15-member artistic committee.

Ethical considerations are paramount, regardless of the actual number of people making decisions. If it is a one-person jury, that person usually is different for each exhibition so that no aesthetic prejudices are established from one year to the next. Multi-person juries or panels are

also often rotated on and off to maintain a flow of ideas. The Artists Foundation in Boston, according to outreach coordinator Cyrus Cassells, looks for "distinguished people in their field from out of state so as to take politics right out of judging" — that is, a local juror knowing a local artist.

Many art organizations outside major urban centers that hold juried exhibitions seek jurors from the big cities. Often, the reason is prestige, perhaps a factor in the decision of the American Association of Retired People to choose Susan Larsen, curator of the permanent collection of New York City's Whitney Museum of American Art, to judge a show of members' artwork. Another reason is the assumption that someone from a major urban institution will maintain high standards of quality when assessing works by regional artists.

A third reason may be exemplified by Berkshire Artisans in Pittsfield, Massachusetts, which has a very conscientious policy with regard to the person selected as the annual juror. That organization chooses people who have been judges elsewhere and whom they have never met.

"If they know the artists whose works they are jurying, they may be swayed by personal feelings," Dan O'Connell, artistic director of Berkshire Artisans, said. "I don't think any of the people who have done jurying for us have ever seen the gallery or have ever been to Pittsfield. I can only guess whether they've ever been to Massachusetts."

One of those jurors was an official at the Texas Commission on the Arts. Another was Renato Danese, director of New York City's prestigious Pace Gallery.

A former curator at the Baltimore Museum of Art who worked in both the museum services and visual arts programs at the National Endowment for the Arts in Washington, D.C. in the 1970s, Danese said that he tries "to approach individual works of art without preconceived notions. I look for quality in whatever style or medium I'm looking at. In all candor, what you'll find in a regional juried show is a great range of work, from traditional academic painting to work by artists who have their nose in the avant-garde and are influenced by it."

Although the Pace Gallery is known for its exclusively avant-garde work, much of which is based on abstraction, he noted that "I have no prejudices against realist landscapes, for instance. A lot of the best art ever produced in America are realist landscapes, and I know to judge each work on its own merits."

Danese said that he "sought to take each artist as an individual entity," a point of view held by many people who do jurying.

Susan Larsen of the Whitney Museum also felt that she can evaluate art that is wholly in contrast to that which is displayed at her institution,

stating that "I'm not prejudiced by the way something looks. I look for evidence of a personal statement. I look for a voice that I haven't heard before and, unless I hear that voice, I'm not terribly interested in the art no matter what it looks like."

She added that much of the work she sees in exhibitions outside of the major urban centers tends to look alike, which she attributes to "various factors: One is the influence of a single teacher; another is a consensus in the community of what they like and will buy; the third is how-to books that everyone reads and everyone obeys down to the letter."

On occasion, however, she will find someone whose work is truly striking. That doesn't necessarily translate into that artist finding him- or herself immediately selected to be in the next Whitney Biennial, "but it might lead to a word-of-mouth recommendation. Someone may ask me if I've seen anyone good in the Northwest, and I'll remember some artist whose work I thought was really good and mention that person's name. That can go a long way."

Judging artists' slides is not a money-making enterprise for anyone, as the payment ranges anywhere from $50 to $1,300 and often involves many hours, days or weeks of work that all has to be done quickly, considering the mountains of slides and applications to go through. The National Endowment for the Arts has recently upped its fees from $75 to $100 a day (usually between three and five 10-hour days), not including any travel, hotel and meal expenses whose rates are established by the federal government's General Services Administration depending on location (Washington, D.C. is worth $121 a day). The larger art competitions generally pay up to $1,000 for jurying their shows, also not including travel expenses; the Artists Foundation pays between $1,100 and $1,300 (flying in out-of-staters), while Berkshire Artisans pays $200. For its part, the Guggenheim Foundation in New York City, which awards fellowships to scores of artists every year in a variety of disciplines, uses "people who are well recognized in their field as panelists," according to a spokeswoman, adding that they all provide their expertise for free.

Jurying tends not to be something art experts do for the money; rather, it is for the exposure to different art than they might otherwise see. Especially for those jurors who are art dealers or curators, looking at art is what they do for a living anyway, and they usually like it.

Many artists look to juried shows to bring in new buyers (or new orders), and the failure to be included in a particular prestigious display may damage one's livelihood and career. Frequently, the charge of bias is raised at jurors by a particular artist who is not chosen, and that is why many groups go to such lengths to establish an impartial jurying system.

Rotating jurors — that is, alternating the subjective opinions that put a display together — may mean that certain artists are in one show, but not in another. No one should be rewarded for selection in last year's show by inclusion in this year's, for these shows do not exist simply to help market a specific group's work; rather, these shows are intended for the public, and different work needs to be seen in order for visitors to remain interested from one year to the next. Artists who put too much of their emphasis on certain shows for their livelihood, instead of diversifying their marketing strategies, will always look to the jurying system with longing and dread.

Chapter 11.

Other Kinds of Support for Artists

Few people believe that it pays to be an artist, but at least some artists pay a little less for goods and services because of what they do. A variety of services exist either for free or at discounted prices for artists, including housing, studio space and office equipment as well as the work of accountants, consultants, doctors, lawyers.

Art Colonies

There are many differences among the 30 some-odd art colonies existing around the country (see Appendix), most of which are along the East Coast, but they are all united by their determination to provide artists with uncluttered time and space in which to work.

Distractions are pared down by the rural settings of most of the colonies and the paucity of telephones, which are usually not located in any of the living areas or studios assigned to artists. It is actually difficult to get in touch with someone at The MacDowell Colony in Peterborough, New Hampshire, as telephones are almost nonexistent, and colony rules prohibit anyone from entering an artist's studio uninvited during the main 9 a.m.-5 p.m. work period. Literary readings, performances, exhibitions and just talk itself tend to be on an ad hoc basis, unscheduled and arising from the mix of people who happen to be at the same place at the same time.

Residencies at colonies range from two weeks to two or three months, with some lasting six or eight months. The Millay Colony in Austerlitz, New York, for instance, invites 60 people a year for one-month residencies with no more than five writers, composers or visual artists at any given time, while the Virginia Center for the Creative Arts at Sweet Briar takes

in an annual 294 artists of all· media for stays of between 30 days and several months with 21-24 people in residence at a time. The Millay Colony is also notable for its refusal to ask artists for application fees (between $10 and $20 at most colonies) or for contributions toward the cost of their stay. Most other colonies ask or demand something — the Hambridge Center for Creative Arts in Rabun Run, Georgia charges between $60 and $75 a week, while the Cummington Community of the Arts in Massachusetts requires $500 a month. It is true, of course, that the fees in no way cover the actual costs of these retreats but are contributions toward the total operating budget.

Various review committees, comprising notable artists, editors, curators and others with expertise, evaluate applications from artists wishing to have a residency. The quality of the candidate's work and whether or not a case has been made for the artist needing a block of uninterrupted time to begin or complete a new project are generally the main criteria for selection.

Some colonies also specialize in particular areas of the arts, although most are interdisciplinary. Real Art Ways in Hartford, Connecticut, for example, is oriented toward video and mixed media artists, while the Institute for Contemporary Arts in Long Island, New York is intended for sculptors and printmakers. Curry Hill Plantation Writer's Retreat in Hattiesburg, Mississippi, the Shenandoah Valley Playwrights Retreat in Staunton, Virginia and Mildred I. Reid Writers Colony in Contoocook, New Hampshire focus on novelists, poets and playwrights.

"There's a wonderful thing that happens at colonies when people from different disciplines get together at dinnertime," Ann-Ellen Lesser, executive director of The Millay Colony, stated. "Artists find that they learn a lot about their own art forms by talking with others about their work. People begin to see that they have basic attitudes in common. That gives a three-dimensional quality to the colony."

Another difference among colonies is whom they choose for residencies. MacDowell and Yaddo (in Saratoga Springs, New York) may be more apt than others to select artists who have substantial professional standing, having published, performed or exhibited work and received some notice, than others which focus on the emerging artist. Even among those aimed at emerging artists, there are differences. "We focus on emerging artists," Mary MacArthur, executive director of The Fine Arts Work Center in Provincetown, Massachusetts, said, adding that "emerging" means "some publishing but no book yet or some exhibiting but no major shows yet."

Yet others attempt to establish a mix between the better-known and lesser-known artists in order to balance innovation and professional standing.

The Virginia Center for the Creative Arts, on the other hand, according to its executive director William Smart, welcomes "serious amateurs," defining "serious" as showing a "seriousness of purpose. Keep in mind that Anthony Trollope was a school inspector and wrote 40 novels on trains traveling between schools. T.S. Eliot worked in a bank most of his life. We don't assume that having a job and only being a Sunday painter makes anyone less serious, or less of an artist, if the work is good."

While offering the chance to work without distractions is the aim of all artist colonies, none keep tabs on anyone to ensure that work is being done. Different artists respond to this freedom in different ways, most taking the opportunity to work hard. Some people work too hard and burn-out within a month.

Other artists find the mostly secluded colony locations and the lack of diversions to be claustrophobic. "Some people are very much city types, thriving on things to do and phone calls," writer Peter Viereck, who has had residencies at MacDowell, Millay and the Virginia Center for the Creative Arts, said. "Hart Crane needed loud jazz music to write his poetry; that would drive me crazy. But you do get people coming to these colonies who spend their time playing cards or ping-pong, maybe talking about their art but not doing anything. They come here and think, 'Golly, now I've got to be creative. What do I do?' For some people, that could be the kiss of death."

He added that there are also "colony bums" who go from one colony to the next, less for the desire to have the time and space in which to work than because they are professors on sabbatical who "line up one colony after another" to fill up the year. These people, he stated, tend not to do very much work and "by the second or third colony have lost their freshness."

Colonies also get their share of repeaters who are invited back year after year — almost 40 percent of those who go to Yaddo, for instance, have been there before — although the increasing desire is to bring in new faces, representing more women, minorities and a geographical mix.

There are many reasons, however, why colonies are not for everyone. It is more often than not the case, in fact, that artists spend a week trying to get used to their surroundings and the freedom before getting down to work. Colony staff members also try to spot people who seem lost and help them get on track. Most do, but some don't or not completely. Those types generally leave early.

Both Mary Frank and Jules Olitski left Yaddo before their respective residencies were up, she because "it was a difficult time in my life and I found it hard to settle down to work, especially since I didn't know what

kind of work I wanted to do," and he because "it was not my studio. It was not my air, not my choice of whom I was talking with or listening to. It wasn't a problem with Yaddo — Yaddo was fine, it was a lovely setting and everything was taken care of — but a personal thing at that time in my life. I did a little painting there, but it didn't really work for me. I found myself doing more writing than painting, writing a short novel about a lesbian witch."

The kind of person who may benefit from an art colony is someone who has something specific to do or who simply needs unfettered time to pursue ideas. "It takes about a week to adjust from what you came from to having everything done for you, but then your work really gets going," Benny Andrews said. "People serving you food, leaving you alone when you want. Man, I could get used to that."

In-Kind Services and Discounts

Receiving commissions, uninterrupted creative time or fellowships are always welcomed by artists, but just as important are materials and services for free or at discounts.

For example, US AIR, the Washington, D.C.-based airline carrier, offers $20,000 in free tickets to a number of performing arts groups in the nation's capital in exchange for promotional notices in these companies' playbooks. New York City's Department of Cultural Affairs has a Materials Donation Service where artists and arts groups may pick up for free such things as paint, office supplies, tools, lumber and metal or anything else that institutions and corporations have discarded. In addition, many art supply stores provide discounts of up to 25 percent to artists. Many lawyers, dentists and doctors as well as various appliance dealers and even hotel operators are willing to trade their goods and services in whole or in part for works of art (see Bartering and Leasing in Chapter 2). Companies as well as professionals may be approached directly about their willingness to trade or provide equipment.

No less interesting, although limited to Chicago artists, is Chicago Artists Abroad (Dept. AA, Columbia College, 600 South Michigan Avenue, Chicago, IL 60605, tel. 312-663-1600), which is funded by the Paul and Gabriella Rosenbaum Foundation and provides funds so that professional artists in that city can perform or exhibit abroad.

Various accountants and lawyers around the country have established volunteer programs for artists and arts organizations, providing their services for free or small fees.

There are, of course, criteria that eligible individuals and organiza-

tions must meet to receive these services, among which are residency and small incomes (nonprofit groups must be registered charitable organizations). Both Texas Accountants & Lawyers for the Arts in Houston and St. Louis Volunteer Lawyers and Accountants for the Arts require artists to submit copies of past tax returns that show net income of $15,000 or less. Washington (D.C.) Area Lawyers for the Arts, which has an accountants program, sets its income guidelines at $12,000 for individuals and $18,000 for families. There is a certain flexibility in this, as small allowances for additional family members (who may generate income) or student loans or sizeable fluctuations in income from one year to the next can be made. Arts organizations also generally must meet certain levels of income eligibility, usually between $50,000 and $100,000 for their annual budgets, although any problem they bring in will be handled. At volunteer lawyers groups, legal consultantions are free but an administrative fee of $10 for individuals and $20 for organizations may be charged, and there are other costs for those wishing to incorporate as a not-for-profit. California Lawyers for the Arts also has an arts arbitration and mediation service that uses a panel of artists, attorneys and arts administrators to conduct hearings and resolve disputes. The charge for this service is $25 or five percent of the amount in controversy, whichever is greater.

At both the accountants and lawyers groups, the question of who is an artist is not one that is probed too deeply, although the problem under discussion must be arts-related.

Not all of these volunteer programs provide the same services. Most answer tax and legal questions over the telephone and offer free or low cost group seminars on such issues as accounting, taxes, record-keeping, gallery contracts and copyright. Not all of the accountants programs, however, provide free help with tax returns. Many of the accountants limit their activities to instructing artists and organizations about what they may deduct, how to inventory their work, what losses to take, what tax forms must be filed, what income counts as income and how to organize their recordkeeping instead of, as many volunteer accountants complain, storing all their receipts in a shoe box. Even those whose accountants will take on preparation of tax returns on a pro bono basis generally won't touch them between February and April 15th, the height of the tax season, and artists are usually advised to file an extension so the accountant can get around to them by the summer. In addition, all filing fees, tax payments and any fines must be paid by the artist.

In general, volunteer lawyers groups seek to settle problems with a consultation or two, avoiding litigation whenever possible. Litigation is

burdensome on a volunteer because going to court takes a lot of time, and it is also possible that other lawyers in the community will take the case on a contingency basis.

There are nine volunteer accountants and 43 volunteer lawyers groups around the country and Puerto Rico (listed in the Appendix). Not every state and city is served by official groups, but there are professionals who are known to offer their services and advice. Artists as well as arts organizations in search of free or discounted help in this area should contact their state bar association or Accountants for the Public Interest (1625 I Street, N.W., Washington, D.C. 20006, tel. 202-659-3797) for names and addresses of individuals or groups who help artists or low-income individuals.

A New York City group, Doctors for Artists (123 West 79 Street, New York, NY 10024, tel. 212-496-5172), refers visual and performing artists to specialists who have agreed to discount their fees by 20 percent or more, and both Northwest Memorial Hospital in Chicago and the Kathryn and Gilbert Miller Health Care Center for the Performing Arts of Roosevelt Hospital in New York City treat the career-related physical ailments of performing and visual artists at reduced fees.

Aside from services that are free, organizations also exist to put money directly into the hands of artists. The Artists Foundation in Boston (8 Park Plaza, Boston, MA 02116, tel. 617-227-2787) raises money for, and manages, the Artist Emergency Loan Fund which provides both no-interest and low-interest six-month loans of up to $500 for artists who are in need. The Artists Welfare Fund in New York City (32 Union Square, New York, NY 10003) also provides interest-free loans to artists who have medical emergencies, and The Craftsman Emergency Relief Fund (CERF, Suite 9, 1000 Connecticut Avenue, N.W., Washington, D.C. 20036, tel. 413-625-9672) offers low-interest loans and outright grants to those working in the crafts field suffering from career-threatening ailments.

In addition, a number of artists have set up foundations to aid artists and arts organizations (see Appendix), including the Adolph Gottlieb Foundation, which assists older artists, as well as the Jackson Pollock-Lee Krasner Foundation and Robert Rauschenberg's Change, Inc., which provide emergency money for artists. The Alice Baber Foundation emphasizes women artists. Andy Warhol, Robert Mapplethorpe and Keith Haring also set up foundations from their estates, although their gift-giving in the arts is exclusively devoted to arts organizations — the Robert Mapplethorpe Foundation, for instance, provides money only for existing institutions for the development or expansion of photography departments. Sculptor Mark de Suvero established the Athena Foundation which

does not give money but does provide an exhibition space for artists at his Long Island City sculpture garden.

Financial assistance, free or discounted goods and services cannot replace artists simply receiving more money for their work, although they're not a bad second best. They reflect this country's form of appreciation and compassion for the creators of art — less than a guaranteed wage but more than a pat on the back.

Chapter 12.

Artists and the Government

It probably doesn't occur to many art collectors to purposefully alter, mutilate or destroy a work of art that they have purchased, but it has happened occasionally. Among others, it has happened to the creations of sculptors Alexander Calder, Isamu Noguchi and David Smith as well as painters Arshile Gorky and Pablo Picasso.

Now, because of the Visual Artists Rights Act of 1990, it may be less likely to happen in the future. The new law, an amendment to the federal copyright law, provides visual artists (narrowly defined as painters and sculptors as well as printmakers and photographers who produce limited editions of 200 or fewer copies of their work) with the right of attribution (to claim "authorship" of their work and object to false attribution). The law also affords artists the right to prevent the owners of their work from distorting or altering their creations without their consent and, in the case of works of "recognized stature," to prevent their destruction.

The law is the outcome of more than a decade of political activism on the part of artists, but it is also a symptom of a general ongoing campaign around the country to regulate the art trade and ensure fair treatment for artists. Looking around, one sees a growing body of art law on the state and federal levels.

Among the main points in this already sizeable body of law are consignment agreements between artists and art dealers (requiring dealers to whom artists have consigned their work to pay the artists after any sales within a reasonable period of time as well as provide an accurate accounting of what sold and for how much), bankruptcy provisions (prohibiting works consigned by artists from being seized by creditors if the gallery owner goes bankrupt), art print disclosure laws for the sale of graphic works of art, warranties of authenticity, permission for artists to submit

their artwork in lieu of a check for the payment of taxes, "moral rights" codes similar to the Visual Artists Rights Act and even "resale royalties" that turn over to artists a percentage of the profit when their work is sold again. Massachusetts has a "Schlock Art" law (requiring dealers of low cost, imitative paintings to label these works "nonoriginal").

More may be on the way eventually, such as copyright protections for the work of commercial artists and restoring the ability of artists to deduct the full market value of their creations when they donate these works to charitable institutions (they currently are only allowed to deduct the cost of their materials). The protections granted in the Visual Artists Rights Act may eventually be extended to include other art forms, such as the "colorization" of old black-and-white movies.

These and other laws reflect the growing sense that the art world is a business like any other, where a great deal of money changes hands, and needs increased governance. "Art has gotten more expensive and has attracted new laws," said Stephen Weil, deputy director of the Hirshhorn Museum in Washington, D.C. "Anything that attracts that much money is bound to be a target for frauds and governmental legislation."

The expanding body of law also reflects the growing number of lawyers who are devoting all or part of their time to defend the interests of artists, collectors, dealers and museums. There are more than 40 volunteer lawyers for the arts organizations around the country, for instance, composed of attornies who advise and sometimes represent needy artists in their battles with the art establishment. The growing number of books available to artists in this area — including *Legal Guide for the Visual Artist, The Artist's Friendly Legal Guide,* and *Business and Legal Forms for Fine Artists* as well as general career guides for artists that include sample artist-dealer contracts — also testify to the growing self-perception of artists as individuals with rights and not just sensitivity.

The art market has traditionally been a business where a good many of the deals are made on a handshake, without benefit of lawyerly provisos. That sense of trust and good faith has been eroded with the growth in prices for art as well as in the numbers of buyers and art galleries all over the country.

One of the benefits of art legislation is that it usually doesn't cost the government significant amounts of money through lost treasury. Congress, however, where thousands of pieces of legislation are introduced every year, has been slow to address calls for specific art laws — it took 10 years, for instance, for Congress to pass an art materials labeling bill that lets artists know whether or not there are toxic ingredients are in the products they regularly use — and the state assemblies have proven more re-

sponsive. It was, in fact, precisely because a number of states around the country had enacted their own labeling laws, each a little different than the others, that art supply makers turned to Congress to create one national code. It took another dozen years for Congress to pass the Visual Artists Rights Act, during which time 10 states (California, Connecticut, Louisiana, Maine, Massachusetts, New Jersey, New Mexico, New York, Pennsylvania and Rhode Island) passed their own versions.

Ten states — Arkansas, California, Kansas, Kentucky, Maryland, Michigan, Nevada, Oregon, Rhode Island and South Carolina — have passed laws allowing artists to deduct their own charitable contributions of artwork on the basis of the pieces' fair market value for state tax purposes. In six states — Connecticut, Kentucky, Maine, Michigan, New Mexico and North Carolina — inheritance taxes may be paid with artworks (California had a statute permitting this but later repealed it). In addition, three states (Massachusetts, New York and North Carolina) permit artists to deduct the cost of their living-working space for tax purposes.

Since 1981, eleven states (Arkansas, California, Georgia, Hawaii, Illinois, Maryland, Michigan, Minnesota, New York, Oregon and South Carolina) have all enacted print disclosure laws, requiring the sellers of art prints to reveal how many prints are in a particular limited edition, whether there are other editions of the print in existence, whether or not the plates are still intact (determining if another edition is possible), the year in which the printing took place and the name and address of the printer.

These laws, as art sometimes is itself, are frequently imports. For instance, the United States did not become a signator to the Berne Copyright Convention, an international copyright law first devised in 1886 that stipulates moral rights for artists, until 1988. The Visual Artists Rights Act is based on legal concepts established in French law for decades. These include the right to determine when a work has been completed (first brought to court by James MacNeil Whistler in 1900, later tested by the heirs of Georges Rouault), the right to always have one's name credited with the work (including advertisements) and the right to prevent one's work from being shown in a way that might harm the artist's reputation (tested in the French courts by painter Bernard Buffet in 1962).

"Moral rights" statutes reflect a changing view of property rights in this country, at least as far as artwork is concerned. Allen Sieroty, former California State Senator who sponsored the nation's first state "moral rights" law for artists in the mid-1970s, stated that "Americans are very concerned with private property and, when we were pushing through the

legislation, we were constantly asked whether the concept serves as a deprivation of private property since artists will still retain an interest in their works. We had to convince legislators that there are already restrictions on the use of private property. Just think about what zoning is."

One of the first highly publicized instances of intentional distortion of a work of art occurred in 1958 when a black-and-white mobile by Alexander Calder, displayed in a building at the Greater Pittsburgh International Airport, was turned into a stationary sculpture and painted the city's official colors, green and gold. A few years before that, sculptor David Smith condemned a purchaser of one of his painted metal sculptures for "willful vandalism" for removing the industrial green paint and, in 1980, the Bank of Tokyo outraged the art world when it removed a 1,600-pound aluminum diamond-shaped sculpture by Isamu Noguchi that hung in the bank's New York City headquarters by cutting it into pieces.

The problem hasn't been wholly confined to sculptors as a mural by Arshile Gorky at the Newark (New Jersey) Airport was subsequently whitewashed, and a painting by Pablo Picasso was cut into numerous one inch square pieces to be sold through magazine advertisements as "original" Picasso works of art by a couple of entrepreneurs in Australia. One of those Australians commented at the time, "If this works, we're going to put the chop to a lot of Old Masters."

Mutilation or destruction of an artist's work (for which the artist has not waived moral rights) is now considered an infringement on copyright, with artists able to sue for either statutory (up to $20,000) damages or actual damages. Those actual damages refer to harm caused an artist's professional reputation by the destruction or distorted appearance of his or her work.

This kind of copyright infringement would not be a criminal violation — the copyright law does include possible jail terms and fines for instances of commercial exploitation, such as bootleg films, books or records — as the damage or destruction of artwork is seen as an area for civil litigation. An artist must hire an attorney to bring action against someone altering or destroying his or her creations.

The general term of copyright protection, which is the life of the artist plus 50 years, does not apply to the moral rights created in this new federal law. Instead, the moral rights last for the life of the artist, the same period of coverage for invasion of privacy, libel, slander and defamation of character.

Those living in one of the 10 states with its own artists protection laws may choose to file a suit under those statutes rather than through the federal law. The Visual Artists Rights Act does not preempt the state laws,

insofar as the states offer protection longer than that provided by the federal legislation. Artists' heirs would want to know that five of those states — California, Connecticut, Massachusetts, New Mexico and Pennsylvania — extend the rights of the creator for the federal copyright period of 50 years beyond the life of the artist.

All of the 10 states also protect works by artists that have already been sold, whereas the new law protects only artwork that is sold by the artist after the new law has been in effect for six months (December 1, 1991, as the law went into effect June 1, 1991).

In general, an artist who believes that his or her copyright has been infringed upon by damage or the destruction of a creation should consult an attorney on the proper jurisdiction and applicable laws.

One aspect of the law of particular interest to muralists and wall sculptors concerns artwork that is attached to a building, and there are special rules that balance the rights of artists and property owners. The owner of a building on which artwork is attached is required to notify the artist that the work should be removed, if it can be removed. The building owner is to write to the last known address of the artist or, if there is no response, to the Copyright Office in Washington, D.C. A special department within the Copyright Office has been created by the Visual Artists Rights Act for the addresses of artists, and artists are advised to send a current address there.

Once the artist is notified that the building owner wishes the artwork removed, the artist has 90 days in which to remove it (at his or her own expense) at which point the artist regains title to the piece. If the artist fails to collect the artwork, or it cannot be physically removed, or the artist cannot be located, all rights under the Visual Artists Rights Act are negated.

This is not to say that the relationship between artists and the government is and always has been favorable. All too often, the laws have seemed punitive. Take tax returns, for instance. Congress voted in 1969 (as amended in 1986) to permit artists to declare deductions based on work-related expenses only if they made a profit in three out of five years (if that requirement isn't met, any net loss from the art activity is considered a nondeductible "hobby" expense); next, it adopted legislation that allows artists to deduct only the cost of materials when donating a work of art to a museum or other charitable tax-exempt institution. (Collectors of art, on the other hand, are entitled to deduct the fair market value of the objects they donate.) The first rule has been a monumental headache for artists come the annual tax season; the second has proven a headache for museums, which saw gifts by artists to their collections drastically reduced.

In truth, the hobby-loss provision was aimed not at artists but at "gentlemen farmers" who annually declared great losses for what was not their prime source of income. There has been an occasional instance where an artist has attempted to write off losses for pursuits unrelated to their vocations — musician Victor Borge and his rock cornish hen farm and painter Peter Hurd and his ranch (both were denied by the government) are examples — but the larger problem is artists attempting to deduct their art-related expenses when they haven't earned a profit. Those artists have suffered.

Not only artists but museums, too, have suffered from the tax disincentives for artists to donate their work to charitable institutions. Before 1970, when the legislation took effect, museums with modern and contemporary art collections regularly received sizeable quantities of objects from artists, usually toward the end of the year when these institutions also were given cash and art objects by other donors.

Since then, there has been a notable drop-off in giving by creators, and legislation has been introduced into Congress to restore the full fair market value deduction to artists. The likelihood of passage in the near future is not great.

It is not only to museums that artists may give their work, of course. The more common recipients these days are charity auctions, especially those benefiting arts centers and social causes. Mike Starn, for example, who creates appropriated art historical imagery with his twin brother Doug, noted that in 1989, "we ended up donating more pieces than we sold" to a variety of Artcetera auctions around the country that generate money for victims of Acquired Immune Deficiency Syndrome (AIDS).

Marcia Lloyd and Gerry Bergstein, both Boston-area painters, have also contributed a sizeable number of their works for AIDS-related and other charity auctions over the past few years and find that their reward is a good conscience.

"Artists often find themselves acting to their own financial disadvantage, and not being able to receive a deduction that a collector could get does bother me," Bergstein said. "What's even more galling is when the charity demands that you pay to get a picture framed before you donate it. They're afraid the picture won't sell and don't want to be stuck with the framing bill. Still, I'll probably continue to donate works because I think I should do what little I can for things I believe in."

For her part, Lloyd likened charitable donations for artists to literally "giving away" their work. "People sometimes try to tell you that, even when you can't get the tax benefits from donating your work, this is great publicity for your career, but it's totally ephemeral publicity," she stated.

"A donation is totally invisible; it doesn't make a difference in your career at all."

Despite the tax disincentives and the inability of artists to capitalize on these charitable events, she echoed Bergstein, stating that "we all have to do what we can, and this is what I can do."

The generosity of artists is well known and can only be commended, but the cost-of-materials deduction policy of the federal government has posed a dilemma for them. In addition, they must discover ways in which to balance making donations and making a living.

"The number of requests for donations of your work jumps up geometrically after you give once," photographer Nicholas Nixon said. "You find yourself on everyone's list. They sometimes treat you as though they're entitled to your work and, once you start to say 'no,' they are not particularly sympathetic. Sometimes, they sneer. I try to couch my 'no' by telling them that 'I'd really like to give something, but I have nothing to spare right now, I'm really sorry.' Something like that."

Other artists have found the same to be true. "I get annoyed at the way you get asked again and again to give something," printmaker and sculptor Leonard Baskin noted, adding that "artists don't get a lot of feedback from the donation of work."

Prices also tend to be low at these charity affairs (one's market is not benefited), they don't often attract important collectors and any increased value of the work does not help the worthy cause but some auction buyer. It is the fact, however, that artists are unable to deduct anything other than the cost of the materials used in making the artwork that has soured artists on these otherwise important events. James Minden, president of National Artists Equity Association, recommends that "if an auction is considered, artists should get their collectors to make the donation."

Even with considerable support for the restoration of full fair market value deductions for artworks donated by their creators, passage of any legislation may be filled with obstacles. An aide to New York Democratic Senator Daniel Patrick Moynihan (who has publicly called for the restoration of the full market value deduction by artists who make charitable donations of their own work) noted that there is "anxiety over the possibility of abuse. With nonartists, we know what something is worth, because the work has been on the market and bought. With artists and their own work, it has never been on the market before and there is a larger potential for people to monkey around with its value. You get so-called 'December art,' where an artist looks around and sees that it's time to pay his taxes, he better whip off some new art to donate. There have been some abuses in the past."

The federal government's slaps at artists were not confined to 1969; another came in the 1986 Tax Reform Act when artists found that they were able to claim deductions only for expenses related to their works that sold in the preceding tax year. If a photographer, for instance, took 20,000 frames in a year and only one of them sold, that person would only be able to write off one-twenty-thousandth of his or her expenses. That was eventually modified to permit current deductions for "qualified artists."

That victory for artists may be encouraging, as the modification was a result of concerted action by artists in various disciplines to lobby their representatives and enlist the support of the press to publicize their case. It is also true that some artists have won Tax Court decisions concerning whether or not their artmaking is for profit or just a hobby.

As the government has taken art and artists more seriously, artists must do the same. Their interests in affordable living-working space, adequate and appropriate health insurance coverage, safe art materials, grant-giving agencies that are free from political interference, moral rights and resale royalties, the expansion of copyright protections, equitable tax treatment and a host of other issues require them to organize as a political unit — the way other economic and social groups have already done.

Regional and national organizations of visual artists already exist (the Washington, D.C.-based National Association of Artists Organizations — 1007 D Street, N.E., Washington, D.C. 20002, tel. 202-544-0660 — as well as one's state arts agency are good places to find these groups) and others can be formed to promote their interests. The portrait of the artist as loner and outsider may have served an aesthetic purpose in the past, but go-it-aloners only impair the ability of all artists attain what others have achieved.

Appendices

Legal Services for Artists and Arts Organizations

Not everyone believes that legal issues are an important part of the art world. "If there are so many legal issues coming up," Gilbert Edelson, administrative vice-president of the Art Dealers Association and an attorney himself, said, "why are there so few lawyers who can make a living from the practice of this so-called 'art law?'"

The reason is that few artists can afford to pay an attorney's fees. Because of this gap, Volunteer Lawyers for the Arts organizations have sprung up around the United States — the first was formed in New York City in 1969 — and in Canada to help individual artists and arts organizations providing services on a pro bono basis.

Alabama
Alabama Lawyers for the Arts
P.O. Box 66634
Mobile, AL 36660
(205) 471-2434

California
California Lawyers for the Arts
Fort Mason Center, Building C
San Francisco, CA 94123
(415) 775-7200

California Lawyers for the Arts
315 West 9th Street, Suite 1101
Los Angeles, CA 90015
(213) 623-8311

San Diego Lawyers for the Arts
1205 Prospect Street, Suite 400
La Jolla, CA 92037 • (619) 454-9696

Colorado
Colorado Lawyers for the Arts
P.O. Box 300428
Denver, CO 80203
(303) 892-7122

Connecticut
Connecticut Volunteer Lawyers for the Arts
Connecticut Commission on the Arts
227 Lawrence Street
Hartford, CT 06106
(203) 566-4770

District of Columbia

District of Columbia Lawyers Committe
for the Arts
918 16th Street, N.W., Suite 503
Washington, D.C. 20006
(202) 429-0229

Washington Area Lawyers for the Arts
2025 I Street, N.W., Suite 1114
Washington, D.C. 20006
(202) 861-00055

Florida

Volunteer Lawyers and Accountants
for the Arts Program
Pinellas County Arts Council
400 Pierce Boulevard
Clearwater, FL 34616
(813) 462-3327

Broward Cultural Affairs Council
100 South Andrews Avenue
Fort Lauderdale, FL 33301
(305) 357-7457

Business Volunteers for the Arts
Museum Tower, Suite 2500
150 West Flagler Street
Miami, FL 33130
(305) 789-3590

Georgia

Georgia Volunteer Lawyers for the Arts
P.O. Box 1131
Atlanta, GA 30303-1131
(404) 577-3517

Illinois

Lawyers for the Creative Arts
213 West Institute Place, Suite 411
Chicago, IL 60610
(312) 944-ARTS

Kansas

Kansas Register of Lawyers for the Arts
c/o Susan J. Whitfield-Lundgren
400 North Woodlawn
East Building, Suite 205
Wichita, KS 67208 • 316) 685-3200

Kentucky

Arts Council Services
609 West Main Street
Louisville, KY 40202
(502) 582-1821

Lexington Council of the Arts
Lexington, KY 40507
(606) 255-2951

Louisiana

Louisiana Volunteer Lawyers for the Arts
c/o Arts Council of New Orleans
821 Gravier Street, Suite 600
New Orleans, LA 70112
(504) 523-1465

Maine

Maine Volunteer Lawyers for the Arts
Maine Arts Commission
55 Capitol Street
State House Station 25
Augusta, ME 04333
(207) 289-2724

Maryland

Maryland Lawyers for the Arts
c/o University of Baltimore Law Center, Rm 400
1420 North Charles Street
Baltimore, MD 21201
(301) 752-1633

Massachusetts

The Arts Extension Service
Division of Continuing Education
University of Massachusetts
Amherst, MA 01003
(413) 545-2360

Lawyers for the Arts
The Artists Foundation, Inc.
8 Park Plaza
Boston, MA 02116
(617) 227-2787

Minnesota
Minnesota Volunteer Lawyers for the Arts
c/o Fred Rosenblatt
150 South 5th Street, Suite 2300
Minneapolis, MN 55402
(612) 335-1500

Missouri
St. Louis Volunteer Lawyers and
 Accountants for the Arts
c/o St. Louis Regional Arts Commission
329 North Euclid Avenue
St. Louis, MO 63108 • (314) 361-7686

Montana
Montana Volunteer Lawyers for the Arts
c/o Joan Jonkel, Esq.
P.O. Box 8687
Missoula, MT 59807
(406) 721-1835

New Jersey
Volunteer Lawyers for the Arts of New
Jersey
36 West Lafayette Street
Trenton, NJ 08608
(609) 695-6422

New York
Volunteer Lawyers for the Arts Program
Albany League of Arts
19 Clinton Avenue
Albany, NY 12207
(518) 449-5380

Arts Council in Buffalo and Erie County
700 Main Street
Buffalo, NY 14202
(716) 586-7520

Huntington Arts Council, Inc.
213 Main Street
Huntington, NY 11743
(516) 271-8423

Volunteer Lawyers for the Arts
1285 Avenue of the Americas
New York, NY 10019
(212) 977-9270/3

Dutchess County Arts Council
39 Market Street
Poughkeepsie, NY 12601
(914) 454-3222

North Carolina
North Carolina Volunteer Lawyers for the Arts
P.O. Box 590
Raleigh, NC 27602
(919) 890-3195 or (800) 443-8437

Ohio
Arnold Gottlieb
421 North Michigan Street, Suite D
Toledo, OH 43624
(419) 243-3125

Cincinnati Area Lawyers and Accountants
 for the Arts
University of Cincinnati, ML003
Cincinnati, OH 45221
(513) 475-4383

Volunteer Lawyers and Accountants
 for the Arts Program
c/o Cleveland Bar Association
Mall Building
118 St. Clair Avenue, 2nd Floor
Cleveland, OH 44114
(216) 696-3525

Pennsylvania
Philadelphia Volunteer Lawyers for the Arts
251 South 18 Street
Philadelphia, PA 19103 • (215) 545-3385

Puerto Rico
Voluntarios par las Arts
Condumo El Monte
Norte Apt. 518A
Hato Rey, Puerto Rico 00919
(809) 758-3986

Rhode Island
Ocean State Lawyers for the Arts
96 Sachem Road
Narrangansett, RI 02882 • (401) 789-5686

South Carolina
South Carolina Lawyers for the Arts
P.O. Box 8672
Greenville, SC 29604 • (803) 232-3874

Tennessee
Tennessee Arts Commission
320 6th Avenue North, Suite 100
Nashville, TN 37219 • (615) 741-1701

Texas
Austin Lawyers and Accountants for the Arts
P.O. Box 2577
Austin, TX 78768 • (512) 476-7573

Texas Accountants and Lawyers for the Arts
1540 Sul Rose
Houston, TX 77006
(713) 526-4876

Utah
Utah Lawyers for the Arts
170 South Main Street, Suite 1400
Salt Lake City, UT 84101
(801) 521-5800

Washington
Washington Volunteer Lawyers for the Arts
203 Pioneer Building
600 First Avenue
Seattle, WA 98104
(206) 223-0502

Canada
Canadian Artists' Representation Ontario
(CARO)
183 Bathurst Street
Toronto, Ontario M5T 2R7
(416) 360-0780/0772

Business and Accounting Services for Artists and Arts Organizations

A painter with a studio off the kitchen needs to figure a home office deduction. A dance company must raise funds and increase its visibility. A printmaker requires a sales tax permit. A sculptor needs to set up a viable bookkeeping system. The arts are filled with technical tax and business problems. Solutions are not difficult to find but, sometimes, a bit difficult to afford as accountants, fundraisers and marketing specialists are a high-priced breed.

Low-income artists and nonprofit arts organizations need not despair, for around the country there are businesspeople and tax specialists who donate their time and services to help those in need. Among the programs specifically aimed at helping individual artists:

District of Columbia
Washington Area Lawyers for the Arts
2025 I Street, N.W., Suite 1114
Washington, D.C. 20006
(202) 861-0055

Georgia
Georgia Volunteer Accountants for the Arts
1395 South Tower, One CNN Center
Atlanta, GA 30303
(404) 658-9808

Illinois
Illinois CPA Society
222 South Riverside Plaza
Chicago, IL 60606
(312) 993-0393

Kentucky
Greater Louisville Fund for the Arts
623 West Main Street
Louisville, KY 40202
(502) 582-0100

Massachusetts
The Artists Foundation
110 Broad Street
Boston, MA 02110
(617) 227-2787

Missouri
St. Louis Volunteer Lawyers and
Accountants for the Arts
329 North Euclid
St. Louis, MO 63108
(314) 361-7686

Ohio
Volunteer Lawyers for the Arts (of the
Cleveland Bar Association)
113 St. Clair Avenue, N.E.
Cleveland, OH 44114-1253
(216) 696-3525

Texas
Austin Lawyers & Accountants for the Arts
P.O. Box 2577
Austin, TX 78768
(512) 476-7573

Texas Accountants & Lawyers for the Arts
1540 Sul Rose
Houston, TX 77006
(713) 526-4876

Texas Accountants & Lawyers for the Arts
c/o Business Committee for the Arts
110 Broadway, Suite 250
San Antonio, TX 78205 • (512) 224-8031

Other Volunteer Lawyers for the Arts groups around the country can also direct artists to accountants known to work with artists for a discounted fee. In addition, volunteer income tax assistance is available in many cities and town for low-income individuals, a category describing many artists, through the National Association of Accountants. For more information about where to find free accounting services, contact Accountants for the Public Interest, 1625 I Street, N.W., Washington, D.C. 20006, tel. 202-659-3797 for the National Directory of Volunteer Accounting Programs.

Many of the Volunteer Accountants for the Arts groups that work with individuals also assist arts organizations, although fewer of the groups that aid organizations provide help for individuals. Among the volunteer groups that work exclusively with nonprofit arts organizations are:

California

Arts Inc.
315 West Ninth Street, Room 201
Los Angeles, CA 90015
(213) 627-9276

Business Volunteers for the Arts/East Bay
1404 Franklin Street, Suite 713
Oakland, CA 94612
(415) 268-0505

Business Volunteers for the Arts
c/o San Francisco Chamber of Commerce
465 California Street
San Francisco, CA 94104
(415) 392-5936

Connecticut

Business Volunteers for the Arts
c/o Arts Council of Great New Haven
110 Audubon Street
New Haven, CT 06511

District of Columbia

Business Volunteers for the Arts
Cultural Alliance of Greater Washington
410 8th Street, N.W., Suite 600
Washington, D.C. 20004
(202) 638-2406

Florida

Business Volunteers for the Arts
150 West Flagler Street, Suite 2500
Miami, FL 33130
(305) 789-3590

Illinois

Business Volunteers for the Arts
800 South Wells Street
Chicago, IL 60607 • (312) 431-3368

New Jersey

Business Volunteers for the Arts
390 George Street
New Brunswick, NJ 08901 • (201) 745-5050

Business Volunteers for the Arts
841 Georges Road
North Brunswick, NJ 08902 • (201) 745-4489

New York

Arts & Business Partnership Network
Arts Council in Buffalo and Erie County
700 Main Street
Buffalo, NY 14202 • (716) 856-7520

Texas

Business Volunteers for the Arts of Fort
Worth and Tarrant County
One Tandy Center, Suite 150
Fort Worth, TX 76102 • (817) 870-2564

Business Volunteers for the Arts
1100 Milam Building, Suite 2725
Houston, TX 77002 • (713) 658-2483

Washington

Business Volunteers for the Arts
1200 One Union Square
600 University Street
Seattle, WA • 98101-3186

Small Business Development Centers also exist in the District of Columbia, Puerto Rico and the Virgin Islands as well as 47 states around the country, providing counseling and advice to small business (including arts organizations).

Art Colonies

In the regular world, most artists have to sneak in their art between a job and taking care of the family or the house or civic obligations. At an art colony, however, the artist is central. There is no excuse for not working, and there's nothing there to do but work. The addresses for the main colonies around the country are:

Act I Creativity Center
Box 10153
Kansas City, MO 64111
(816) 753-0383

Edward F. Albee Foundation
14 Harrison Street
New York, NY 10013
(212) 226-2020

Anderson Ranch Arts Center
P.O. Box 5598
Snowmass Village, CO 81615
(303) 923-3181

Artpark
P.O. Box 371
Lewiston, NY 14092
(716) 745-3377 or (716) 754-9001

Blue Mountain Center
Blue Mountain Lake, NY 12812
(518) 352-7391 or (518) 242 0180

Career Advance of Visual Artists (CAVA)
c/o National Foundation for Advancement in the Arts
3915 Biscayne Boulevard
Miami, FL 33137
(305) 573-0490

Centrum Foundation
P.O. Box 1158
Fort Warden State Park
Port Townsend, WA 98368
(206) 385-3102

Cummington Community of the Arts
R.R. 1, Box 145
Cummington, MA 01026
(413) 634-2172

Curry Hill Plantation Writers Retreat
404 Crestmont Avenue
Hattiesburgh, MS 49401
(601) 264-7034

Djerassi Foundation
Resident Artist Program
2325 Bear Gulch Road
Woodside, CA 94062
(415) 851-8395

Dobie Paisano Fellowship Project
University of Texas
Main Building 101
Office of Graduate Studies
Austin, TX 78712
(512) 471-7213

Dorland Mountain Colony
P.O. Box 6
Temecula, CA 92390
(714) 676-5039

Dorset Colony House
Box 519, Church Street
Dorset, VT 05251
(802) 867 9390

Alden B. Dow Creativity Center
Northwood Institute
Midland, MI 48640 • (517) 832-4403

Fine Arts Work Center
24 Pearl Street, Box 565
Provincetown, MA 02657
(508) 487-9960

Hambridge Center for the Arts
P.O. Box 339
Rabun Run, GA 30568
(404) 746-5718

Kalani Honua
Intercultural and Retreat Center
P.O. Box 4500
Kalapana, HI 96778
(808) 965-7828

The Institute for Contemporary Arts
46-01 21 Street
Long Island City, NY 11101
(718) 784-2084

John Michael Kohler Arts Center
608 New York Avenue
Sheboygan, WI 53082-0489
(414) 458-6144

D.H. Lawrence Fellowship Committee
University of New Mexico
Albuquerque, NM 87131
(505) 277-6347

The MacDowell Colony
163 East 81 Street
New York, NY 10028
(212) 535-9690

Maitland Art Center
231 West Packwood Avenue
Maitland, FL 32751
(305) 645-2181

The Millay Colony for the Arts
Steepletop
Austerlitz, NY 12017
(518) 392-3103

Villa Montalvo Center for the Arts
P.O. Box 158
Saratoga, CA 95071
(408) 741-3421

The National Foundation for the Advancement of the Arts
3915 Biscayne Boulevard
Miami, FL 33137
(305) 573-0490

National Musical Theater Conference
234 West 44 Street,
New York, NY 10036
(212) 382-2790 or (203) 443-5378

National Playwrights Conference
234 West 44 Street
New York, NY 10036
(212) 382-2790

Eugene O'Neill Theater Center
National Critics Institute
234 West 44 Street
New York, NY 10036
(212) 382-2790

Niangua Colony
Route 1
Saratoga, CA 95071 • (no telephone)

Ossabaw-Island Project
Ossabaw Island
P.O. Box 13397
Savannah, GA 31406 • (no telephone)

Palenville Interarts Colony
P.O. Box 59
Palenville, NY 12463
(518) 678-9021

Peter's Valley Craftsmen
Star Route
Layton, NJ 07851
(201) 948-5200

The Ragdale Foundation
1260 North Green Bay Road
Lake Forest, IL 60045
(312) 234-1063

Real Art Ways
Media Residency Program
94 Allyn Street
Hartford, CT 16103-1402
(203) 525-5521

Mildred I. Reid Writers Colony
Penacook Road
Contoocook, NH 03229
(603) 746-3625 or (407) 278 3607 (winter)

Roswell Museum and Art Center
100 West 11 Street
Roswell, NM 88201
(505) 624-6744/6745

Sculpture Space
12 Gates Street
Utica, NY 13502
(315) 724-8381

Shenandoah Playwrights Retreat
Pennyroyal Farm
Route 5, Box 167-F
Staunton, VA 24401
(703) 248-1868

Squaw Valley Community of Writers
P.O. Box 2352
Olympic Valley, CA 95730
(916) 583-5200

Ucross Foundation
2836 U.S. Highway
14-16 East
Clearmont, WY 82835
(307) 737-2291

Virginia Center for the Creative Arts
Mt. San Angelo
Sweet Briar, VA 24595
(804) 946-7236

Friends of Weymouth
Weymouth Center
P.O. Box 839
Southern Pines, NC 28387
(919) 692-6261

Helene Wurlitzer Foundation of New Mexico
P.O. Box 545
Taos, NM 87571 • (505) 758-2413

The Corporation of Yaddo
P.O. Box 395
Saratoga Springs, NY 12886
(518) 584-0746

The Yard
P.O. Box 405
Chilmark, MA 02535
(617) 645-9662

Yellowsprings Institute
1645 Art School Road
Chester Springs, PA 19425
(215) 827-9111

There are also a number of art colonies abroad, run by Americans or which will accept Americans for residencies. They are:

Altos de Chavron
1 Gulf & Western Plaza
New York, NY 10023
(212) 333-3388

American Academy in Rome
41 East 65 Street
New York, NY 10021
(212) 517-4200

Bellagio Study and Conference Center
c/o Rockefeller Foundation
1133 Avenue of the Americas
New York, NY 10036
(212) 869-8500

The Camargo Foundation
64 Main Street, P.O. Box 32
East Haddam, CT 06423

Chateau de Lesvault
Onlay, 58370 Villapourcon
France • (33) 866-84-32-91

DAAD — Germany
Artists-in-Berlin Program
German Academic Exchange Service
Bureau Berlin, P.O. Box 126240
Steinplatz 2 • D-1000 Berlin 12 Germany

Heli
Israeli Center for the Creative Arts
212 Beni Ethraim Street
Naoz Aviv
Tel Aviv, Israel 69985
Corinna • 03-478704

Leighton Artist Colony
c/o The Banff Centre
P.O. Box 1020
Banff, Alberta
Canada, T0L 0C0
(403) 762-6216

Mish Kenot Sha'anaim
P.O. Box 8215
Jerusalem 91081
Israel

Saskatchewan Writers/Artists Colony
P.O. Box 3986
Regina, Saskatchewan
Canada M5S 1T6
(306) 757-6310

Saskatchewan Writers/Artists Colony
P.O. Box 3986
Regina, Saskatchewan S4P 3R9
Canada
(306) 757-6310

Scottish Sculpture Workshop
1 Main Street
Lumsden, Aberdeenshire
Scotland AB5 4JN
Lumsden
04648 372

The Tyrone Guthrie Center
Annaghmakerrig, Newbliss
County Monaghan
Ireland
047-54003

Public Art Programs

Either through mandated Percent-for-Art programs or simply an interest in making art available (and visible) to more people, public art programs have been growing as has the number of pieces commissioned through these various private and state agencies. On the government side, there are:

General Services Administration
Art-in-Architecture Program
18th & F Street, N.W., Room 3331
Washington, D.C. 20405
(202) 566-0950

Veterans Administration
Art-in-Architecture Program
811 Vermont Avenue, N.W.
Washington, D.C. 20402

Alaska
Alaska State Council on the Arts
619 Warehouse Avenue, Room 220
Anchorage, AK 99501-1682
(907) 279-1558

Municipality of Anchorage
P.O. Box 196550
Anchorage, AK 99519-6650
(907) 264-6473

Arkansas
Arkansas Arts Council
Heritage Center East
Suite 250
Little Rock, AR 72201
(501) 371-2539

Arizona
Arizona Commission on the Arts
417 West Roosevelt
Phoenix, AZ 85003
(602) 255-5882

Casa Grande Arts & Humanities Commission
300 East Fourth Street
Casa Grande, AZ 85222
(602) 836-7471

City of Chandler
125 East Commonwealth
Chandler, AZ 85225
(602) 821-8520

Glendale Arts Commission
5127 West North Avenue
Glendale, AZ 85301
(602) 937-7554

Phoenix Arts Commission
2 North Central Avenue, Suite 125
Phoenix, AZ 85004
(602) 262-4637

Tucson/Pima Arts Council
P.O. Box 27210
Tucson, AZ 85726 • (602) 624-0595

California
Berkeley Civic Arts Commission
2180 Milvia Street
Berkeley, CA 94704

California Arts Council
1901 Broadway, Suite A
Sacramento, CA 95818-2492
(916) 445-1530

Carlsbad Cultural Arts
City of Carlsbad
1200 Elm Avenue
Carlsbad, CA 92008
(619) 931-2901

City and County of San Francisco
Department of City Planning
450 McAllister Street
San Francisco, CA 94102
(415) 558-2266

City of Brea
No. 1 Civic Center Circle
Brea, CA 92621 • (714) 990-7713

City of Concord
Planning Department
Concord, CA • (415) 671-3159

City of Davis
Parks & Community Service Department
23 Russell Boulevard
Davis, CA 95616
(916) 756-3747

City of Garden Grove
11391 Acacia Parkway
Garden Grove, CA 92640
(714) 741-5040

City of Irvine
2815 McGaw
P.O. Box 19575
Irvine, CA 92713 • (714) 660-3801

City of Laguna Beach
505 Forest Avenue
Laguna Beach, CA 92651
(714) 497-3311, ext. 211

City of Mountain View
Planning Department
P.O. Box 7540
Mountain View, CA 94039

City of Palm Desert
73510 Fred Waring Drive
Palm Desert, CA 92260
(619) 346-0611, ext. 288

City of Palo Alto
1313 Newell Road
Palo Alto, CA 94303 • (415) 329-2218

City of San Jose
Fine Arts Officer
145 West San Carlos Street
San Jose, CA 95113 • (408) 277-5144

City of Santa Barbara
P.O. Drawer P-P
Santa Barbara, CA 93102
(805) 963-1663

City of Thousand Oaks
401 West Hillcrest Drive
Thousand Oaks, CA 91360
(805) 497-8611, ext. 200

City of Walnut Creek
P.O. Box 8039
Walnut Creek, CA 94596
(415) 943-5866

County of Santa Cruz
701 Ocean Street, Room 220
Santa Cruz, CA 95060 • (408) 425-2395

Los Angeles Community Redevelopment Agency
354 South Spring Street
Los Angeles, CA 90013 • (213) 977-1763

Sacramento Housing & Redevelopment Agency
c/o Sacramento Metropolitan Arts Commission
800 Tenth Street, Suite 2
Sacramento, CA 95814
(916) 449-5558

Sacramento Metropolitan Arts Commission
City Percent for Art
(also, County Percent for Art)
800 Tenth Street, Suite 2
Sacramento, CA 95814
(916) 449-5558

San Francisco Arts Commission
45 Hyde Street, Room 319
San Francisco, CA 94102
(415) 558-3463

Santa Barbara County Arts Commission
1100 Anacapa Street
County Courthouse
Santa Barbara, CA 93101
(805) 963-7131

Santa Cruz City Arts Commission
346 Church Street
Santa Cruz, CA 95060
(408) 429-3778

Santa Monica Arts Commission
215 Santa Monica Pier
Santa Monica, CA 90401
(213) 393-9975

Colorado
Colorado Council on the Arts Humanities
770 Pennsylvania Street
Denver, CO 80203
(303) 866-2618

Commission on Cultural Affairs
303 West Colfax, Suite 1600
Denver, CO 80204
(303) 575-2678

Loveland High Plains Arts Council
Box 7058
Loveland, CO 80537
(303) 667-2659

Connecticut
Connecticut Commission on the Arts
190 Trumball Street
Hartford, CT 06106
(203) 566-4770

City of Hartford
Office of Cultural Affairs
550 Main Street, Room 300
Hartford, CT 06103
(203) 722-6493

City of Middletown
Commission on Art
Spencer Municipal Annex
207 Westfield Street
Middletown, CT 06457
(203) 344-3520

City of New Haven
Department of Cultural Affairs
770 Chapel Street
New Haven, CT 06510
(203) 787-8956

District of Columbia
District of Columbia Commission on the Arts
1111 E Street, N.W., Suite B500
Washington, D.C. 20004
(202) 724-5613

Delaware
Wilmington Arts Commission
City/County Building
800 North French Street
Wilmington, DE 19801
(302) 571-4100

Florida
Broward County Art in Public Places
Program
100 South Andrews Avenue
Fort Lauderdale, FL 33301
(305) 357-7457

City of Miami Planning Department
275 Northwest Second Street
Miami, FL 33218
(305) 579-6086

Florida Department of State
Division of Cultural Affairs
The Capitol
Tallahassee, FL 32399-0250
(904) 488-2180

Lee County Art in Public Places Board
P.O. Box 398
Department of Community Services
Fort Myers, FL 33902
(813) 335-2284

Metro-Dada Art in Public Places
111 N.W. First Street, Suite 610
Miami, FL 33218
(305) 375-5362

Orlando Public Art Board
Planning & Development Department
400 South Orange Avenue
Orlando, FL 32801
(305) 849-2300

Georgia
Clarke County Community Relations
Division
P.O. Box 352
Athens, GA 30603
(404) 354-2670

Fulton County Arts Council
42 Spring Street, S.W.
Plaza Level 16
Atlanta, GA 30303 • (404) 586-4941

Hawaii
Mayor's Office on Culture & the Arts
530 South King Street
City Hall, 4th Floor
Honolulu, HI 96813 • 808) 523-4674

State Foundation on Culture & the Arts
335 Merchant Street, Room 202
Honolulu, HI 96813
(808) 548-7657

Iowa
Iowa Arts Council
State Capitol Complex
Des Moines, IA 50319
(515) 281-4451

Illinois
Art-in-Architecture Program
Illinois Capital Development Board
401 South Spring, 3rd Floor
Springfield, IL 62706
(217) 782-9561

Beacon Street Gallery
4520 North Beacon
Chicago, IL 60640
(312) 561-3500

Chicago Office of Fine Arts
78 East Washington Street
Chicago, IL 60602
(312) 744-8941

Evanston Arts Council
Noyes Center
927 Noyes
Evanston, IL 60201 • (312) 491-0266

Louisiana
Arts Council of New Orleans
World Trade Center
2 Canal Street, Suite 936
New Orleans, LA 70130
(504) 523-1465

Maine
Maine Commission on the Arts and
Humanities
55 Capitol Street, Station 25
Augusta, ME 04333 • (207) 289-2724

Maryland

City of Baltimore
Civic Design Commission
700 Municipal Building
Baltimore, MD 21202
(301) 396-3671

Mayor's Advisory Committee on Art & Culture

21 South Eutaw Street
Baltimore, MD 21201

Montgomery County Art in Public Architecture

Department of Facilities & Services
110 North Washington Street
Rockville, MD 20850
(301) 738-8411

Montgomery County Planning Department

8787 Georgia Avenue
Silver Springs, MD 20907
(301) 495-4570

Massachusetts

Arts on the Line
Cambridge Arts Council
57 Inman Street
Cambridge, MA 02139
(617) 864-5150

Massachusetts Cultural Council

80 Boylston Street
Boston, MA 02116 • (617) 727-3668

Office of the Arts & Humanities

City Hall, Room 720
Boston, MA 02201 • (617) 725-3850

Michigan

Cultural Arts Division
Parks & Recreation Department
26000 Evergreen
Southfield, MI 48037 • (313) 354-4717

Michigan Commission on Art in Public Places

1200 Sixth Avenue, P-120
Detroit, MI 48226
(313) 256-2800

Minnesota

Duluth Public Arts Commission
400 City Hall
Duluth, MN 55802-1196
(218) 723-3385

Minnesota State Arts Board

Department of Administration
432 Summit Avenue
St. Paul, MN 55102
(612) 297-3371

Missouri

Kansas City Municipal Arts Commission
City Hall, 26th Floor
Kansas City, MO 64106
(816) 274-1515

Regional Arts Commission

329 North Euclid Avenue
St. Louis, MO 63108
(314) 361-7441

Montana

Montana Arts Council
35 South Last Chance Gulch
Helena, MT 59602
(406) 444-6430

North Carolina

North Carolina Arts Council
Department of Cultural Resources
Raleigh, NC 27611
(919) 733-2111

The Arts Council, Inc.

305 West Fourth Street
Winston-Salem, NC 27101
(919) 722-2585

Nebraska
Nebraska Arts Council
1313 Farnam-on-the-Mall
Omaha, NE 68102-1873
(402) 554-2122

New Hampshire
New Hampshire State Council on the Arts
40 North Main Street
Concord, NH 03301
(603) 271-2789

New Jersey
Cape May County Cultural & Heritage
Commission
DN 101 Library Office Building
Cape May Court House, NJ 08210
(609) 465-7111, ext. 419

New Jersey State Council on the Arts
109 West State Street
Trenton, NJ 08625
609-292-6130

New Mexico
City of Albuquerque
Cultural Affairs
423 Central Avenue, N.W.
Albuquerque, NM 87102
(505) 848-1370

City of Las Cruces
200 North Church
Las Cruces, NM 88001 • (505) 526-0280

New Mexico Arts Division
224 East Palace Avenue
Santa Fe, NM 87501 • (505) 827-6490

New York
Arts Council of Rockland
Rockland County Health Center
Building A, Room 201
Pomona, NY 10970 • (914) 354-8400

Battery Park City Redevelopment Authority
1 World Financial Center, 18th Floor
New York, NY 10281-1097
(212) 416-5376

Buffalo Arts Commission
920 City Hall
Buffalo, NY 14202
(716) 855-5035

Metro Transportation Authority
Arts for Transit
347 Madison Avenue, 5th Floor
New York, NY 10017
(212) 878-7452

New York State Council on the Arts
915 Broadway
New York, NY 10010
(212) 614-2900

New York City Department of Cultural Affairs
Percent for Art Program
2 Columbus Circle
New York, NY 10019
(212) 974-1150

Port Authority of New York & New Jersey
1 World Trade Center, Room 82W
New York, NY 10048
(212) 466-4211

Ohio
Arts Commission of Greater Toledo
618 North Michigan Street
Toledo, OH 43624
(419) 255-8968

Ohio Arts Council
727 East Main Street
Columbus, OH 43205-1796
(614) 466-2613

Oklahoma
Tulsa Arts Commission
2210 South Main
Tulsa, OK 74114
(918) 584-3333

Oregon
Beaverton Arts Commission
P.O. Box 4755
Beaverton, OR 97076
(503) 526-2222

Facilities Development Department
City of Eugene
One Eugene Center
Eugene, OR 97401
(503) 687-5074

Metropolitan Arts Commission
City Percent for Art
(also County Percent for Art)
1120 S.W. Fifth Avenue
Portland, OR 97204 • (503) 796-5111

Oregon Arts Commission
838 N.W. Summer Street
Salem, OR 97301 • (503) 378-3625

Pennsylvania
City of Pittsburgh Art Commission
Public Safety Building
Pittsburgh, PA 15219
(412) 255-2211

Fairmount Park Art Association
1530 Locust Street
Suite 3A
Philadelphia, PA 19102
(215) 546-7550

Office of Arts & Culture
Percent for Art Program
1680 Municipal Services Building
Philadelphia, PA 19102-1684
(215) 686-8685

Philadelphia Redevelopment Authority
1234 Market Street, 8th Floor
Philadelphia, PA 19107
(215) 854-6692

Rhode Island
Warwick Consortium of the Arts &
Humanities
3275 Post Road
Warwick, RI 02886
(401) 738-2000, ext. 372

South Carolina
South Carolina Arts Commission
1800 Gervais Street
Columbia, SC 29201
(803) 734-8696

Tennessee
Tennessee Arts Commission
320 Sixth Avenue, North Suite 100
Nashville, TN 37219
(615) 741-1701

Texas
Arts Council of Brazos Valley
111 University, Suite 217
College Station, TX 77840
(409) 268-2787

City of Austin
Art in Public Places
Parks & Recreation Department
P.O. Box 1088
Austin, TX 78767 • (512) 477-1508

City of Corpus Christi
c/o Multicultural Center
1581 North Chaparral
Corpus Christi, TX 78401 • (512) 883-0639

Division of Cultural Affairs
Majestic Theatre, Suite 600
1925 Elm Street
Dallas, TX 75021 • (214) 670-3687

Texas Commission on the Arts
Box 13406
Capitol Station
Austin, TX 78711
(512) 463-5535

Utah
Salt Lake Art Design Board
54 Finch Lane
Salt Lake City, UT 34102
(801) 538-2171

Utah Arts Council
617 East South Temple
Salt Lake City, UT 84102
(801) 533-5895

Vermont
Vermont Council on the Arts
136 State Street
Montpelier, VT 05602
(802) 828-3291

Virginia
Virginia Beach Arts & Humanities
Commission
Municipal Center
Virginia Beach, VA 23456
(804) 427-4701

Washington
Bellevue Arts Commission
P.O. Box 90012
Bellevue, WA 98009
(206) 455-6885

City of Kent Arts Commission
220 Fourth Avenue South
Kent, WA 98032 • (206) 872-3350

City of Seattle Department of Construction and Land Use
400 Municipal Building
Seattle, WA 98104
(206) 625-4591

Edmonds Arts Commission
700 Main Street
Edmonds, WA 98020
(206) 775-2525, ext. 269

Everett Cultural Commission
3002 Wetmore
Everett, WA 98201
(206) 259-8708

King County Arts Commission
828 Alaska Building
618 Second Avenue
Seattle, WA 98104
(206) 344-7580

Mountlake Terrace Fine Arts Council
5303 228th Street, S.W.
Mountlake Terrace, WA 98043
(206) 776-8956

Municipality of Metropolitan Seattle
Downtown Seattle Art in Transit Project
821 Second Avenue
Seattle, WA 98199
(206) 684-1406

Renton Municipal Arts Commission
200 Mill Avenue South
Renton, WA 98055 • (206) 235-2580

Seattle Arts Commission
305 Harrison Street
104 Center House
Seattle, WA 98109 • (206) 625-4223

Spokane Arts Commission
West 808 Spokane Falls Boulevard
Spokane, WA 99201-3333
(509) 456-3857

Washington State Arts Commission
Mail Stop GH-11
Olympia, WA 98504-4111
(206) 753-3860

Wenatchee Arts Commission
P.O. Box 2111
Wenatchee, WA 98801
(509) 662-6991

Wisconsin
Madison Committee for the Arts
215 Monona Avenue, Room 120
Madison, WI 53710
(608) 266-6089

Milwaukee Art Commission
P.O. Box 324
Milwaukee, WI 53201
(414) 223-5818

Wisconsin Arts Board
107 South Butler Street
Madison, WI 53703 • (608) 266-1968

West Virginia
West Virginia Arts & Humanities Commission
Department of Culture & History Center
Capitol Complex
Charleston, WV 25305
(304) 348-0240

Wyoming
Wyoming Council on the Arts
2320 Capitol Avenue
Cheyenne, WY 82002 • (307) 777-7742

There are also a number of private, nonprofit organizations around the country that sponsor public works of art. As with the government agencies, these organizations have their own policies with regard to whether public art projects are open to all artists or only those living within the state or municipality. These include:

Arts Festival of Atlanta
1404 Spring Street, Suite 1
Atlanta, GA 30309
(404) 885-1125

Cedar Arts Forum, Inc.
415 Commercial, Suite 310
Waterloo, IA 50701
(319) 291-6333

Foundation for Art Resources
P.O. Box 38145
Los Angeles, CA 90038
(213) 661-2290

Installations
930 E Street
San Diego, CA 92101
(619) 232-9915

Inter-Arts of Marin
1000 Sir Francis Drake Boulevard
San Anselmo, CA 94960
(415) 457-9744

International Sculpture Center
1050 Potomac Street
Washington, D.C. 20007
(202) 965-6066

Los Angeles Festival
P.O. Box 5210
Los Angeles, CA 90055-0210
(213) 689-8800

Otis Art Institute
Parsons School of Design
2401 Wilshire Boulevard
Los Angeles, CA 90051 • (213) 251-0556

Palm Beach County Council on the Arts
1555 Palm Beach Lakes Boulevard
Room 206
West Palm Beach, FL 33401-2371
(305) 471- 2901

Pasco Fine Arts Council
2011 Moog Road
Holiday, FL 33590
(813) 845-7322

Public Arts Fund
25 Central Park West
Suite 25R
New York, NY 10023 • (212) 541-8423

San Luis Obispo County Arts Council
P.O. Box 1710
San Luis Obispo, CA 93406 • (805) 544-9251

Washington Project for the Arts
434 Seventh Street, N.W.
Washington, D.C. 20004 • (202) 347-4813

Artists Supporting Artists — Foundations

The history of art and the history of art patronage are one and the same. In general, one tends to think of the main patrons as the church and nobility or, in more modern times, the state, foundations, corporations and private individuals. One should not forget, however, parents (who have historically subsidized their artist-childrens' ambitions) and spouses (who work in order to support the other). Parents and spouses are clearly responsible for the creation of more art than any pope, king or corporate CEO.

Artists also help out each other when they can, and this form of support has been a constant and growing factor in the art world. After the critical and mass success of *L'Assomoir*, for example, novelist Emile Zola found himself on every painter's and novelist's guest list, and the writer was helpful to many. Andy Warhol, Gertrude Stein and F. Scott Fitzgerald among others were also generous to their friends, establishing their own "salons" of needy artists.

Increasingly, the process of artists helping each other has become formalized, with prosperous artists establishing foundations for needy colleagues. A number of these foundations are cited below.

Edward F. Albee Foundation
(Supports the art colony of the same name)
14 Harrison Street
New York, NY 10013 • (212) 226-2020

Artist Fellowship, Inc.
47 Fifth Avenue
New York, NY 10003 • (212) 255-7740

Artists Space/Committee for the Visual Arts
(Provides up to $200 for individuals and up to $500 for groups to cover exhibition costs)
223 West Broadway
New York, NY 10013
(212) 226-3970

Athena Foundation
P.O. Box 6259
Long Island City, NY 11106

Alice Baber Foundation
15 East 36 Street, #2C
New York, NY 10016
(212) 696-1788

Change, Inc.
P.O. Box 705
Cooper Station
New York, NY 10276
(212) 473-3742

Blanche E. Coleman Foundation
Boston Safe Deposit and Trust Co.
One Boston Place
Boston, MA 02106
(617) 722-7300

Eben Demarest Trust
#807
4601 Bayard Street
Pittsburgh, PA 15213
(412) 621-4464

Adolph and Esther Gottlieb Foundation
380 West Broadway
New York, NY 10012
(212) 226-0581

Keith Haring Foundation
676 Broadway
New York, NY 10012
(212) 477-1579

Robert Mapplethorpe Foundation
1370 Avenue of the Americas
New York, NY 10019
(212) 977-9750

National Academy of Design
Edwin Austin Abbey Memorial Scholarship
(Provides funds enabling post-graduate
muralists to travel in order to study
important mural paintings)
1083 Fifth Avenue
New York, NY 10028

Jackson Pollock-Lee Krasner Foundation
725 Park Avenue
New York, NY 10021 • (212) 517-5400

Religious Arts Guild
Paul D'Orlando Memorial Art Scholarship
(Awarded to an art student at an accredited
school who is a member in good standing
of a Unitarian Universalist Society for at
least one year prior to date of application)
25 Beacon Street
Boston, MA 02108 • (617) 742-2100

Louis Comfort Tiffany Foundation
P.O. Box 480
Canal Street Station
New York, NY 10013 • (212) 431-9880

Andy Warhol Foundation
for the Visual Arts
22 East 33 Street
New York, NY 10016
(212) 683-6456

Archives of American Art

What happens to artists is not only of interest to themselves and their families but also to collectors, dealers and researchers now and in the future. The art they create is housed in private collections, art galleries and museums, but there is also a place for their private papers — letters, diaries, receipts, sketchpads, photographs, catalogues, resumes and even newspaper clippings — to which artists may wish to donate these items while alive or through their wills. That place is the Archives of American Art, a bureau of the Smithsonian Institution since 1969 with offices around the country.

The Archives was founded in 1954 by E.P. Richardson, director of the Detroit Institute of Art from 1945 to 1962 and a scholar of American art who was quite frustrated in his attempts to research certain artists whose papers had seemingly vanished. There are currently over 10 million documents available for research, as all of the papers that are collected are catalogued, microfilmed and permanently stored. The Archives has generally been a low profile organization that has relied on artists knowing about it for donations of papers. However, more recently, the Archives has established an oral history project that currently contains over 2,000 interviews with artists, collectors and dealers concerning what has happened in their lives and careers.

To contact the Archives of American Art:

AA/PG Building
Smithsonian Institution
8th and 'F' Street, N.S.
Washington, D.C. 20560
(202) 357-2781

1285 Avenue of the Americas
New York, NY 10019
(212) 399-5015

87 Mount Vernon Street
Boston, MA 02108
(617) 565-8444

Detroit Institute of Arts
5200 Woodward Avenue
Detroit, MI 48202 • (313) 226-7544

Philadelphia Museum of Art
Attention: Marina Pacini
26th and Parkway
P.O. Box 7646
Philadelphia, PA 19101
(215) 787-5407

M.P.H. deYoung Memorial Museum
Golden Gate Park
San Francisco, CA 94118
(415) 556-2530

Henry E. Huntington Library and Art Gallery
1151 Oxford Road
San Marino, CA 91108
(818) 405-7847

State Arts Agencies

So many resources — such as artists advocacy organizations, artist clubs, funding sources, health insurance programs, libraries of pertinent information, seminars and services of all kinds — exist for artists of all disciplines and media that no one book could fully include them all. State arts agencies are among the best places to find out what programs and opportunities are available. They are:

Alabama State Council on the Arts
1 Dexter Avenue
Montgomery, AL 36130-5401
(205) 242-4076

Alaska State Council on the Arts
619 Warehouse Avenue
Anchorage, AK 99501
(907) 279-1558

American Samoa Council on Culture, Art and Humanities
P.O. Box 1540
Office of the Governor
Pago Pago, AS 96799
011-684-633-4347

Arizona Commission on the Arts
417 West Roosevelt Avenue
Phoenix, AZ 85003
(602) 255-5882

Arkansas Arts Council
225 East Markham
Little Rock, AR 72201 • (501) 371-2539

California Arts Council
1901 Broadway, Suite A
Sacramento, CA 95818
(916) 322-8911

Colorado Council on the Arts
750 Pennsylvania Street
Denver, CO 80203
(303) 894-2617

Connecticut Commission on the Arts
227 Lawrence Street
Hartford, CT 06106
(203) 566-4770

Delaware Division of the Arts
820 North French Street
Wilmington, DE 19801
(302) 571-3540

District of Columbia Commission on the Arts and Humanities
410 8th Street, N.W.
Washington, D.C. 20004
(202) 724-5613

Florida Arts Council
Department of State, The Capitol
Tallahassee, FL 32399-0250
(904) 487-2980

Georgia Council for the Arts
2082 East Exchange Place, Suite 100
Tucker, GA 30084 • (404) 493-5780

Guam Council on the Arts and Humanities
Office of the Governor
P.O. Box 2950
Agana, GU 96910 • 011-671-477-7413

Hawaii State Foundation on Culture and the Arts
335 Merchant Street
Honolulu, HI 96813 • (808) 548-4145

Idaho Commission on the Arts
304 West State Street
Boise, ID 83720 • (208) 334-2119

Illinois Arts Council
100 West Randolph Street
Suite 10-500
Chicago, IL 60601 • (312) 814-6750

Indiana Arts Commission
47 South Pennsylvania Street
Indianapolis, IN 46204 • (317) 232-1268

Iowa Arts Council
1223 East Court Avenue
Des Moines, IA 50319
(515) 281-4451

Kansas Arts Commission
700 Jackson, Suite 1004
Topeka, KS 66603
(913) 296-3335

Kentucky Arts Council
Berry Hill
Louisville Road
Frankfort, KY 40601
(502) 564-3757

Louisiana State Arts Council
900 Riverside North
P.O. Box 44247
Baton Rouge, LA 70804
(504) 342-8180

Maine Arts Commission
55 Capitol Street
State House Station 25
Augusta, ME 04333
(207) 289-2724

Maryland State Arts Council
15 West Mulberry Street
Baltimore, MD 21201 • (301) 333-8232

Massachusetts Cultural Council
80 Boylston Street
Boston, MA 02116
(617) 727-3668

Michigan Council for the Arts
1200 6th Avenue, Executive Plaza
Detroit, MI 48226-2461
(313) 256-3735

Minnesota State Arts Board
432 Summit Avenue
St. Paul, MN 55102
(612) 297-2603

Mississippi Arts Commission
239 North Lamar Street
Jackson, MS 39201
(601) 359-6030/6040

Missouri Arts Council
111 North 7th Street, Suite 105
St. Louis, MO 63101
(314) 444-6845

Montana Arts Council
48 North Last Chance Gulch
Helena, MT 59620
(406) 443-4338

Nebraska Arts Council
1313 Farnam-on-the-Mall
Omaha, NE 68102-1873
(402) 595-2122

Nevada State Council on the Arts
329 Flint Street
Reno, NV 89501
(702) 789-0225

New Hampshire State Council on the Arts
40 North Main Street
Concord, NH 03301
(603) 271-2789

New Jersey State Council on the Arts
4 North Broad Street, CN 306
Trenton, NJ 08625-0306
(609) 292-6130

New Mexico Arts Division
224 East Palace Avenue
Santa FE, NM 87501
(505) 827-6490

New York State Council on the Arts
915 Broadway
New York, NY 10010
(212) 614-2909

North Carolina Arts Council
Department of Cultural Resources
Raleigh, NC 17611
(919) 733-2821

North Dakota Council on the Arts
Black Building, Suite 606
Fargo, ND 58102 • (701) 237-8962

Northern Marianas Islands Commonwealth Council for Arts and Culture
P.O. Box 553, CHRB
Saipan, MP 96950
011-670-322-9982/9983

Ohio Arts Council
727 East Main Street
Columbus, OH 43205
(614) 466-2613

State Arts Council of Oklahoma
Jim Thorpe Building, Suite 640
Oklahoma City, OK 73105
(405) 521-2931

Oregon Arts Commission
835 Summer Street, N.E.
Salem, OR 97301 • (503) 378-3625

Pennsylvania Council on the Arts
216 Finance Building
Harrisburg, PA 17120
(717) 787-6883

Institute of Puerto Rican Culture
Apartado Postal 4184
San Juan, PR 00905
(809) 723-2115

Rhode Island State Council on the Arts
95 Cedar Street, Suite 103
Providence, RI 02903-1034
(401) 277-3880

South Carolina Arts Commission
1800 Gervais Street
Columbia, SC 29201
(803) 734-8696

South Dakota Arts Council
108 West 11th Street
Sioux Falls, SD 57102
(605) 339-6646

Tennessee Arts Commission
320 6th Avenue North, Suite 100
Nashville, TN 37219-0708
(615) 741-1701

Texas Commission on the Arts
P.O. Box 13406, Capitol Station
Austin, TX 78711
(512) 463-5535

Utah Arts Council
617 East South Temple Street
Salt Lake City, UT 84102
(801) 533-5895

Vermont Council on the Arts
136 State Street
Montpelier, VT 05602
(802) 828-3291

Virgin Islands Council on the Arts
41-42 Norre Gode
P.O. Box 103
St. Thomas, VI 00804
(809) 774-5984

Virginia Commission for the Arts
James Monroe Building
101 North 14th Street, 17th Floor
Richmond, VA 23219
(804) 225-3132

Washington State Arts Commission
9th and Columbia Building
Mail Stop GH-11
Olympia, WA 98504-4111
(206) 753-3860

West Virginia Department of Education & the Arts
Arts & Humanities Section
Division of Culture & History
Capitol Complex
Charleston, WV 25305
(304) 348-0240

Wisconsin Arts Board
131 West Wilson Street, Suite 301
Madison, WI 53702
(608) 266-0190

Wyoming Council on the Arts
2320 Capitol Avenue
Cheyenne, WY 82002
(307) 777-7742

Bibliography

The art world has become complicated enough that no one book will suffice — there are, in fact, many hundreds available if all of the manuals and guides that the various Volunteer Lawyers for the Arts groups have published over the years are counted.

These publications serve different purposes, some explaining specific issues of business or law, others offering advice to artists on their careers, still others compiling resource lists for creators. Some of the more helpful publications are noted:

American Council for the Arts. **Money for Visual Artists**. New York: ACA and Allworth Press, 1991.

Caplin, Lee.**The Business of Art**. Englewood Cliffs: Prentice Hall, 1989.

Christensen, Warren, Ed. **National Directory of Arts Internships.** Los Angeles: National Network for Artist Placement, 1989.

Conner, Floyd et al. **The Artist's Friendly Legal Guide.** Cincinnati: North Light Books, 1988.

Conrad, Barnaby III. Absinthe: **History in a Bottle.** San Francisco, Chronicle Books 1988.

Crawford, Tad. **Business and Legal Forms for Fine Artists.** New York: Allworth Press, 1990.

Crawford, Tad. **Business and Legal Forms for Illustrators.** New York: Allworth Press, 1990.

Crawford, Tad. **Business and Legal Forms for Authors and Self-Publishers.** New York: Allworth Press, 1990.

Crawford, Tad. **Legal Guide for the Visual Artist.** New York: Allworth Press, 1989.

Crawford, Tad and Eva Doman Bruck. **Business and Legal Forms for Graphic Designers.** New York: Allworth Press, 1990.

Dardis, Tom. **The Thirsty Muse: Alcohol and the American Writer.** New York: Ticknor & Fields, 1989.

Gordon, Elliott and Barbara Gordon. **How to Sell Your Photographs and Illustrations.** New York: Allworth Press, 1990.

Graphic Artists Guild Handbook: **Pricing and Ethical Guidelines**. Graphic Artists Guild, 1991

Holden, Donald. **Art Career Guide.** New York: Watson-Guptill, 1983.

Hoover, Deborah A. **Supporting Yourself as an Artist.** New York: Oxford University Press, 1989.

Jeffri, Joan. **ArtsMoney: Raising It, Saving It, and Earning It.** Minneapolis: University of Minnesota Press, 1983.

Jeffri, Joan, Ed. **Artisthelp: The Artist's Guide to Human and Social Services.** New York: Neal-Schuman,1990.

Kruikshank, Jeffrey L. and Pam Korza. **Going Public: A Field Guide to the Developments of Art.** Amherst: Arts Extension Service, University of Massachusetts, 1989.

Langley, Stephen and James Abruzzo. **Jobs in Arts and Media Management.** New York: ACA Books, 1991

Leland, Caryn. **Licensing Art and Design.** New York: Allworth Press, 1990.

McCann, Michael. **Artist Beware.** New York: Watson-Guptill, 1979.

Messman, Carla. **The Artist's Tax Workbook.** Lyons & Burford (revised annually).

MFA Programs in the Visual Arts: A Directory. New York: College Art Association of America, 1987.

Michels, Caroll. **How to Survive & Prosper as an Artist.** New York: Henry Holt and Company, 1988.

NAAO Directory. Washington, D.C.: National Association of Artists Organizations, 1989.

Roosevelt, Rita K., Anita M. Granoff and Karen P.K. Kennedy. **Money Business: Grants and Awards for Creative Artists.** Boston: The Artists Foundation,1985.

Rossol, Monona. **The Artist's Complete Health and Safety Guide.** New York: Allworth Press, 1990.

Snyder, Jill. **Caring for Your Art: A Guide for Artists, Collectors, Galleries, and Art Institutions.** New York: Allworth Press,1990.

Whitaker, Ben. **The Philanthropoids: Foundations and Society.** New York: William Morrow, 1974.

White, Virginia P. **Grants for the Arts.** New York: Plenum Press, 1980.

Wilson, Lee. **Make It Legal.** New York: Allworth Press, 1990.

Index